Piero

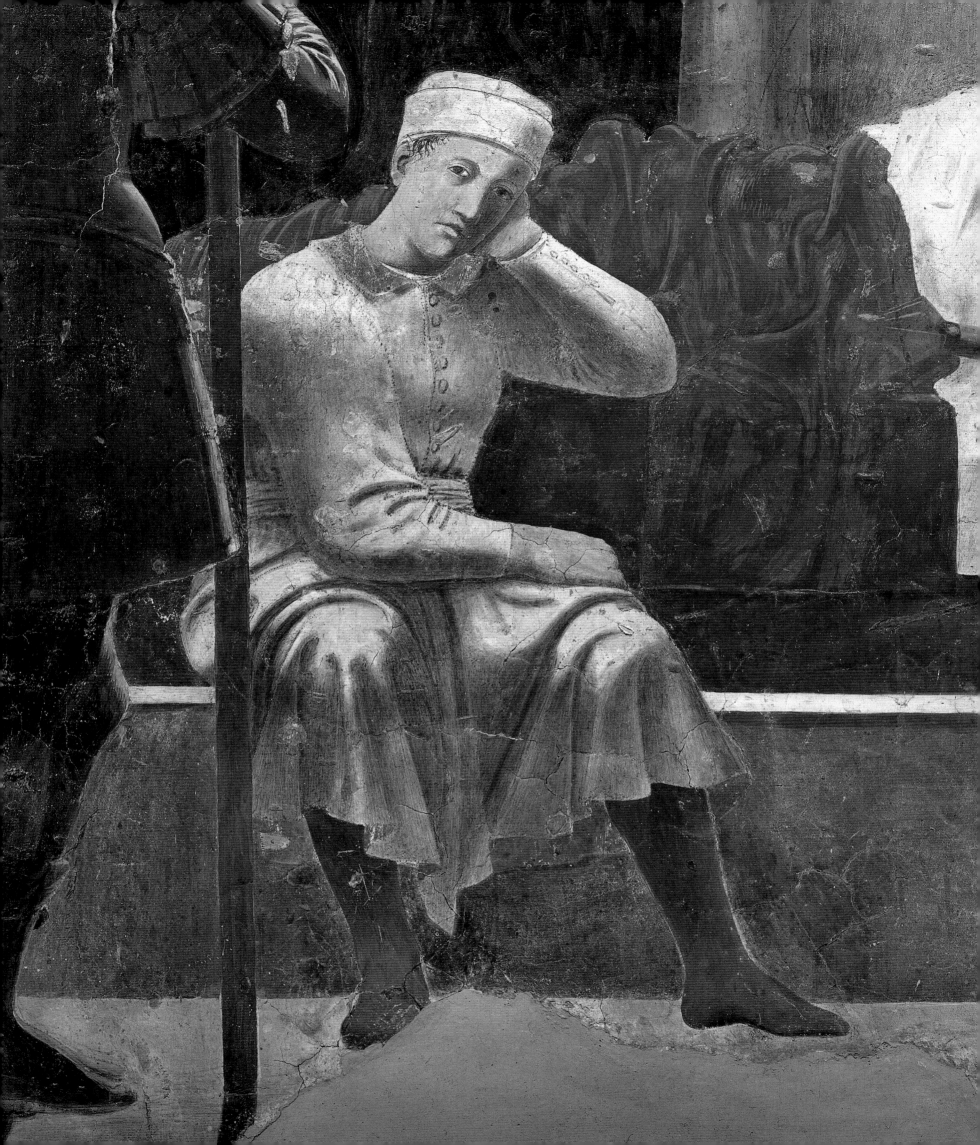

Birgit Laskowski

Piero
della Francesca

1416/17–1492

KÖNEMANN

1 (frontispiece)
Constantine's Dream (detail ill. 31), 1452–1466
Fresco, 329 x 190 cm
San Francesco, Arezzo

© 1998 Könemann Verlagsgesellschaft mbH
Bonner Str. 126, D-50 968 Köln

Art Director: Peter Feierabend
Project Manager and Editor: Sally Bald
Assistant: Susanne Hergarden
German Editor: Ute E. Hammer
Assistant: Jeannette Fentroß
Translation from the German: Fiona Hulse
Contributing Editor: Susan James
Production Director: Detlev Schaper
Assistant: Nicola Leurs
Layout: Bärbel Messmann
Typesetting: Greiner & Reichel, Cologne
Reproductions: CLG Fotolito, Verona
Printing and Binding: Neue Stalling, Oldenburg
Printed in Germany

ISBN 3-8290-0247-5
10 9 8 7 6 5 4 3 2 1

Contents

PIERO DELLA FRANCESCA: AN OVERALL VIEW

Piero della Francesca occupies an entirely special position amongst the artists of the Italian Early Renaissance. Where his artistic importance is concerned, he can be mentioned in the same breath as Masaccio, Uccello and Fra Angelico. He succeeded uniquely in harmonizing the intellectual and spiritual values of his age, the diverse artistic influences and impulses, and the tensions between religious piety and the human need for development.

In his artistic endeavors, Piero della Francesca was driven by a strong intellectual curiosity. The decisive factor in this, apart from what we know of his theoretical mathematical talent, was the experience he gained during his early years as a student and assistant in Florence, working for as important an artistic personality as Domenico Veneziano. These experiences, his theoretical studies, new and stimulating contacts, as well as his own experiments, enabled him to develop his own unmistakable idiom of expression. He created works of art which, in their harmonious appearance blending the traditional and modern, spiritual exploration and earthly presence, theoretical competence and aesthetic consciousness, were amongst the most typical works that were produced in Italy during the 15th century.

In his works, in his mathematical and in particular his geometrical investigations and writings, and in his political involvement in the administration and planning of his native town of Sansepolcro, Piero contributed to the overcoming of the strict medieval separation of fields of knowledge and professions, and played an active part in the cultural development of his age.

One serious problem when looking at and evaluating art nowadays is the fact that the work of an artist, which is after all of primary importance, often comes down to us in a decidedly fragmentary way, and that a major part of it has been lost during the course of the centuries. In the context of Italian Quattrocento painting, this is particularly true of fresco painting, which was the preferred method of decorating churches as well as sacred and secular state rooms, and which was prone to falling victim to structural alterations made during later periods and changes in stylistic requirements. What

remains of the work of Piero della Francesca can be compared with the remains of a ruined palace, whose carefully guarded remnants convey a pale reflection of its former size and splendor.

Much the same is true where the artist's life is concerned. Compiling a conclusive and homogeneous biography such as art historians often present to us, making frequent use of acrobatic twists and turns, from the few definite dates in the life and work of an artist is particularly difficult, if not impossible, in the case of Piero della Francesca, due to the extremely scant information available.

Piero's precise date of birth is unknown. His name first appears in official records on 18 October 1436, as a witness at the drawing up of a will in Sansepolcro, and he must already have been at least twenty years old at this time, as that was the minimum age required for this purpose. This makes it likely that he was born in 1416/17. The fact that his artistic development had already progressed a long way by 1436 is proven by a receipt for a payment to the local artist Antonio d'Anghiari for the painting of standards and flags. Piero's name appears amongst the master's assistants. Though there are records showing that Piero was again working in Sansepolcro, or Borgo San Sepolcro, as the place was known at the time, in 1438, there is nothing to contradict the possibility that he received further artistic training in a large centre, such as Florence. In 1439, at any rate, he was working with Domenico Veneziano and other assistants to create the frescoes in the choir of the Florentine church of Sant' Egidio. Piero's decision to perfect his art with Domenico Veneziano speaks for his interest in the brightest and most colorful line of development in Early Renaissance painting, an interest that would have a determining influence on the rest of his life.

This is true of one of Piero's first larger works, the altar painting of the *Baptism of Christ* (ill. 7) destined for the main church in Sansepolcro. Various iconographical elements indicate that the work was created in about 1439, the year in which the Council of Ferrara and Florence attempted to reunite the Eastern churches with the Western church. In this work, with its conical bodies which seem stilted and are lit and modelled by a strong

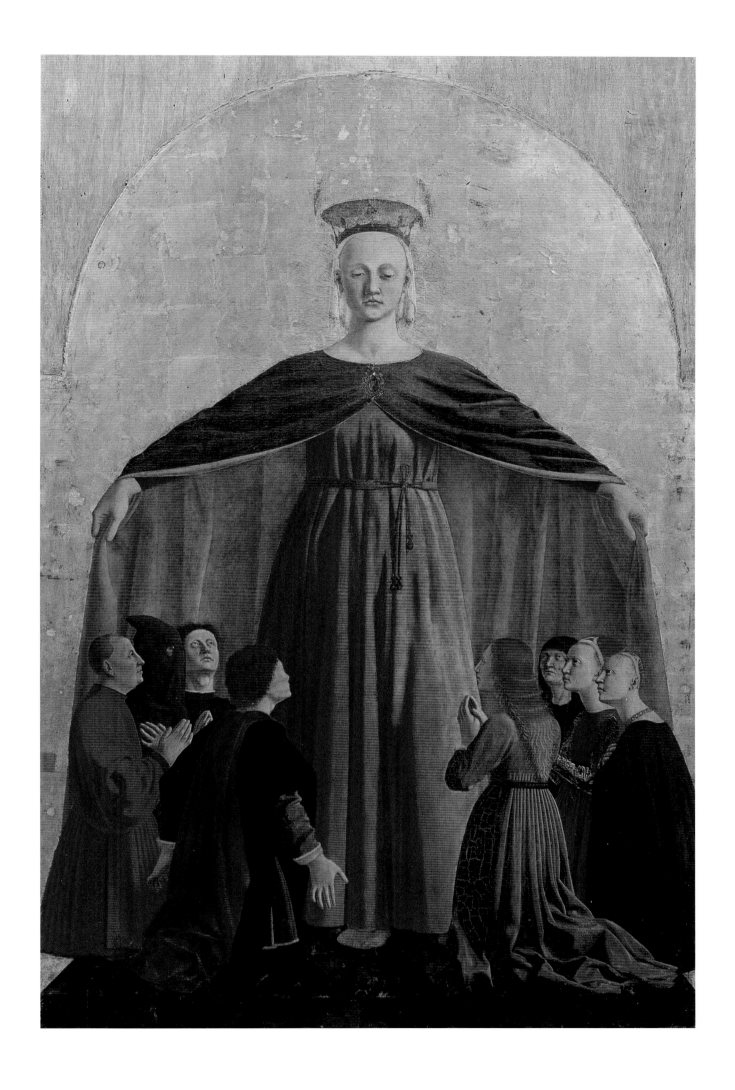

3 Domenico Veneziano
Madonna and Child with Saints, ca. 1445
Altarpiece of Santa Lucia de' Magnoli
Tempera on panel, 209 x 216 cm
Galleria degli Uffizi, Florence

In his altarpiece, Piero della Francesca's teacher creates a particularly light atmosphere by keeping the colors to pastel tones, connected to an impressive structuring of the pictorial space: pink, reseda green and sky blue reflect the springlike light that is entering the loggia from the top right. In its centre, slightly raised, are the enthroned Madonna and Child. The more powerful red in St. John the Baptist's cape and the shoes of St. Lucia contrasts with the silvery shimmer on the garments of St. Francis and St. Zenobius.

light, the further stylistic development of Piero is, as it were, programmatically arranged.

On 11 January 1445, Piero was commissioned by the Compagnia della Misericordia in Sansepolcro to produce a large altarpiece with several panels. In the contract, three years were given for the completion of the polyptych, but the altar was not finished until 1460, when the central panel showing the *Madonna of Mercy* was finished. The first two panels, *St. Sebastian* and *St. John the Baptist*, have a heaviness which is clearly reminiscent of Masaccio's figures. For the panel of *St. Bernardine of Siena*, the year 1450 is considered to be the earliest possible date. He was canonized in 1450 and is already surrounded by a halo on the picture, which means that it must have been produced after this date.

Recently discovered sources show that during the 1440s Piero stayed and worked in Urbino, Ferrara and presumably also Bologna. The frescoes produced during this period no longer exist. In 1451 he was in Rimini. There he signed a monumental fresco of St. Sigismund and the portraits of Sigismondo Malatesta, the ruler of Rimini.

All of Piero's works display the artist's interest in detailed landscapes and garments, indicating influences from the north, in particular Flemish ones. This is also true of two early picture panels showing St. Jerome (ills. 5, 6), one of which is dated 1450. Above all, the saint's books, which are depicted in detail, can only be understood through a knowledge of northern models. They do not appear in Italian painting before Piero.

The painted architectural elements which were introduced for the first time in the Sigismondo fresco in Rimini accord with Leon Battista Alberti's theoretical requirements (which he demonstrated in practice in the Tempio Malatestiano) for the imitation of classical architecture. The *Flagellation* (ill. 70), a painting produced after Piero's period in Rimini, was an early highlight in the arrangement of a pictorial space according to the laws of perspective by means of skillfully composed architectural backdrops.

From an artistic point of view, the year of 1452 was particularly important for Piero. Bicci di Lorenzo, the Florentine artist who had been engaged upon painting the decorations for the main chapel in San Francesco in Arezzo, died, and Piero was appointed to continue and

complete the cycle of frescoes depicting scenes from *The Legend of the True Cross* that the Bacci family had commissioned. There are records that the work was completed by 1466, though it is possible that it was finished earlier.

Characteristic of the cycle is the consistent perspectival arrangement of the scenes and the soft and light-filled colors, once again reminiscent of Domenico Veneziano, which is enclosed in a strict style of drawing characteristic of Florence, though its rigor weakens somewhat during the course of the work. The first phase of the work, up to 1458, comprised the scenes in the lunettes and the painted frames, which were carried out by several assistants to cartoons produced by the master.

In 1458/59, Piero was working in Rome. Nothing remains of the frescoes mentioned in documents, including some in the Vatican. His encounter with the Flemish and Spanish artists working in the Vatican was directly reflected in the subsequent sections of the frescoes in Arezzo: Piero increasingly emphasized details and realistic atmospheric phenomena. An example of this is the night scene of *Constantine's Dream* (ill. 31).

The fresco of the *Resurrection* (ill. 59) in the town hall in Sansepolcro also dates from the time of his journey to Rome. The almost unapproachable solemnity of this monumental composition is highlighted by the pyramid-shaped arrangement of the scene and the hieratic frontal view of Christ.

The fresco painting of *St. Mary Magdalene* (ill. 55) in the cathedral of Arezzo signaled the completion of the work in San Francesco.

In the meantime, Piero created a polyptych for the nuns of Sant'Antonio in Perugia, which Vasari praised very highly.

In about 1465, the double portrait of Federico da Montefeltro and Battista Sforza, the duke and duchess of Urbino (ills. 66, 67), was produced. The rear of the panels was decorated with allegorical triumphal processions with painted inscriptions of homage. The distant, meticulously painted landscape backgrounds are reminiscent of the atmospheric landscape of Jan van Eyck.

In 1454, Piero was commissioned by the Augustinian monks of Sansepolcro to produce a large polyptych, to be finished within the space of eight years. However, the final account was not drawn up until 1469. In this work,

Piero chose to omit the usually obligatory golden background. He particularly emphasized the linearity and statue-like monumentality of the saints' figures, which he positioned in front of open skies and classical balustrades.

Twenty years after the first wave of enthusiasm for perspective that Piero had unleashed in the Emilia-Romagna region, and which had been particularly influential on the works of Cosimo Tura, Francesco Cossa, Ercole de Roberti and the Lendinara brothers, Piero returned to Urbino once more in the early 1470s. The first work he produced at the Montefeltro court was the *Madonna of Senigallia* (ill. 77), a majestic depiction of the Madonna with what, in the context of European painting, is a unique background, a mysterious mixture of architecture and light production.

It is likely that the so-called *Pala Montefeltro* (ill. 75) was created before 1475, as the duke is depicted in the picture without the Order of the Garter that was conferred upon him in 1474. In this painting, the northern and Flemish influences are not restricted to the reflections of light on the carpet and armor: the Spanish painter Pedro Berruguete, who was trained in Flanders, is said to have completed several details in the picture.

The complex, colorful architectural backdrop is once again in keeping with Alberti's creations and is clearly reminiscent of motifs with which we are familiar from Sant'Andrea in Mantua. Competing with the architecture are the monumental figures in the picture, also arranged as it were in a tectonic manner, and bathed in a light, atmospheric range of tones.

This quality of color is characterized even more comprehensively in the last known painting by Piero, the *Nativity* (ill. 112). Though the assimilation of cultural influences is no less intellectual in this work than in the earlier ones, it is still surprising to see the reduced perspectival arrangement and the loving attention to detail.

In 1482, Piero bought a house in Rimini. In 1487 he drew up his will, "sound in spirit, intellect and body" as it says in that document. At this point the artist was not yet suffering from the eye problems which were to lead to his becoming totally blind during the last years of his life. Piero della Francesca died on 11 October 1492, in his native town, where in accordance with the wishes expressed in his will he was also buried.

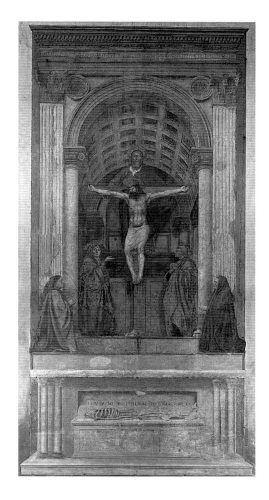

4 Masaccio
Trinity, 1425–1428
Fresco, 667 x 317 cm
Santa Maria Novella, Florence

Masaccio's fresco is one of the first examples of the new style of painting. The pictorial space is arranged entirely according to the principles of central perspective and the figures have their assigned places within it: the donors at the front, followed by Mary and St. John, and finally the crucified Christ, the Holy Spirit in the form of a dove and God the Father. This means that the observer of the work also has his own position. Seen from a distance of about four meters, one gains the illusion of a chapel in the architectural style of Brunelleschi.

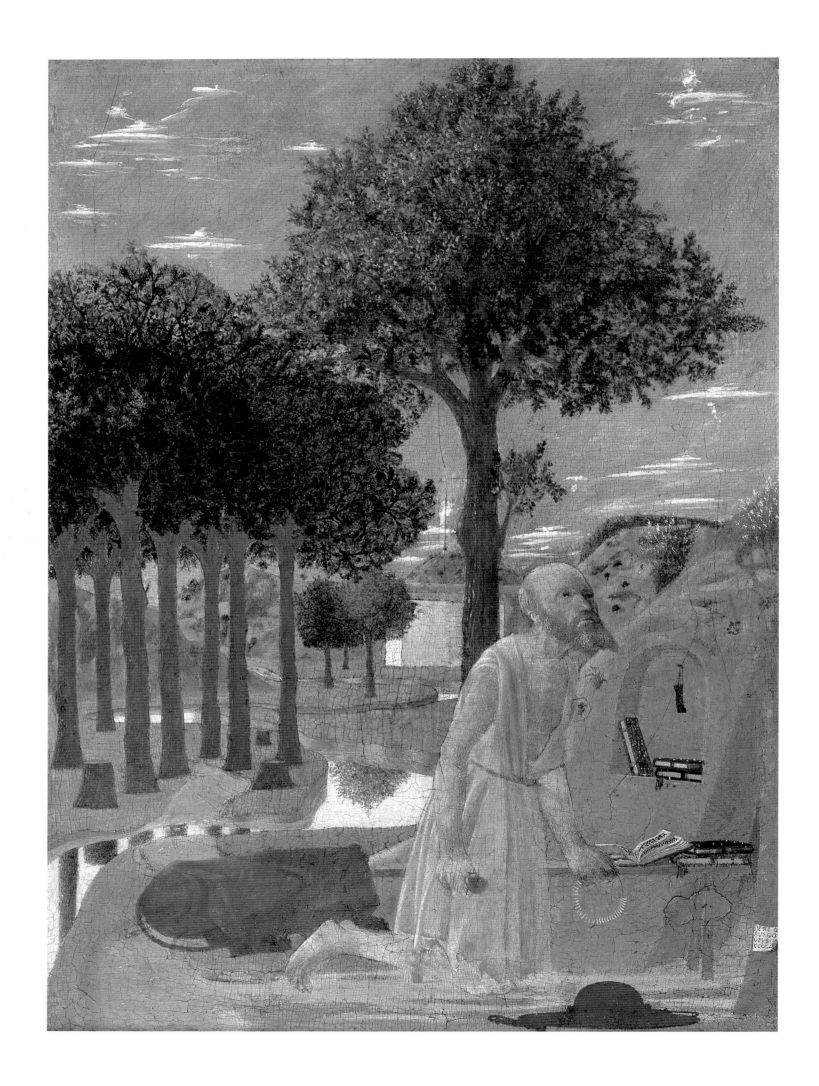

THE EARLY WORKS

Many of Piero's works no longer exist today, and there are very few definite dates for those that have survived the years. The only means that can be used to somewhat narrow down the period during which they were created are contracts that give the date on which a work was commissioned, and a few biographical details. Frequently, however, there are references to contemporary historical events in the paintings themselves. It is also occasionally helpful to take into account events in ecclesiastical history: often, for example, the date on which a particular saint was canonized is known. If that person is depicted with a halo, the picture was presumably created after that date. One of the few dated works we have of Piero's is *St. Jerome Penitent* (ill. 5). The painting, the signature on which was originally visible, was until 1968 covered by an old overpainting, which made it impossible to conduct an art historical evaluation of the work. The inscription, attached to the tree in the foreground on the right, gives the name of the artist and the year the work was created: PETRI DE BURGO OPUS MCCCCL. According to this, it is possible that the picture was produced during one of the journeys which Piero undertook at this time.

St. Jerome, a Father of the Church (ca. 347–420), is said to have spent three years living in retreat in the desert of Chalcis; previously he had been engaged in studying the sciences in Rome. Western Christianity has him to thank for the translation of the Bible from the Hebrew and Greek into Latin, known as the Vulgate. In accordance with the detailed description of his life in the "Legenda Aurea" (the important collection of saints' legends), there were two basic ways in which the saint was depicted, both of which appeared in about 1400. One was as a penitent hermit, and the other type – most popular amongst the Dutch – was as a scholar indoors, seated at the desk in his study. This latter method of depiction interpreted the saint as the prototype of the humanist scholar.

Piero decided in favor of a peculiar combination of these iconographical patterns: the rock in front of which St. Jerome is kneeling has a niche in which books and writing implements are contained. The shining red cardinal's hat is lying on the ground, like an implement

which is useless in this situation, and is an allusion to the future career of the saint. This part of the composition to a certain extent represents the interior character of the indoor depictions. The rest of the painting is devoted to the landscape, which is anything but a desert: a fertile plain extends behind the penitent, and there is a building in front of the hills in the background. A stream winds its way across the landscape and among the trees, and a path crosses it and winds between the trees into the background.

The gentle colors are presumably a result of the relatively poor state of preservation of the work. It is, however, also possible that this is an early attempt on the part of Piero to develop his own entirely individual colors which create a realistic representation of the atmospheric conditions of a scene under an open sky. The shapes of the clouds are reminiscent of rotating geometrical bodies. We encounter them repeatedly in Piero's works (cf. ills. 36, 37). The colors play at least as important a role in defining the space as the forms. Thus, for example, the brown shades which are rhythmically repeated in the picture and gradually become lighter guide the gaze of the observer through the picture and prompt him to comprehend the spatial relationships. This aspect would in later years become a characteristic of Piero della Francesca's art.

Piero created a further depiction of St. Jerome in the painting of *St. Jerome and a Donor,* a work which is generally given an earlier date (ill. 6). As with the painting just described, it is signed with an inscription on the tree trunk serving as the base for the crucifix: PETRI DE BURGO SANCTI SEPULCRI OPUS. It is not, however, dated. A variety of dates have been suggested, varying from 1440 to 1450. The diagonal position of the Cross is noticeable. The reason for this seems, however, to have less to do with the perspectival structure of the painting than with the desire to highlight the relationship of the Cross to St. Jerome. The believer, depicted in a red garment and identified by an inscription as Girolamo Amadi, has visited St. Jerome in his hermitage. He is clearly disturbing him at his studies: the saint is in the process of turning over a page in his book. The expression on his face reveals that he is unwilling to be interrupted at his reading. Piero uses

5 *St. Jerome Penitent*, 1450
Tempera on chestnut panel, 51 x 38 cm
Staatliche Museen zu Berlin – Preußischer Kulturbesitz, Gemäldegalerie, Berlin

The penitent saint kneels in a landscape covered with trees and bordered by hills. In his right hand he holds a stone in order to strike his breast, in the left a rosary. He is looking up at a simple wooden cross that – scarcely visible today – is attached to the tree trunk on the right edge of the picture. At his side are, on the left, the sleeping lion out of whose paw he pulled a thorn, and on the right some books, one of which is open. The saint is taking no notice of the red cardinal's hat lying before him. In this work the artist is creating an unusual combination of the two representational types of St. Jerome in his study and the penitent St. Jerome in the desert.

contrasts to separate the two figures and their "worlds" from each other. Above the believer, who is wearing a red garment, arches the dense, green crown of a tree, while the saint himself appears in his penitential robe beneath the open, bright blue of the sky.

Piero was able to study the clever spatial shaping achieved by placing color contrasts into the depths of the picture in the frescoes in the Brancacci Chapel in Florence, created in 1425 by Masaccio; here, Masaccio created a masterly example of the concept of advancing and retreating colors, where colors gradually lighten the further away they are, which was perfected during the course of the Quattrocento. In his early work, which includes the Brancacci frescoes, he still preferred the interplay of light and shadow to depict space and positioned contrasts evenly right into the background of the picture.

Piero's *Baptism of Christ* (ill. 7) has a similar accentuation of depth, coupled with a brightness that is permeated by light, as in *St. Jerome and a Donor*. The painting, which is semicircular at the top, is the central panel of an altar in several parts, produced by Matteo di Giovanni in about 1465. The lavish construction of the frame leads us to the conclusion that the structure was destined to be the main altar in a larger church. Some art historians consider this piece to be a work by the mature Piero in about 1460, whereas others give it a particularly early date, as its light pastel colors are reminiscent of Domenico Veneziano's altar in Santa Lucia de' Magnoli, created in about 1445 (cf. ill. 3).

It has repeatedly been mentioned in art historical research that the construction of the picture is based on geometric shapes (ill. 9). One of the suggestions is that the composition is based on the Platonic shapes with which Piero deals in his treatise "De Corporibus Regularibus". The painting is constructed of simple basic forms: a semicircle sitting on a square. If a sketch of an equilateral triangle with the tip pointing down were drawn in the square, it would meet the toes of Christ's engaged leg. In the centre of the triangle are the folded hands of the Son of God, and the centre of the base line is marked by the dove. The square, circle and equilateral triangle are shapes whose special feature lies in the fact that they are regular and cannot be simplified further. That they not only determine the format but also the posture and shape of Christ in this picture means that they must be interpreted as a first reference to the theme of the depiction: in the Baptism, Christ is revealed to us as the Son of God. In consequence, all other pictorial figures – with one exception – are arranged by Piero parallel to the frontal figure of Christ, which is not overlapped by anything else. The most conspicuous example of this is St. John the Baptist. The fingers of his left hand do not extend beyond the limits of his garment – as if to maintain an imaginary border.

In this baptismal scene, the laws of nature appear to have been annulled: the river has stopped flowing at the point where Christ's feet are standing in the bed of the river. In accordance with iconographical tradition, Jesus is shown being baptized in the Jordan. Piero was particularly interested in using the water as a reflective surface. This preference, entirely related to his endeavors for perspective, made it possible to achieve heightened spatial effects. It was, however, also problematic in that it was not traditionally permitted to depict Christ as a reflection or simply doubled. Almost unnoticeable reflections around the ankles of the two protagonists show that they are standing in water. The way in which Piero della Francesca paints the river as flowing almost vertically from the middle distance of the picture into the foreground is unusual in 15th-century Italian painting.

The four Gospels correspond in their account of the Baptism of Christ in that, at the decisive moment, the heavens were opened and the Holy Spirit descended as a dove, and a voice from heaven introduced Christ: "This is my beloved Son, in whom I am well pleased." (Matthew 3:17; cf. Mark 1:9–11, Luke 3:21 ff., John 1:29–34). But how was an artist to depict the opened heavens? While he could not paint the unpaintable, he could nonetheless allude to it and visualize what was absent. One of the Greek priests in the background is pointing up to the sky. His gesture expresses his astonishment, though he is clearly interpreting the event as a miracle of nature; the ecclesiastical dignitaries have turned their backs to Jesus, which shows that they have failed to connect the natural spectacle with him and have not recognized its true dimension. The man awaiting baptism to the right behind St. John, who is just in the process of getting undressed and is pulling his garment over his head, is also not able to see anything at this moment. So that there is no chance of missing the allusion made using the priest's figure, he is highlighted by the artist. The figures of the man undressing for baptism and St. John frame the figure, the extended right arm of the Baptist is an extension of his pointing arm, and the extended left leg of the Baptist once again picks up the direction in which he is pointing.

One starting point for interpreting the work assumes that the painting should be seen in the context of the efforts to reunite the Western and Eastern churches. While we have no precise information about the people who commissioned the work, it is possible that the picture was destined for an altar dedicated to St. John in the Camaldolese monastery, the later cathedral of Borgo San Sepolcro. Ambrogio Traversari, the monastery's abbot, had been intensively involved in the efforts to reconcile the Western and Eastern churches. Traversari died in 1439, the same year in which the Council of Ferrara and Florence took place in an attempt to reunite the churches. It is therefore quite likely that the painting was intended as a work of remembrance for this abbot. This interpretation is also supported by the date of 1440, which is when the majority of academics agree the work was created. This would also suggest a different interpretation of the three angels, who differ from the traditionally depicted motifs. In depictions of the Baptism, the angels normally hold the garment of the new life ready for Jesus; the new life starts after the forty days that he spends in the desert. In this case, however, they do not appear to be fulfilling this function, unless the pink

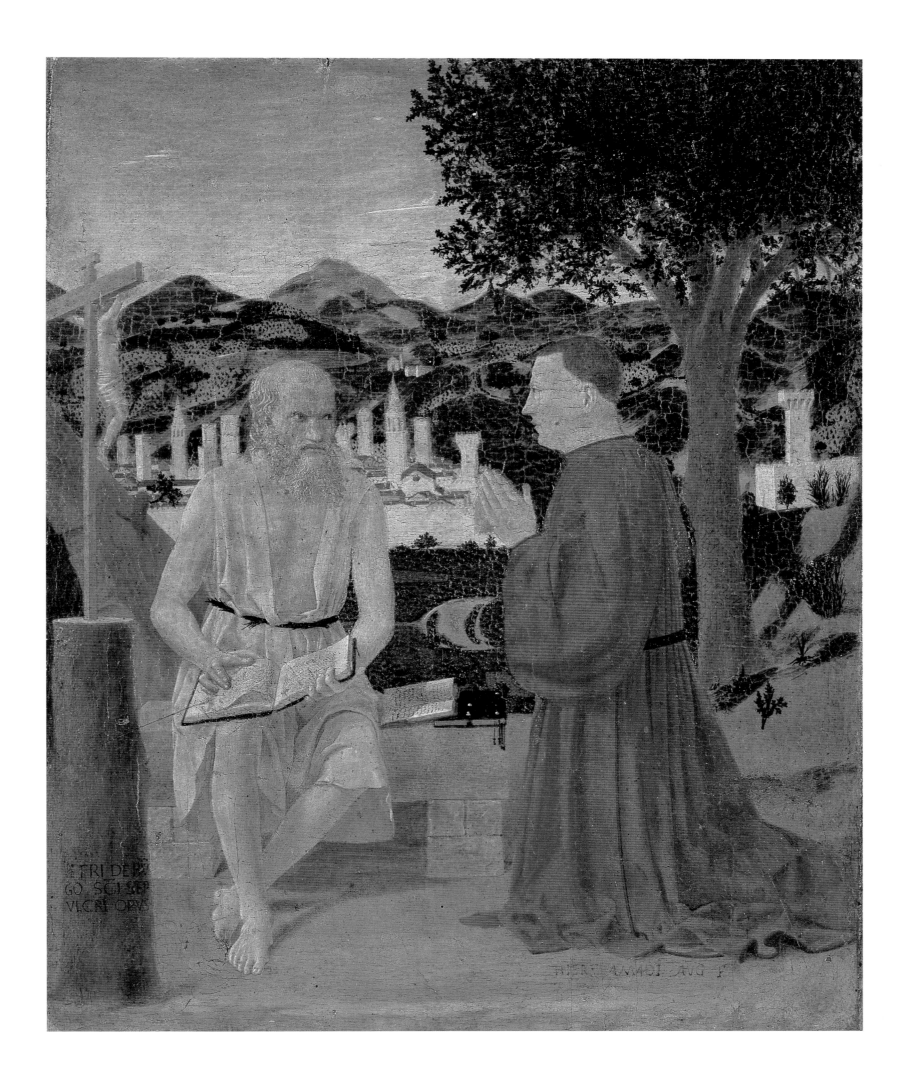

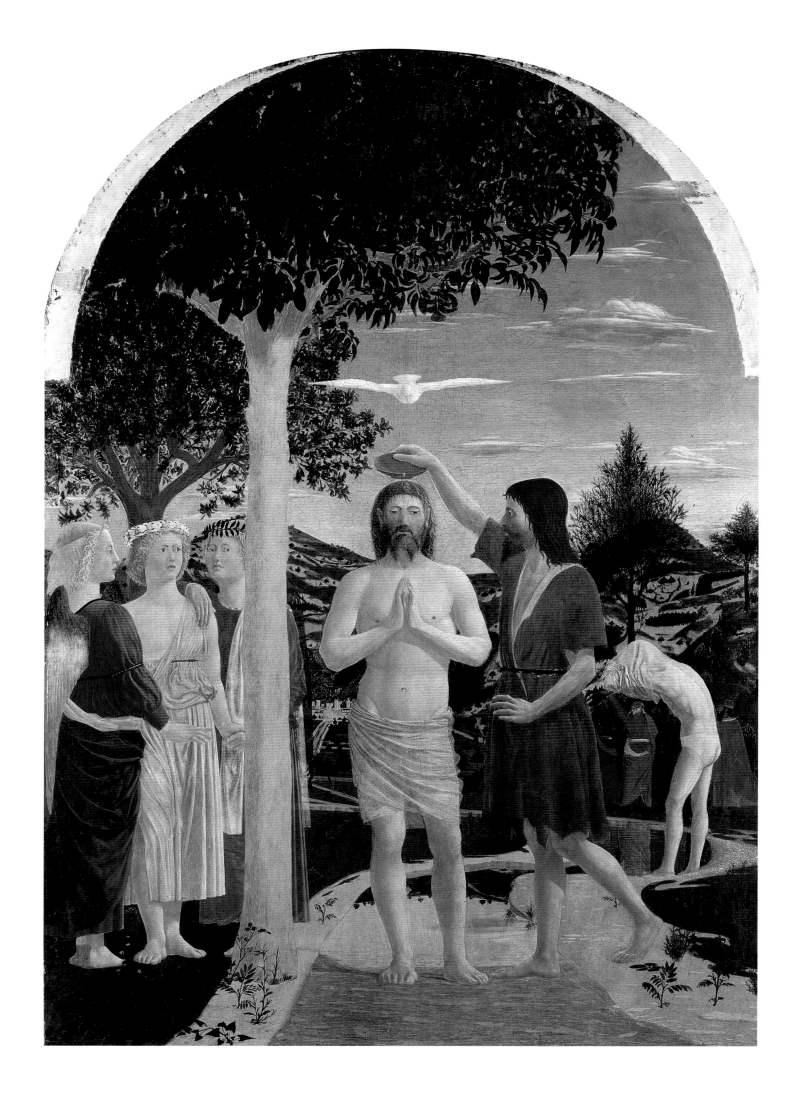

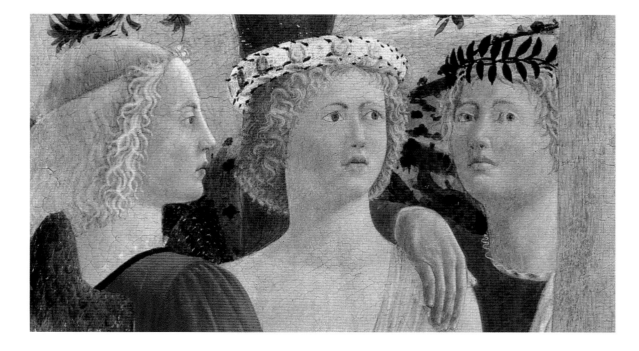

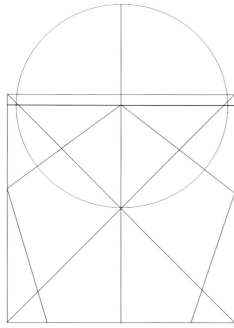

As in *St. Jerome Penitent*, in the *Baptism of Christ* Piero is also using monumental figures in front of a small-scale landscape. Once again the sense of spatial depth is created more by the relation of the individual forms to each other – it is noticeable how the trees are related to the figures – and orientation within the pictorial space is made possible mainly by comparing these details. This method of composition dominates the central perspective which is also present. It ensures that the observer is never able to comprehend the spatiality of the scene without some effort. In this way Piero is able to emphasize powerfully the religious theme and its spiritual importance. The traditional and pious intention of conveying the miracle of the incarnation to the observer is achieved using formal means. When compared to *St. Jerome Penitent*, which is analyzed above, it is quite likely that the *Baptism of Christ* was produced later, in about 1450 or even 1460; this is suggested by stylistic points such as the structure of the picture surface, the composition of the pictorial space, and the structuring of the relationship between this and the figures in the picture.

The *Baptism of Christ* proves that Piero della Francesca knew how to circumvent the laws of central perspective where he felt it to be required by the picture's message. After all, he himself – very much later in life – wrote a treatise on perspective which displays a high degree of competency and is one of the most important treatments of this theme in the Early Renaissance.

material over the shoulder of the angel on the right is meant to represent this garment.

According to this new interpretation, the three heavenly messengers should be interpreted as a symbol of harmony, and together with the Greek priests in the background they are an allusion to the reunion of the churches. After all, the angel in the centre is moving one hand towards the other. Within the context of the picture, however, the group of angels has one more thing to offer that provides us with information about the understanding of art during that period. For Piero makes use of an artistic trick which he frequently employed. The angel on the right is looking out of the picture, turning towards the observer who, once he notices him, wants to know his significance. In the Renaissance this sort of pictorial figure was called a *festaiuolo*. The role he plays is always a subordinated one, such as that of the angel here. In addition, the figure is related to other similar ones. In this case, the heads and faces of the two other angels are only slightly different from the third one. These, however – and this is a clear difference – are giving their full attention to the baptized Christ. First of all, therefore, the observer is being drawn into the picture so that the most important event in the story can be brought to his attention. In addition, the garments worn by the ecclesiastical dignitaries and angels form a contrast, with many associations, of warm and gently cool color rhythms. Piero was to use such references, whose role is to structure the picture, on a large scale in his frescoes in the church of San Francesco in Arezzo.

8 (above left) *Baptism of Christ* (detail ill. 7), 1440–1460

The angel on the right of the group of three looks directly at the viewer. He is thus given the role of the *festaiuolo*.

9 (above right) Compositional scheme of the *Baptism of Christ*

The structure of the picture is determined by a square with a semicircle resting above it. In the centre of the circle into which the semicircle could be extended appears the dove whose wings also mark the upper edge of the square. Christ is standing in its centre. If one were to draw an equilateral triangle with the tip pointing down within this square, one would find that the tip coincides with the toes of Christ's engaged leg, while his folded hands form the centre of the triangle.

7 (opposite) *Baptism of Christ*, 1440–1460
Tempera on panel, 167 x 116 cm
The National Gallery, London

Jesus is seen in a frontal view standing next to St. John the Baptist. Above him, foreshortened according to the laws of perspective, floats the dove of the Holy Spirit. On the left, next to a large tree under whose dense canopy the baptism is taking place, three angels in antiquated dress are observing the events. Behind a man about to be baptized, who is just getting undressed, is a group of Greek priests. Their garments are reflected in the Jordan. In the distance the silhouette of the town of Sansepolcro is visible.

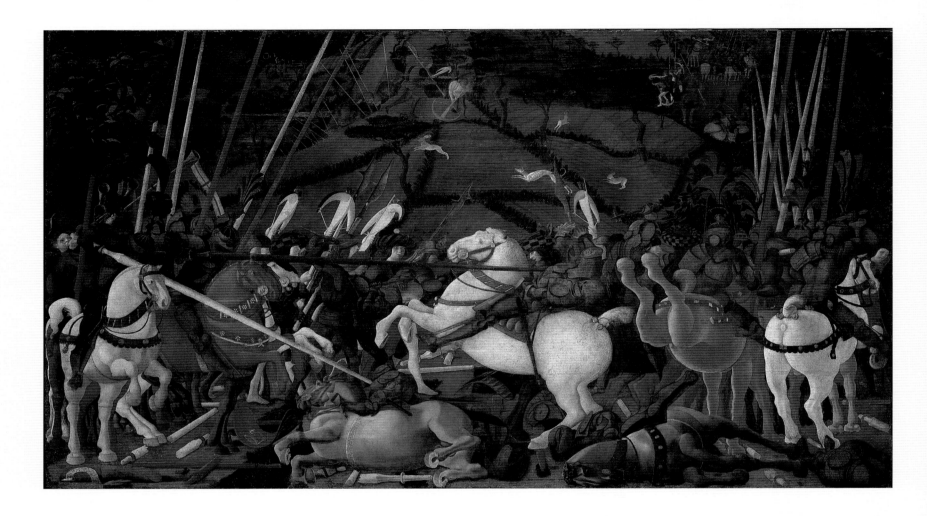

One of the first artists to examine the theoretical basis of painting was Cennino Cennini. He published his discoveries in about 1390 in the "Libro dell'arte", a set of practical instructions aimed at professional artists. The problem of perspective was not, however, examined until the Early Renaissance, in connection with the laws of classical optics and based on Euclid's insights into the properties of light. Leon Battista Alberti, in particular, made an intensive investigation of the problems of perspectival depiction in his treatise "De Pictura" (On Painting), which appeared in 1435.

The Italian version of 1436 was dedicated to Brunelleschi, who according to Vasari was one of the first in the 15th century to undertake investigations of perspective. In front of his field of vision he arranged a framed grille of small squares and precisely transferred the contents of the individual fields onto a pictorial medium. The precise depiction of a particular view was only guaranteed if one kept to a stipulated visual distance from the projected plane within the frame.

Alberti then developed a more flexible method of central perspective composition, which with some alterations continues to be valid to this day. In it, the picture plane is an imaginary section through the visual pyramid – the radial connection between the eye of the observer and the individual points of measurement of the object in question. The eye is connected by an imaginary infinite straight line with a vanishing point on the distant horizon. This is the point towards which all the lines in the section of reality being observed are converging, at right angles to the picture plane. Alberti called the picture created in this way *vetro tralucente* (translucent glass, window). While other topics covered by Alberti were the composition of the picture, the treatment of color and the profession of the artist in general, Piero della Francesca, in his treatise "De Prospectiva Pingendi" (On Perspective in Painting) restricted himself entirely to perspective. Piero followed Alberti only in that he divided painting into three areas: *disegno*, *commensuratio* and *colorare* (drawing, measurement and color). However, he limited his treatise mainly to the aspect of *commensuratio*, which meant "measurement in composition". Compared to Alberti, his discussions are much more closely related to practice. In the first book, Piero explains the projection of surfaces, in the second that of geometric bodies and in the third that of more complex bodies and spaces (ills. 11, 12). The discoveries of Alberti and Piero della Francesca would, during the following years, be used as a basis for Leonardo da Vinci's writings on light

10 Paolo Uccello
The Battle of San Romano, 1440–1450
Tempera on panel, 182 x 323 cm
Galleria degli Uffizi, Florence

Alberti's treatise "De Pictura" (On Painting), which was published in 1435, greatly encouraged contemporary painters to use central perspective in their works. This is shown particularly impressively by Uccello's battle paintings: the flight of the soldiers on the left, the horses lying on the ground or the kicking horse on the right side. The picture shows the centre one of three equally large panels whose theme is the battle between Florence and Siena. Here the victory of the Florentines under the leadership of Niccolo da Tolentino is depicted.

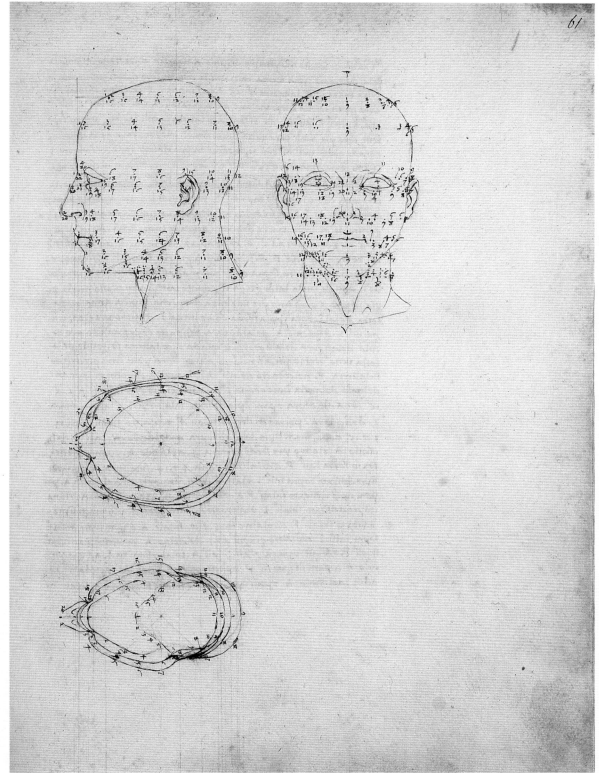

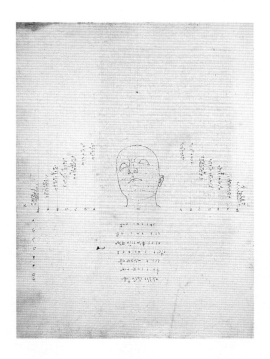

11 (right) Sketch of a human head, before 1482
From: Piero della Francesca, "De Prospectiva Pingendi"
Biblioteca Ambrosiana, Milan

The human head is being measured with a view to
perspectival depiction: the profile view appears next to
the frontal view; the view from above is also shown. This
drawing makes it clear that the use of perspective gave a
scientific foundation to art.

12 (below) Drawing of a foreshortened head, before
1482
From: Piero della Francesca, "De Prospectiva Pingendi"
Biblioteca Ambrosiana, Milan

and space in his posthumously published treatise on painting, the so-called "Codex Urbinas Latinus 1270".

Piero wrote two further works: a pamphlet on applied mathematics, "Trattato del Abaco" (On the Abacus), and a treatise, "De Quinque Corporibus Regularibus", about the five regular bodies of geometry whose distinguishing feature is that they can be placed within a sphere and cannot be further simplified: they are the tetrahedron, cube, octahedron, dodecahedron and icosahedron. Their sides are formed by regular polygons. He did not – like the classical philosopher Plato – assign these bodies to the elements and also did not interpret their symbolic character, but only investigated the mathematical and geometric properties of their forms. This sober approach characterizes all the treatises written by Piero. Here, the artist was concerned with mathematics rather than philosophy.

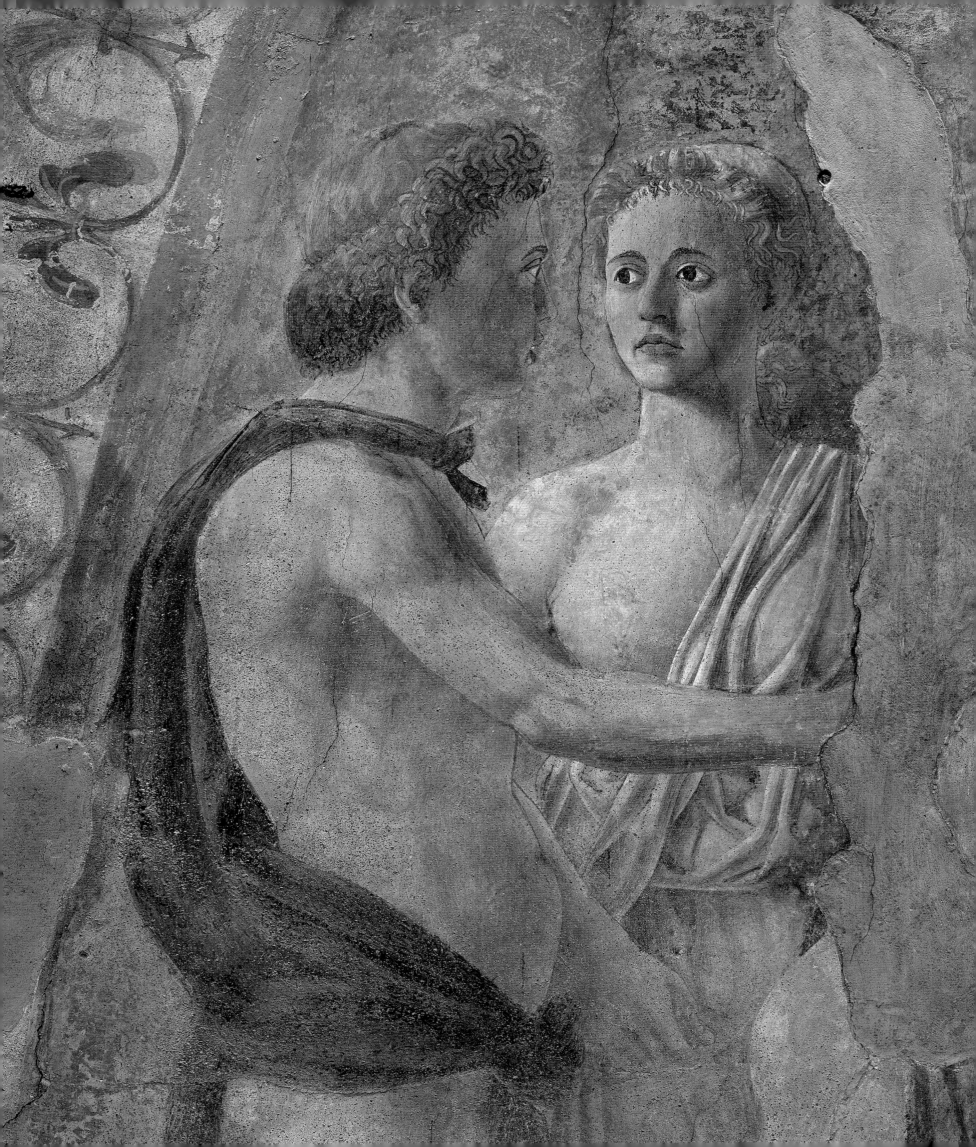

THE FRESCOES IN AREZZO

Piero della Francesca put his theoretical expertise on depiction using perspective into practice in extremely varied ways. The compositional breaks, which are at variance with theory, are always intentional. Much has, so to speak, been deliberately "badly designed", which is to say that the spatial relationships have intentionally been designed in such a way that they cannot be easily understood straight away.

The purpose of this is to require the observer to make a more intensive study of the pictures. At the same time, this method keeps him at a distance from the events depicted. It produces a moment of confusion which increases the religious humility and spiritual attentiveness towards what is being depicted: human understanding is not capable of grasping what can be seen in the paintings.

This interesting aspect is characteristic of the majority of Piero's paintings, in particular his main work, the frescoes in the church of San Francesco in Arezzo (ills. 14, 16).

When Piero della Francesca was commissioned to decorate the main chapel in the Franciscan church, he was already known beyond the borders of his immediate native region. He had worked for the royal courts of Ferrara, Rimini and Urbino and was a respected artist.

At the beginning of the 1450's, Piero started work on the cycle of frescoes in Arezzo. The choir of the Franciscan church of San Francesco, with its typical single-aisled ground plan, was built at the very beginning of the Quattrocento. The right of patronage was adopted by the Baccis, an old-established family of merchants. In 1417, Baccio di Maso Bacci had died, and in his will he had decreed that the chapel should be decorated. His heirs did not fulfil his wishes for another 30 years. In 1447, Francesco Bacci commissioned the already elderly Florentine artist Bicci di Lorenzo to decorate the chapel, and sold a vineyard in order to be able to finance the work. However, Bicci di Lorenzo was not able to complete his designs, which owed much to the Late Gothic style, as he became ill shortly afterwards and died in 1452. It is probably at this point that the commission was given to Piero by Francesco's son, Giovanni Bacci, who was closely connected to the humanist circles in Arezzo. Piero may therefore have

begun work on the extensive cycle of frescoes, which was to be his main work, in about 1452; even the considerable damage which many sections of the cycle have suffered during the course of the years has not been able to diminish its magic.

The frescoes were completed by 1466 at the latest, when Piero was commissioned by the Arezzo confraternity of the Misericordia to paint a standard: in the contract, the successful frescoes are mentioned as the criteria for his selection for the task.

The scenes present the eventful story of the True Cross from the beginnings mentioned in Genesis to the year AD 628, when the stolen Cross was returned to Jerusalem. They are derived from the "Legenda Aurea", put together by Jacobus da Voragine between 1224 and 1250.

In the Franciscan orders, there was a tradition of venerating the Cross. The allusion is clear: because of his piety, God marked St. Francis of Assisi – through a vision – with the stigmata, the five wounds that Christ received on the Cross. As a result, two famous painted versions of the material already existed: Agnolo Gaddi had decorated the church of Santa Croce in Florence with scenes from the Legend of the True Cross, and Cenni di Francesco had also used them as his model in San Francesco in Volterra.

Piero della Francesca's work differed considerably from that of his important predecessor, Agnolo Gaddi. Many of the differences are not of much consequence – the *Burial of the Wood*, for example, is shown as an independent picture –, but there are other things that are significant and can be viewed as iconographical innovations. These include the *The Queen of Sheba in Adoration of the Wood and the Meeting of Solomon and the Queen of Sheba* (ill. 21), *Constantine's Dream* (ill. 31) and the *Battle between Constantine and Maxentius*.

Piero does not arrange the individual scenes according to the chronological sequence in which they happened, but uses formal points that make it possible to relate them to each other thematically. So, for example, Constantine's victory is not only the sequel to his dream, but is primarily the counterpart to the *Battle between Heraclius and Chosroes*. The observer is confronted not with a continual but with a symmetrical arrangement of

13 *Death of Adam* (detail ill. 18), 1452–1466

The young man is looking – strangely uninterested in what is taking place – out of the picture into the distance. He is looking across to the prophet in the opposite tympanum, as if he were foreseeing the future course of the story of man's salvation and the advent of the Savior, whose death for the sake of Christianity is connected with the event depicted here.

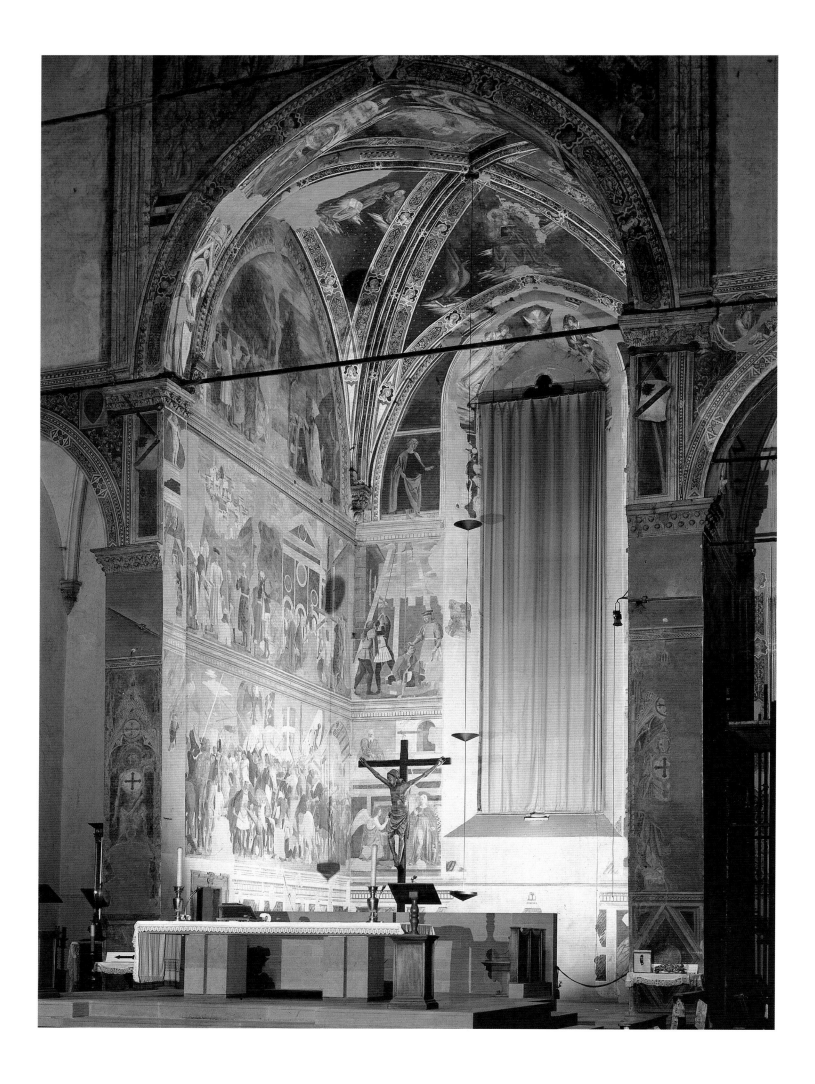

14 (opposite) *The Legend of the True Cross*, 1452–1466
Frescoes
San Francesco, Choir (main chapel), left half, Arezzo

Frescoes by Bicci di Lorenzo, produced by him up to
shortly before the time when he died in 1452, still remain
on the groin vaulting and the intrados of the arches. On
the long wall are the following frescoes by Piero (from
bottom to top): the *Battle between Heraclius and Chosroes*,
the *Discovery and Proof of the True Cross* and the *Exaltation
of the Cross*. On the rear wall, from top to bottom: a
Prophet, the *Torment of the Jew* and the *Annunciation*.

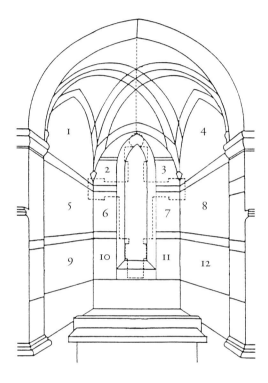

15 (above) Scheme of the arrangment of the frescoes
San Francesco, Choir (main chapel), Arezzo

1 *Exaltation of the Cross* (ill. 46)
2 *Prophet, possibly Ezekiel* (ill. 49)
3 *Prophet, possibly Jeremiah* (ill. 50)
4 *Death of Adam* (ill. 18)
5 *Discovery and Proof of the True Cross* (ill. 38)
6 *Torment of the Jew* (ill. 37)
7 *Burial of the Wood* (ill. 28)
8 *The Queen of Sheba in Adoration of the Wood and the
 Meeting of Solomon and the Queen of Sheba* (ill. 21)
9 *Battle between Heraclius and Chosroes* (ill. 41)
10 *Annunciation* (ill. 29)
11 *Constantine' Dream* (ill. 31)
12 *Battle between Constantine and Maxentius* (ill. 33)

16 (right) *The Legend of the True Cross*, 1452–1466
Frescoes
San Francesco, Choir (main chapel), right half, Arezzo

The apse contains the following scenes (from bottom to
top): *Constantine's Dream*, the *Burial of the Wood*, a
Prophet. The following are on the long wall (from top to
bottom): the *Death of Adam*, the *Queen of Sheba in
adoration of the Wood and the Meeting of Solomon and the
Queen of Sheba* and the *Battle between Constantine and
Maxentius*.

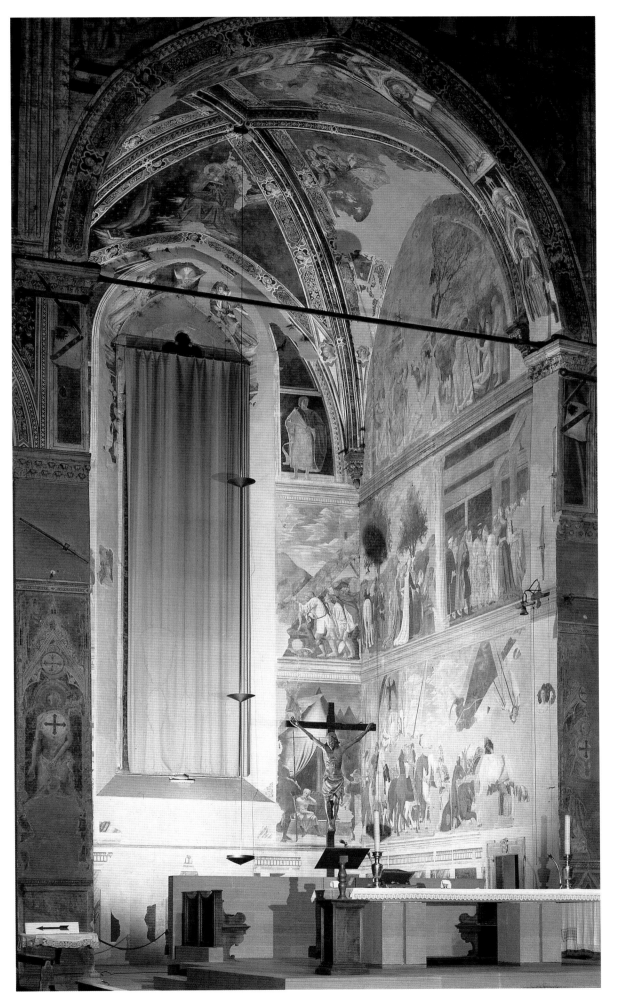

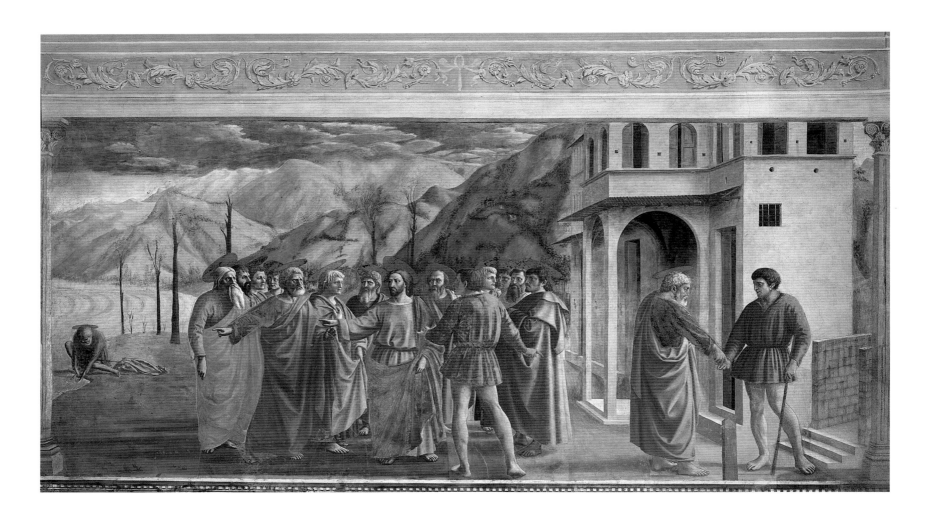

17 Masaccio
Tribute Money, ca. 1425
Fresco, 247 x 597 cm
Santa Maria del Carmine, Brancacci Chapel, Florence

The fresco narrates an event from the Gospel according to St.
Matthew (17:24 – 27): a tax collector comes to Christ to demand
the tribute money (center). Christ then orders St. Peter to catch a
fish, saying that he will find a piece of money in its mouth (left)
which he can use to pay it (right). The design of the tax collector in
the center of the picture may have been Piero's inspiration for the
nude figure seen from the rear in the *Death of Adam*.

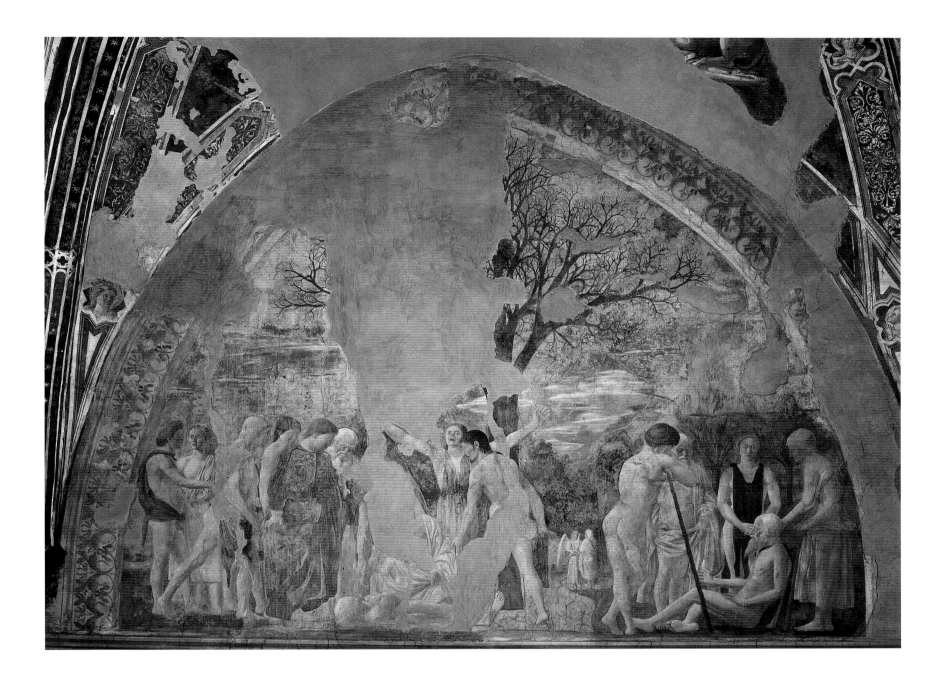

18 *Death of Adam*, 1452–1466
Fresco, 390 x 747 cm
San Francesco, Arezzo

The fresco narrates several scenes simultaneously and should be read
from right to left: the dying Adam, supported by Eve, sends his son
Seth to the archangel Michael in order to fetch oil to prolong his
life. In the background Seth carries out his errand: but instead of
the oil he receives a young tree. On the left the dead Adam is being
mourned by his descendants and Seth is planting the young shoot
which will grow into the Wood of the Cross.

the pictures. The symmetry is immediately apparent on entering the choir. In the lunettes, scenes are depicted that take place outdoors. They mark the beginning and end of the narrative sequence and were the first to be produced. In the middle register, the painter narrates events in courtly surroundings in front of an architectural backdrop. In the lower registers, two large historical battles are depicted (cf. scheme of the arrangement of the frescoes). There are typological as well as formal aspects, meaning that certain Old Testament scenes are placed opposite ones from the New Testament, as the former were considered to be the models for the latter.

The extent to which Piero is making demands of the observer becomes clear above all at the corners of the chapel. There, the picture scenes are constructed in such a way as to create confusion. The *Discovery and Proof of the True Cross* and *Torment of the Jew* (ills. 37, 38), for example, meet at the top left corner. In the process, two houses that are foreshortened according to the laws of perspective meet, and while they can be seen together they do not make any sense when one does so. Such a structure relies on an observer who will cooperate and recognize them as not belonging together, who will be capable of keeping the two pictorial surfaces apart and concentrating on just one picture. Similar observations can be made on the opposite side, where the sky in the scene of the *Burial of the Wood* merges into the depiction of the story of the Queen of Sheba (ills. 21, 28).

Despite such observations, it is possible to recognize rules of composition to which Piero keeps in all the pictures. All the frescoes are subordinated to the natural source of light entering by the chapel's central window, and this creates harmony. Another uniting feature is the consistently applied slight foreshortening seen from below. In addition, the figures are shown at a similar distance and comparable scale. In this way, Piero guarantees the incorporation of the various scenes into the overall text of the legend.

The narrative begins in the right lunette with the *Death of Adam* (ills. 18–20). The dying forefather of mankind sends his son Seth to the archangel Michael in order to ask for the oil of compassion. Instead, Seth brought back a shoot from the Tree of Knowledge, which is planted in the mouth of the dead man when he is buried. It will by the age of Solomon grow into a healthy tree.

The expressive naturalism in this account of mankind's first experience of death is reminiscent of works by Masaccio. In his fresco of the *Tribute Money* (ill. 17), there is a figure which "reappears" on Piero's wall painting *Death of Adam* (ill. 18). The almost completely destroyed figure seen from behind in the centre of the events is, in the position of its legs and feet, very like the tax collector standing in a similar position in Masaccio's work. In addition, the determined depiction of the naked figures shows that Piero was studying classical art. Thus, the figure of the naked young man leaning on a stick is reminiscent of the *Pothos* produced by the Greek sculptor and architect Scopas (mid 4th century BC). Such a quotation from antiquity does not mean that

Piero must have spent some time in Rome. Copies of the work were also available in Florence.

On the basis of the harmonious use of color, it is possible to say that the *Death of Adam* is one of the earlier frescoes in the cycle. The features that have made the frescoes in Arezzo so famous – the sublime, peaceful aura of the figures and the sensitive weighting of the colors that is so rich in contrasts – are first visible in *The Queen of Sheba in Adoration of the Wood and the Meeting of Solomon and the Queen of Sheba* (ills. 21–27), which is the next work in terms of content and probably also chronologically.

We are indeed transported to the age of Solomon here. On her journey to see Solomon, the Queen of Sheba recognizes that the beam in a bridge is the holy Wood that has grown from the aforementioned shoot and will be used to fashion the Cross on which Jesus will give up his life for the sins of Christendom. She prophesies to the king that Judaism will fall because of the influence of this piece of wood, leading him to give the command that it should be buried. Piero depicts the meeting of the two monarchs in a very even-handed manner. The queen lowers her head in a gesture of humility, though this gesture should really be made by Solomon, as the wise queen has the advantage on him of knowing about the significance of the Wood of the Cross. The two events which follow on chronologically take place in different "rooms". The adoration takes place in the open, the meeting inside a palace. Compositional means are used to create a close relationship between the two spaces. Thus, the Queen of Sheba is depicted in the two scenes as a mirror reflection. The way she is bowing before Solomon is therefore the result of compositional considerations. The observer is being stimulated to track down these correspondences and interpret them as a reference to the correlations as regards content.

As has already been mentioned, the meeting between the Queen of Sheba and Solomon is new with regard to traditional iconography. It is possible that Piero was inspired to make this thematic addition by Lorenzo Ghiberti's depiction of the meeting in bas relief on the Gates of Paradise on the Baptistery in Florence, created between 1430 and 1437. There is possibly also a contemporary reason for the depiction: the council for the reuniting of the Eastern and Western churches took place in 1439. The meeting of the Queen of Sheba and Solomon could quite likely have been an allusion to this event.

The fresco of the *Burial of the Wood* was not produced by Piero himself. He left its execution to his student Giovanni da Piamonte, and his style can be recognized in that he had a somewhat heavier hand than his master.

Piero added an *Annunciation* to the rear wall of the chapel, in the lower fresco register to the left of the chapel window, and its presence is justified in that it is a kind of pendant to *Constantine's Dream* on the opposite side of the window (ills. 29, 31). Both Mary and the emperor receive a message from a heavenly messenger which will play a decisive part in their future fate. In addition, it was traditionally believed that the birth and death of Adam, as well as the Crucifixion of

19 (opposite, above) *Death of Adam* (detail ill. 18), 1452–1466

The plain way in which the first human couple is depicted is conspicuous. As during the Renaissance the classical age stimulated artists to dedicate themselves to producing depictions of nudes, it comes as no surprise that the young man leaning on a stick is derived from a classical sculpture – the *Pothos* by Scopas (mid-4th century AD).

20 (opposite, below) *Death of Adam* (detail ill. 18), 1452–1466

Seth is planting a shoot from the Tree of Knowledge into the mouth of the dead Adam. It will grow to become the Wood of the Cross. Once again stimuli for the expressive depiction of grief, such as that shown by the woman in the background on the left, are to be found in the works of Masaccio, such as his polyptych in Pisa (1426).

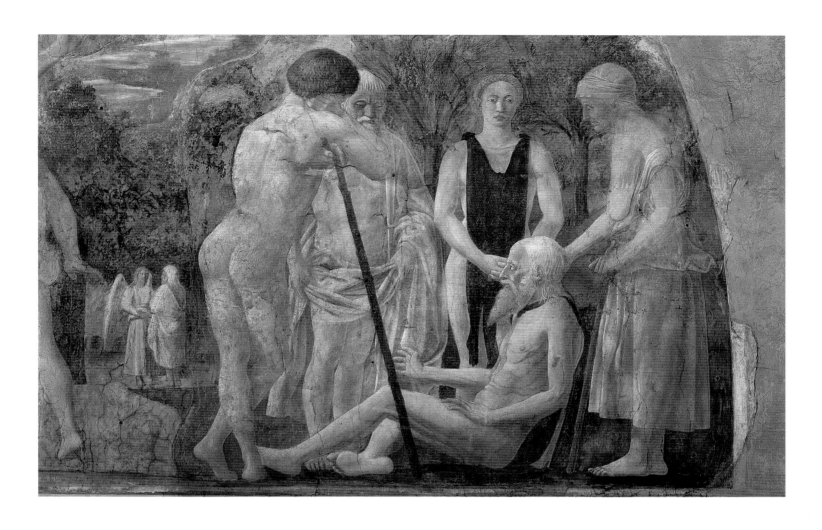

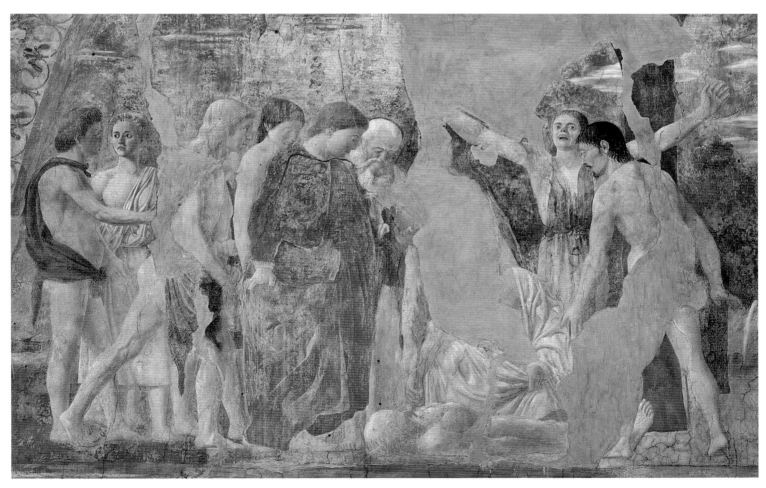

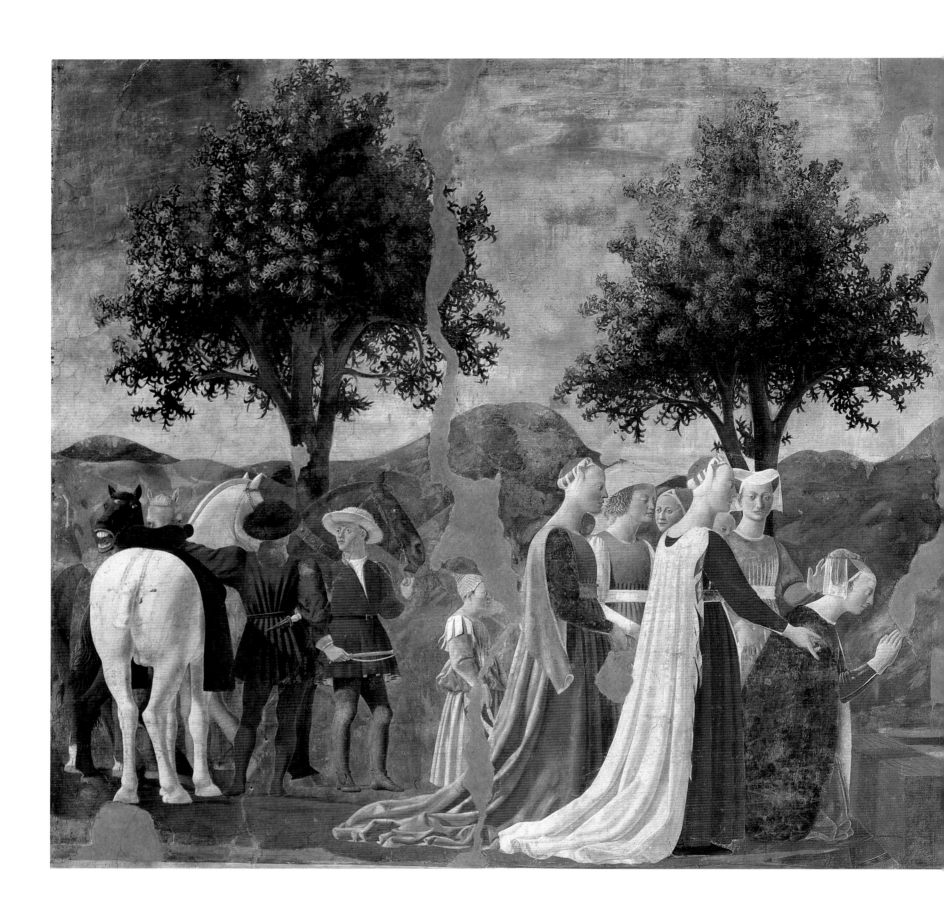

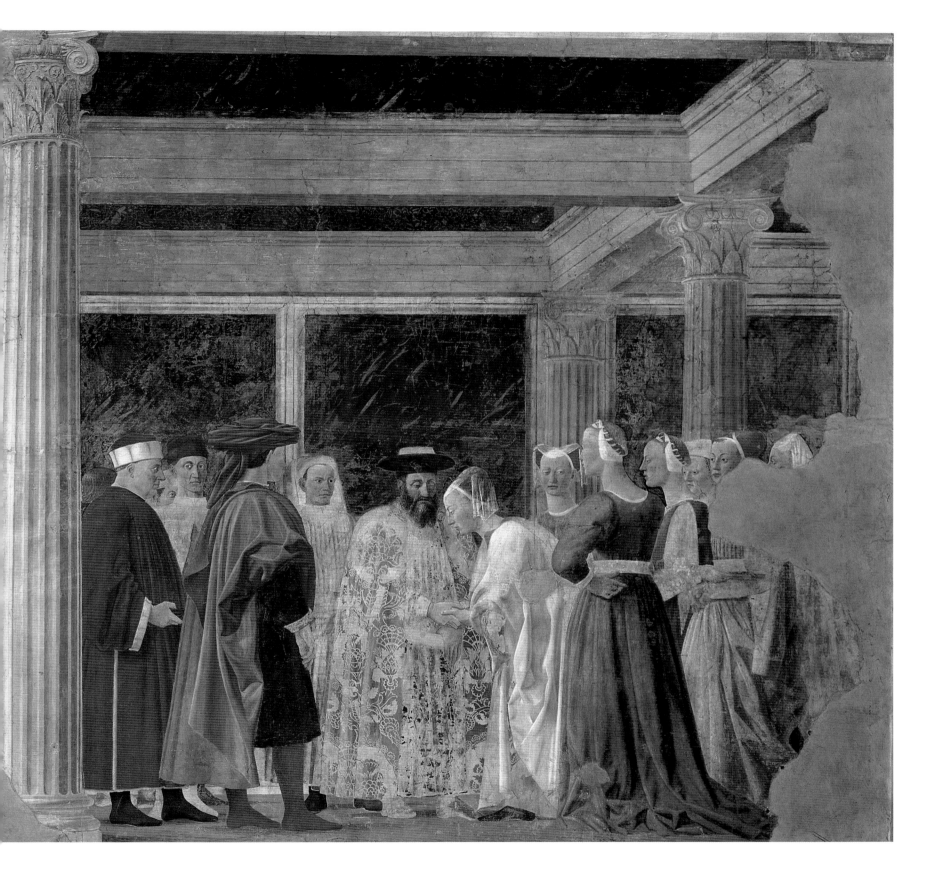

21 *The Queen of Sheba in Adoration of the Wood and the Meeting of Solomon and the Queen of Sheba*, 1452–1466
Fresco, 336 x 747 cm
San Francesco, Arezzo

Surrounded by her ladies-in-waiting, the Queen of Sheba is on the left, kneeling reverently in front of the beam in the bridge which she has recognized as being the Wood. At the left edge of the picture two grooms are in conversation. In the right half of the picture, the meeting of the queen and Solomon is taking place inside a palace, surrounded by his court.

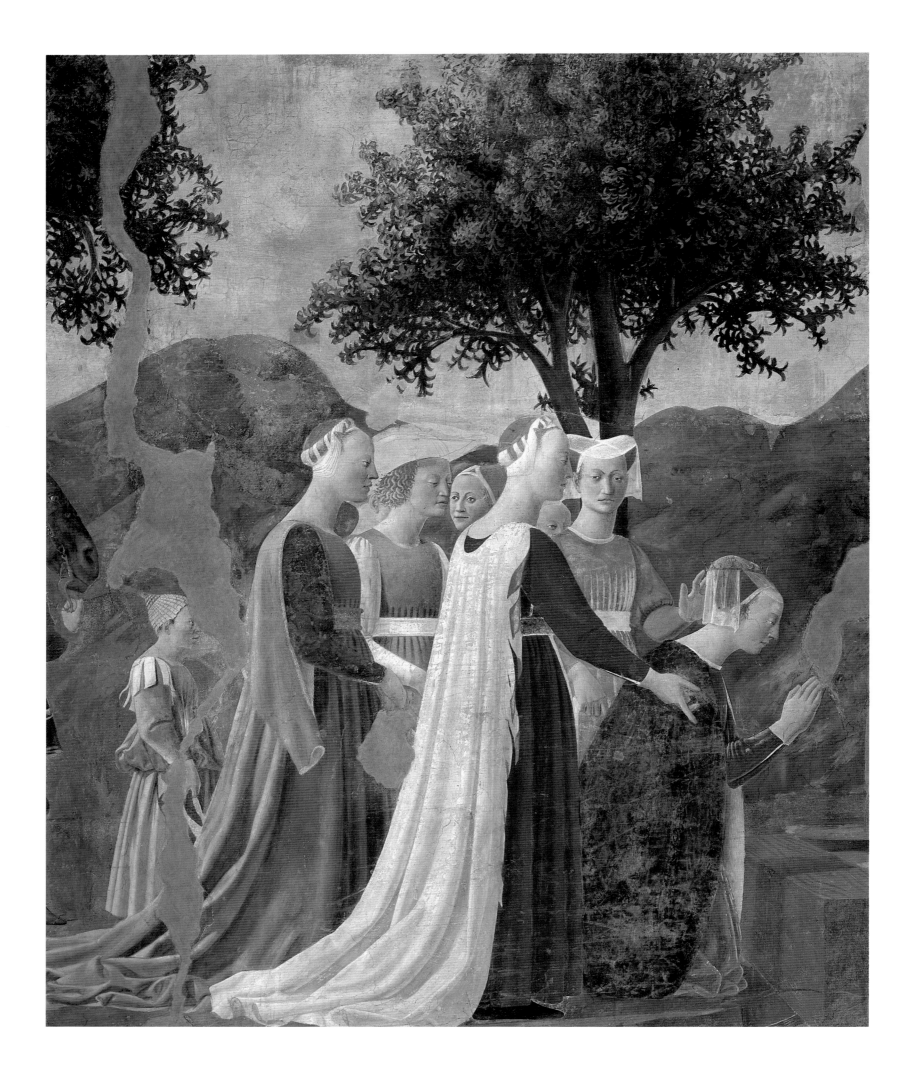

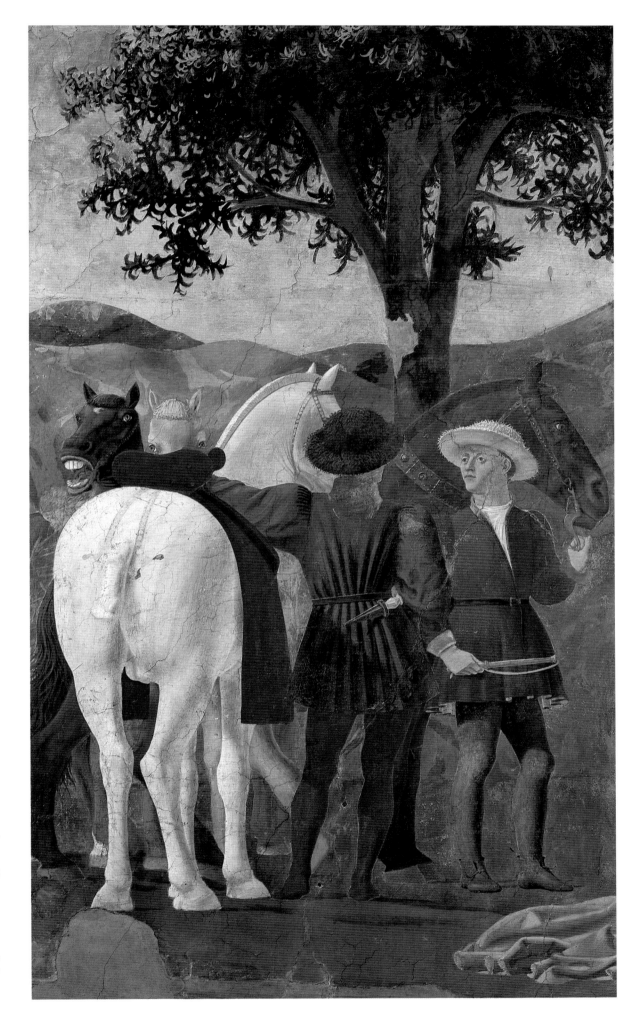

22 (opposite) *The Queen of Sheba in Adoration of the Wood and the Meeting of Solomon and the Queen of Sheba* (detail ill. 21), 1452–1466

The tall elegant ladies-in-waiting are dressed in an alternating rhythm of cold and warm colors which are harmoniously graded. The one standing closest to the observer is pointing to the Wood in front of which the Queen of Sheba is kneeling – in an analogy to Empress Helena in the *Proof of the True Cross* on the opposite wall.

23 (right) *The Queen of Sheba in Adoration of the Wood and the Meeting of Solomon and the Queen of Sheba* (detail ill. 21), 1452–1466

This detail is a good example of the well-planned way in which Piero structured the composition: the two riders are positioned as precisely as the horses' heads behind them. The contrast of white and black alternates in their headgear. This horizontal connection between the figures is joined by a vertical one: the upper garment of the rider on the left is of the same color as the leggings of the one on the right – and vice versa.

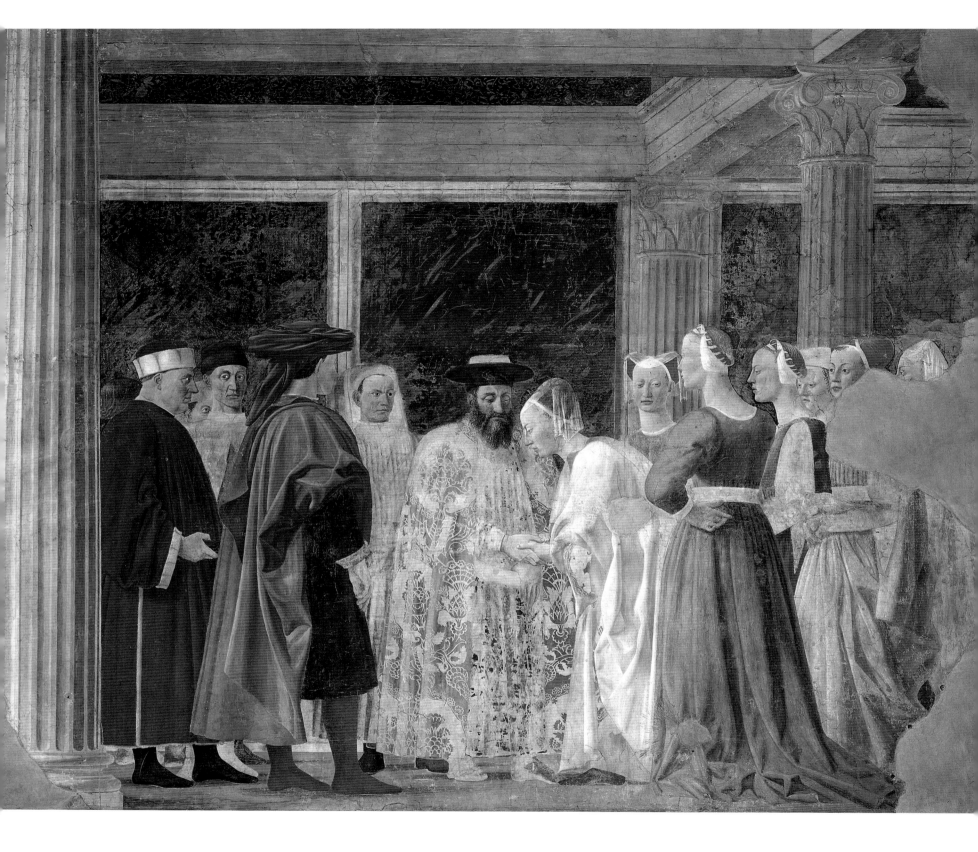

24 *The Queen of Sheba in Adoration of the Wood and the Meeting of Solomon and the Queen of Sheba* (detail ill. 21), 1452–1466

The meeting of the king and queen takes place in a space where the architecture takes up the classical formal language: fluted columns, composite columns and architraves which are structured by fascias. Solomon and his elegantly clad companions occupy the left half of the picture, and the Queen of Sheba and her retinue the right half.

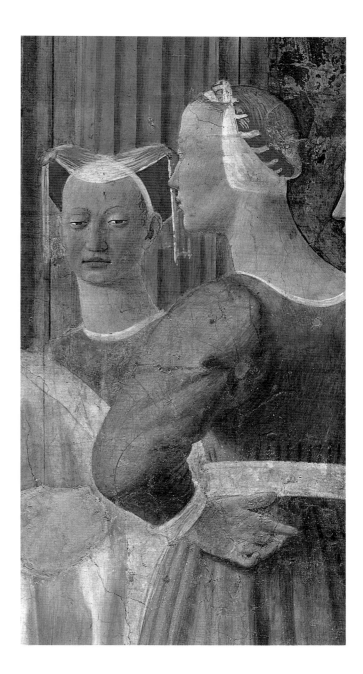

25 *The Queen of Sheba in Adoration of the Wood and the*
Meeting of Solomon and the Queen of Sheba (detail ill. 21),
1452–1466

The ladies-in-waiting are wearing dainty head-dresses
and, in accordance with the fashion of the period, their
foreheads are shaved. The white of the caps and veils
contrasts with the colors of their garments – above all the
red and green – and is repeated in individual parts of their
clothing such as the sleeves, belts and linings.

26 *The Queen of Sheba in Adoration of the Wood and the*
Meeting of Solomon and the Queen of Sheba (detail ill. 21),
1452–1466

The two ladies-in-waiting directly behind the queen, seen
in a frontal and profile view, are mirror images of those
in the opposite scene which takes place in the open.
Their features are very similar: this suggests that the
same cartoon was used for several of the figures.

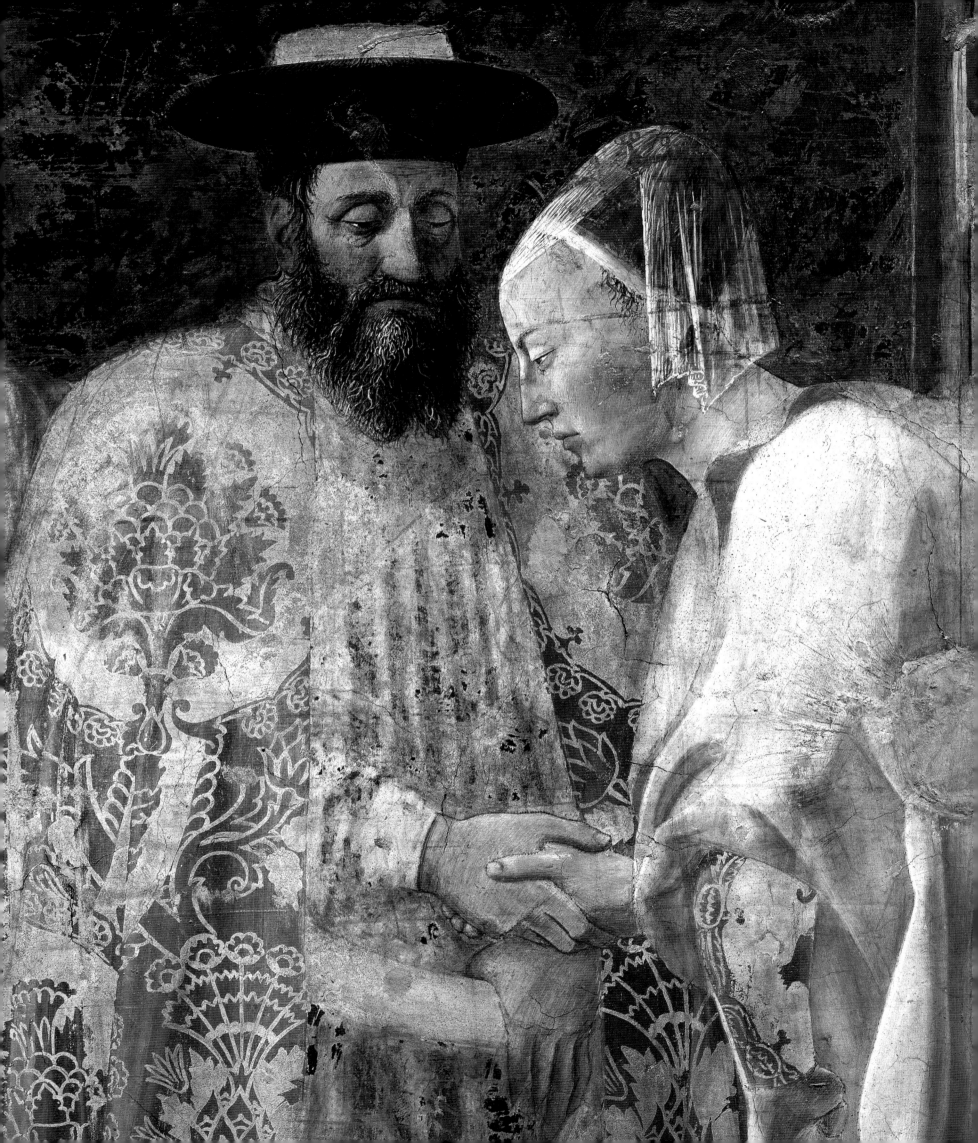

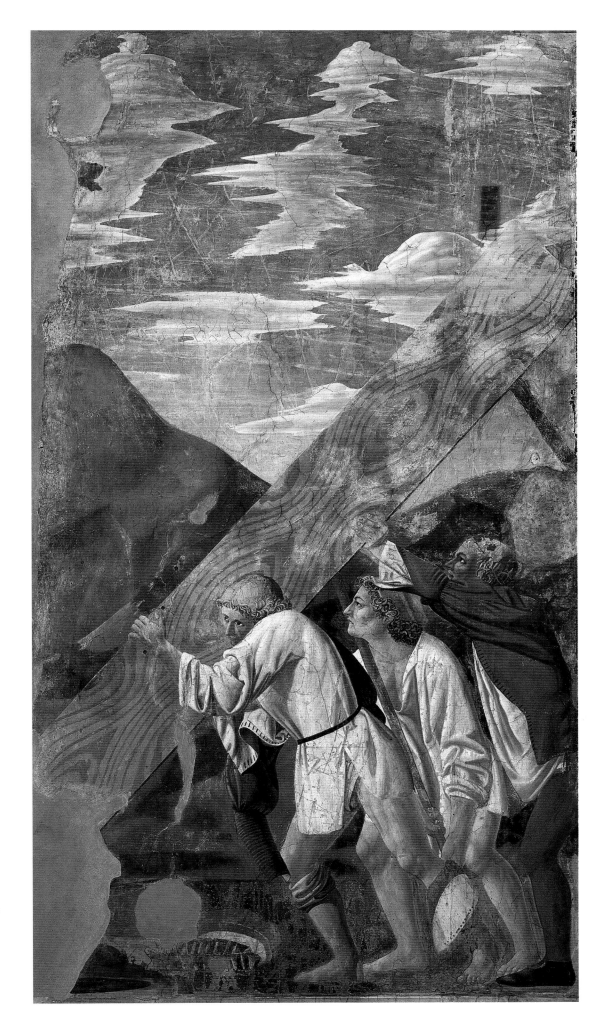

27 (opposite) *The Queen of Sheba in Adoration of the Wood and the Meeting of Solomon and the Queen of Sheba* (detail ill. 21), 1452–1466

The queen is bowing before Solomon. Thus, her posture corresponds to her genuflection in the adoration scene. In addition, the garments of the two figures display the artistic wealth which Piero was able to develop in his treatment of textiles.

28 (right) Giovanni da Piamonte and Piero della Francesca
Burial of the Wood, 1452–1466
Fresco, 356 x 190 cm
San Francesco, Arezzo

The Wood that the Queen of Sheba has recognized is to be buried on the orders of Solomon and is raised on sticks to be transported. The helpers are clearly having to work hard and make a considerable effort. The grain of the beam surrounds the head of the man at the front like a halo – an allusion to Christ's walk to Golgotha. In contrast, his assistant on the right edge of the picture is wearing a wreath of Bacchus – the symbol of his connection to earth.

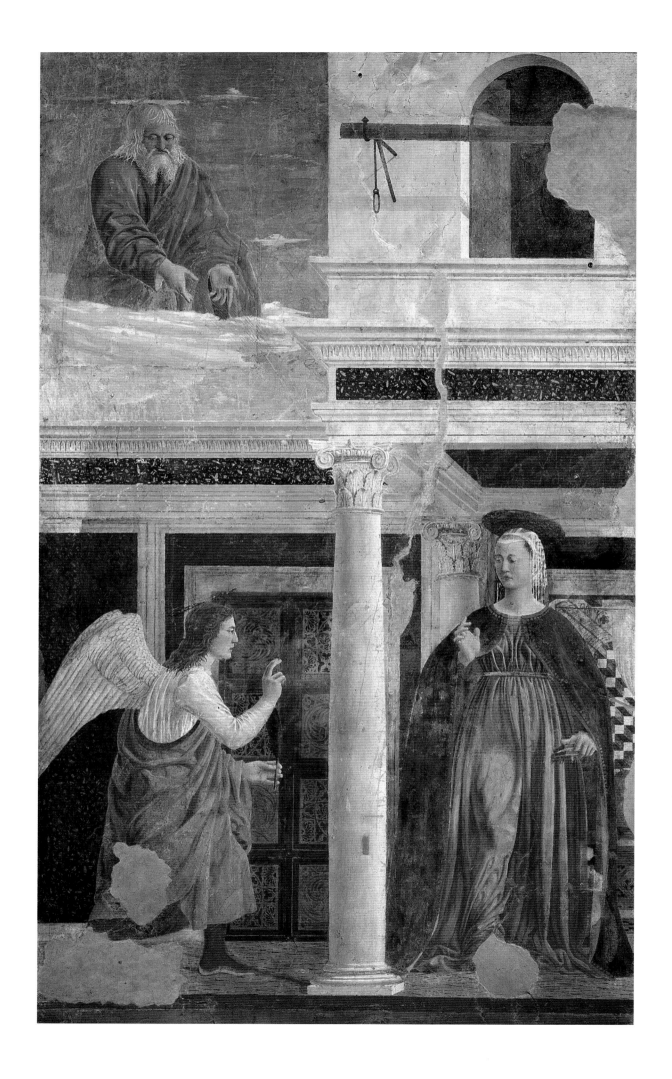

Christ, took place on the same date as the Annunciation, which according to the Roman calendar was 25 March.

Piero's conception of the Annunciation reveals much of the artist's understanding of art, and that of his age. Mary is standing in a columned loggia which the angel is approaching. The positioning of the columns is noticeable. The corner column at the front is placed exactly between Gabriel and the Virgin. The architrave, which is depicted in an extreme foreshortening and which rests on the columns, forms a diagonal which connects the hands of God the Father with the face of Mary. Here the modern structural method of perspective is being conspicuously used to serve the Christian theme.

The colors of the garments worn by Mary and God the Father correspond. Mary is also connected to him by the direction of the light. Piero frequently used various levels of light in order to refer to different levels of meaning. God the Father is sending the rays of his spirit across to Mary, and they light up the upper half of the pictorial field. The lighting of the remaining parts

of the painting once more corresponds to the natural source of light from the church window next to the fresco. Behind Mary one can see the highly skilled reproduction of inlay work: Piero himself created several designs for intarsias, which were very popular during the Renaissance for the furnishing of private aristocratic chambers. Exceptionally artistic examples are the cupboards in the study of Isabella d'Este-Gonzaga and the famous *studiolo* of the Duke of Montefeltro.

Like the Queen of Sheba and her ladies-in-waiting, God the Father also has features that constantly recur in the entire cycle. It might seem unbelievable. but the features of God reappear in the face of the Persian king Chosroes (ill. 43). This should be seen as a programmatic element in Piero's work. The figures are not only similar, it is also not easy to differentiate between main and secondary figures. The purpose of this stylization was presumably to accentuate the triviality of individuality in the face of the important events.

The *Annunciation* refers to motifs from the New

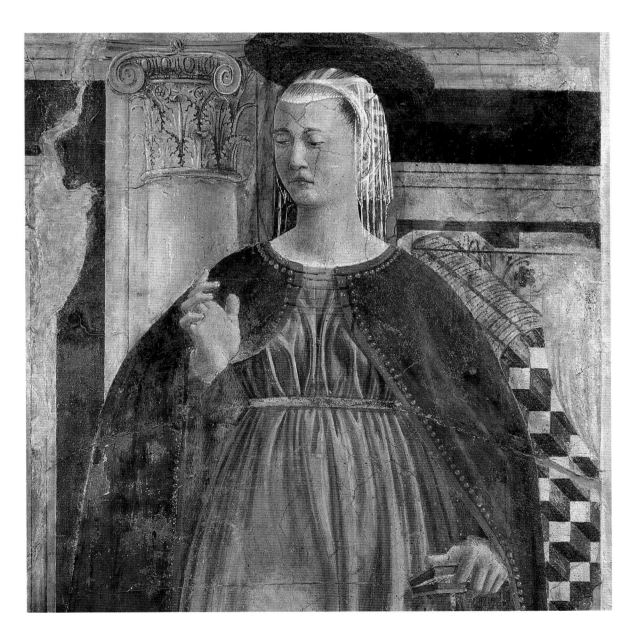

29 (opposite) *Annunciation*, 1452–1466
Fresco, 329 x 193 cm
San Francesco, Arezzo

Mary receives the angel's message in the narthex of a lavishly decorated building. At the top left, God the Father is sending out his divine rays. The angel has raised one hand in greeting. In the other he is holding a palm frond.

30 (right) *Annunciation* (detail ill. 29) 1452–1466

Mary is facing the observer in a frontal position and is dressed in red and blue, the colors traditionally associated with the Virgin. Her lowered eyelids and the hand which she is raising in question show that she belongs to the type of Madonna known as the *Cogitatio* (reflection). The trompe-l'œil arrangement of the wall behind her to the right reflects Piero's knowledge of contemporary intarsia art.

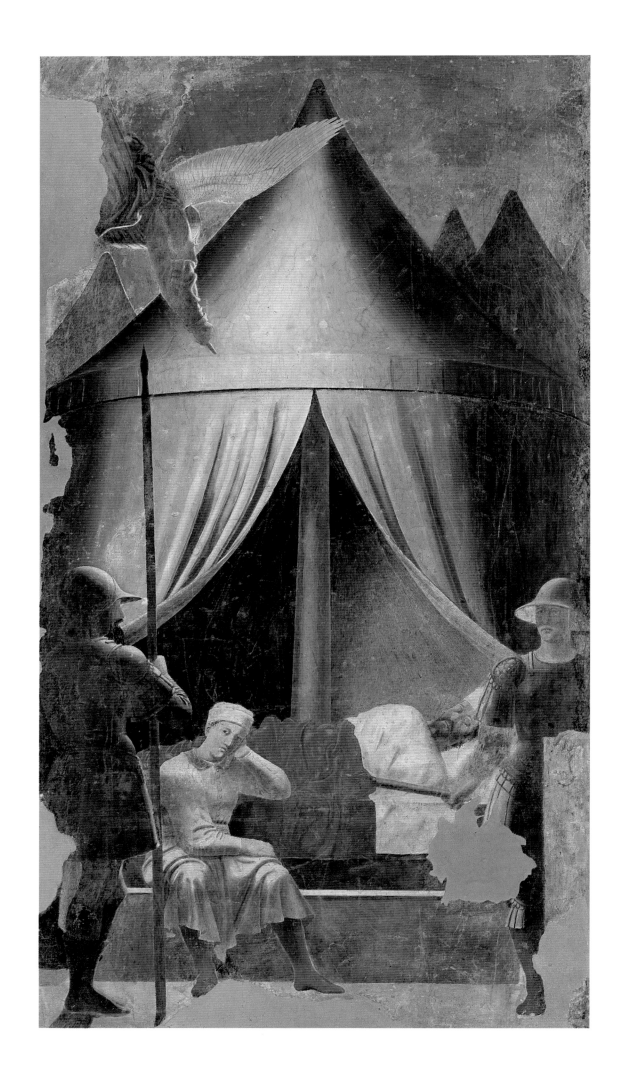

Testament on numerous occasions, but was not only comprehensible to educated contemporaries. Pictures in churches never had a solely decorative role: their purpose was always to educate. The few literate churchgoers were usually acquainted with the sections of the Bible to which the pictures referred. For the many illiterate people, in contrast, the painting would serve as an alternative to reading, and was meant to instruct and edify them and inspire them to meditation. They were familiar with the relevant texts from the readings of the Gospel on Sundays.

Once again there is a gap of several centuries. The prophecies of the Queen of Sheba have been fulfilled: the Wood has resurfaced and Jesus has been crucified on it, Jerusalem has been destroyed and the kingdom of the Jews has been broken up. Constantine I and Maxentius are fighting for power over the Roman Empire. In his dream (ills. 31, 32), the pagan emperor is converted – a decisive moment in the history of Christianity, for this is when it is recognized as the official religion. In AD 313, Constantine issued the Edict of Milan, which officially mandated toleration of Christians. Piero staged this decisive moment as a change from dark to light. The atmospheric composition of *Constantine's Dream* is one of the first great depictions of a night scene in the history of art.

What could be more natural than to structure the account of a vision as an appearance of light? The word vision is derived from the Latin *visio*, which literally means "to see". The medium of sight is light; one cannot make anything out in the dark. The two soldiers on watch frame the event and at the same time contribute to its interpretation. The erected lance of the soldier on the left is pointing to the angel who, in the right arm he is stretching out, is holding the Cross, the source of light. The extension of his arm points straight at the emperor, parallel to the edge of the right flap of the tent. The light leads to this point: it is, as it were, a spiritual illumination, liberating the emperor from the dark night of his heathen ignorance. The light bathes the night scene in an unreal brightness. The folded back tarpaulin of the tent does not, however, merely indicate the emperor, it also draws the soldier on the right into the events. He is the counterpart of the one opposite. He is gazing out of the picture, along the line of his horizontally held lance, and is an allusion to the battle which will take place on the following day. Not until Caravaggio (1571–1610) at the beginning of the 17th century would a such a dramatic lighting effect be staged in a similar way.

In about 1458/59, Piero's work on the frescoes was interrupted by a journey to Rome. Many art historians believe that they are able to identify the stylistic influences of the impressions of the "Eternal City", with which Piero returned to Arezzo, on the subsequent paintings. Unfortunately, we only have indirect information about Piero's work in Rome. In the church of Santa Maria Maggiore there is a fresco of *St. Luke* which was created in about 1458/59 and was probably executed by a student of Piero's. Nothing remains of the

31 (opposite) *Constantine's Dream*, 1452–1466
Fresco, 329 x 190 cm
San Francesco, Arezzo

In a vision before the battle against Maxentius, it is revealed to Emperor Constantine that he will be assured of victory if he converts and becomes a Christian. The emperor is relaxing under the tent roof of his temporary war camp, guarded by his bodyguard and two soldiers. From the top left an angel is approaching. In his hand he holds out a tiny cross: In this sign you shall conquer! Piero composes the vision as a manifestation of light taking place at night.

32 (right) *Constantine's Dream* (detail ill. 31),
1452–1466

The figure looking out of the picture lost in thought conveys an impression of the powerlessness of the guard behind whose back the event is taking place. At the same time, both the red-white contrast of his leggings and garment and the position of his arms direct our gaze to the emperor's bed.

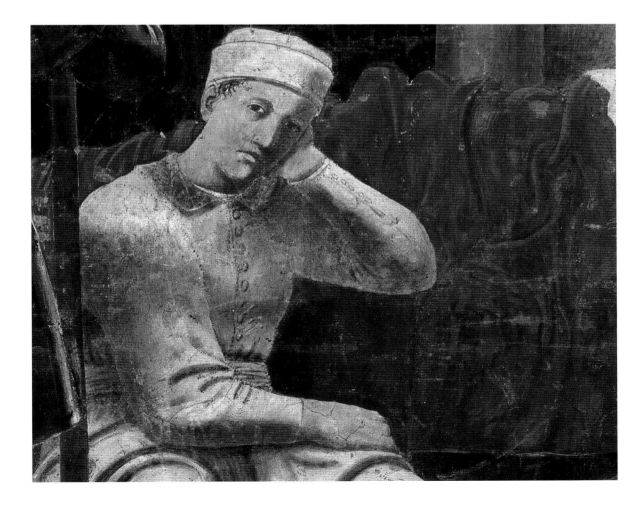

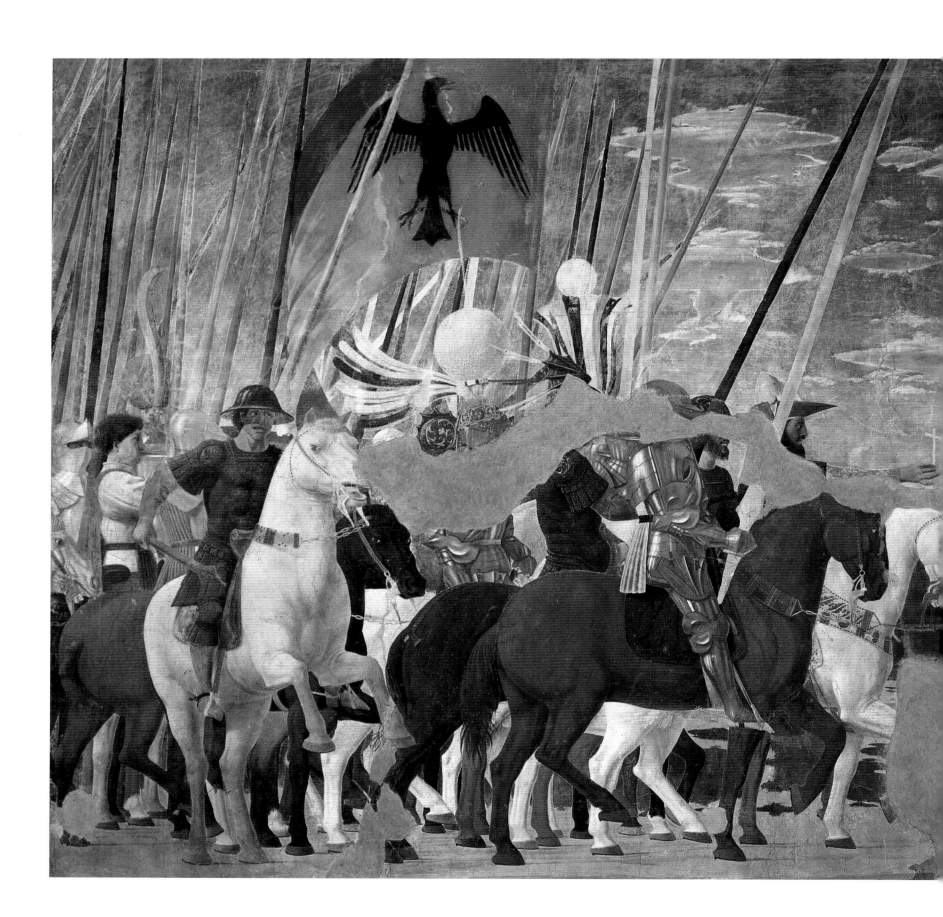

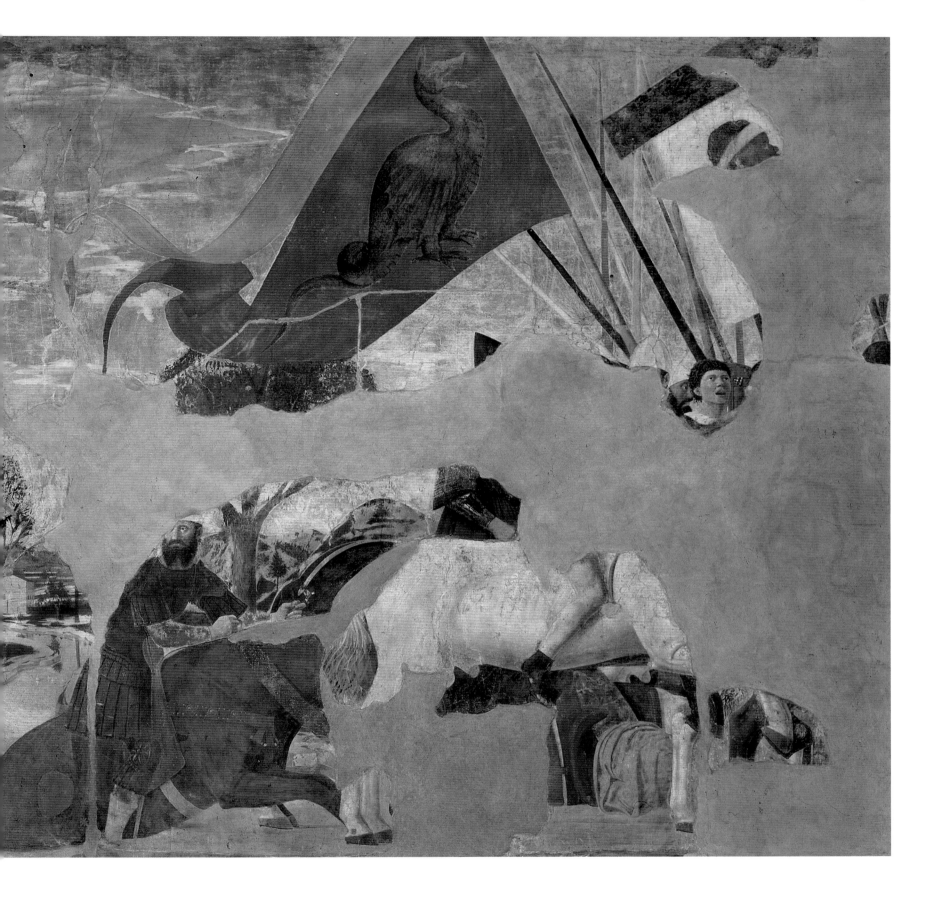

33 *Battle between Constantine and Maxentius*, 1452–1466
Fresco, 322 x 764 cm
San Francesco, Arezzo

The depiction of the military confrontation, which took place in AD 312 by the Ponte Milvio in front of the gates of Rome, fills the entire width of the wall. From the left the army led by Constantine is approaching. He is carrying the cross in front of him, the very sight of which is enough to cause the soldiers of Maxentius to take flight. They flee without fighting. In the center the Tiber divides the pictorial space and leads our gaze into the background.

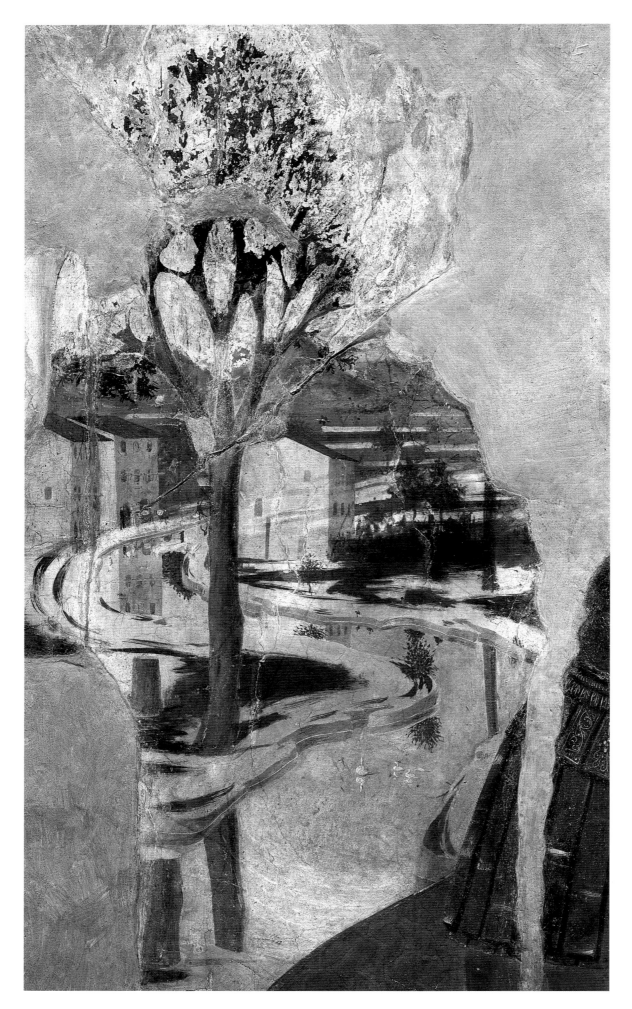

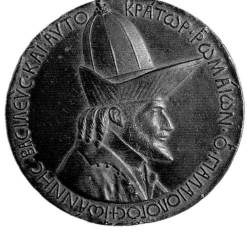

35 (above) Pisanello
Medal of John VIII Palaeologus, 1438/39
Bronze, diameter 10.4 cm
Museo Nazionale del Bargello, Florence

The portrait of the bearded Greek emperor with the striking head-dress was the model for a particular type of Palaeologus which arrived in Italian art after the Council of 1439. In Piero's work, he is also not only present in the features of the Greek ambassador and in the conspicuous hat worn by Pilate in the *Flagellation*; he is also visible in the profile depiction of Emperor Constantine in the battle fresco in Arezzo.

34 (left) *Battle between Constantine and Maxentius* (detail ill. 33), 1452–1466

The scenery in the background is dominated by peaceful aspects. The Tiber, whose smooth surface reflects the trees, is flowing calmly. A traveller is following the banks and birds are swimming in the water – a rural idyll which appears to be completely undisturbed by the events in the foreground and corresponds to the silent course of the battle.

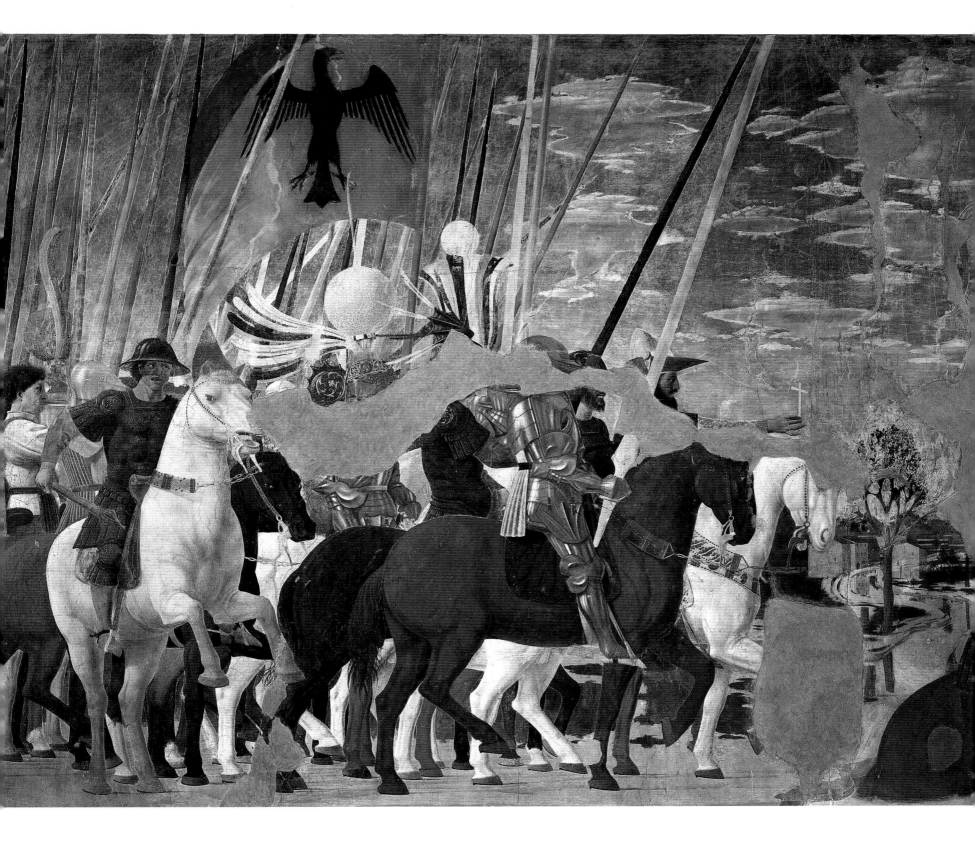

36 *Battle between Constantine and Maxentius* (detail ill. 33),
1452–1466

The soldiers of Constantine are riding along in a tight-knit group.
Their horses are arranged in ranks of strongly contrasting light and
dark shades. Their smooth coloring contrasts with the highlights on
the armor. The lances are pointing upwards to heaven, confident of
victory, each picked out in a different color. The eagle on the
broadly billowing flag represents imperial power.

works that, as we know from documents, he himself carried out in the Vatican.

There are indeed some aspects to be observed in the frescoes created after his return to Arezzo that testify to the effect of the works of art he saw in Rome. It is above all the compositional harmony of his battle paintings that might well derive from pictures on classical Roman sarcophagi and Trajan's Column. The column in the Forum of Trajan, which was dedicated in about AD 114, is surrounded by a continuous frieze of reliefs which depicts the conquest of Dacia by Trajan. It must, however, be added that Piero might already have seen Flemish tapestries in Rimini and Ferrara, which have a similar compositional density to the Roman friezes and bas reliefs.

The *Battle between Constantine and Maxentius* (ill. 33), which follows the emperor's dream, is severely damaged. There is a watercolor copy in the Graphische Sammlung Düsseldorf which shows the work in a better state of preservation. It was produced by Johann Anton Ramboux in about 1820. As the figures were to be depicted to a standardized scale, the artist was here faced with the task of representing a victorious and a retreating army in the same picture. Piero's solution is as simple as it is irresistible. He uses a small number of riders and many lances to represent both armies, and in a narrow gap between the two parties shows us a broad landscape in the background. The spaciousness in the background represents the distance between the two armies. All the lances of Constantine's soldiers – entirely in contrast to the opposing forces – are pointing to heaven, just as if they were countless references to the fact that the advance is being directed from on high. The emperor appears in front of the last vertical line of the ranks. The white line emphasizes his profile. It is strikingly reminiscent of portraits of Emperor John Palaeologus (ill. 35), the ruler of the Byzantine Empire who died in 1448. He had spoken in favor of an end to the schism at the Council in 1438/39, and had asked for support in his battle against the Turks. The similarities between Constantine and this emperor were repeatedly interpreted as a hidden demand for a new crusade against the Infidel. In the meantime, the Byzantine emperor's project for the churches to present the heathen threat with a united front had fallen through. In 1453, Constantinople fell to the Turks, and there was a general demand for a crusade to recapture it. Is it possible that the frescoes in Arezzo were a type of crusade propaganda?

This is another fresco in which the weighting of color creates relationships of form and content. Here Piero combines chain mail and armor from the 15th century with classical Roman war dress. He was evidently interested in the 15th-century armor because of its conspicuous forms and shining surface effects. The eagle on the large banner – in black on a golden yellow background with a red border – is turning its head to the right, its beak opened in a threatening manner. In the enemy's flag showing the dragon, the colors have been used the other way round: a red background with a golden border. The white spheres between the

lances act as a counterbalance to the colorful vertical lines.

The horses of Constantine and the soldier in armor create an intensive contrast of brown and white. This contrast is repeated on the other side of the river: here, it is the white horse which stands in the foreground, and the dark horse next to it is scarcely recognizable because of the damage to the fresco. In the center, a rider is attempting to gain the shore. On the above mentioned copy, it is possible to see that there was a mirror image equivalent to the figure of Constantine on the right side of the picture. This figure wore the same hat – though the colors are again arranged the other way round.

Here the battle has more of the appearance of a military parade – and indeed the outer movement on almost all the frescoes has the character of a procession. Piero dramatizes the battle's peaceful course by means of a clever compositional change of pace. On the left the movement is agitated; it slows down towards the center of the picture, finally comes to a complete halt, and in the scene where the riders are taking flight on the right, suddenly speeds up again.

Helena, the mother of Constantine, is deeply moved by the conversion of her son. She decides to discover the Cross that Christ died on in Jerusalem and honor him by erecting it again. But in Jerusalem there is only one Jew called Judas who knows the place where the Cross is. Not until he is tortured does he reveal his secret. Judas, a name which makes everyone immediately think of Christ's betrayer, becomes a betrayer in favor of Christianity in the *Torment of the Jew* (ill. 37) carried out by Giovanni da Piamonte: he leads Helena to the temple of Venus, below which the crosses are hidden. The temple is torn down and they dig for the crosses below.

These are the events depicted in the left part of the fresco of the *Discovery and Proof of the True Cross* on the left wall of the chapel (ills. 38–40). The two events depicted here were traditionally presented in one picture. The fresco is, as it were, an exemplary proof of the way in which Piero united events which took place in different places and at different times in one picture. The left edge of the temple divides the fresco in half. The floors of the two equally important halves of the picture are, however, of different colors. In the background on the left a town rises up, and on the right there is a view of houses along a street. Helena is present in both scenes. This means that it is possible to see the two halves of the picture as scenes that are different but nonetheless belong together. According to the text on which the picture was based, the temple actually belongs to the left half of the picture, as it is connected with the place where the crosses were buried. And formal means are actually used to relate it to the left half of the picture. Above all, though, the building is indisputably part of the right half, as the resurrection of the dead man takes place in front of its portal. The building plays the part of temple for the left side, but on the right side it already plays the role of a Christian church. It becomes clear that there is support for this interpretation in Piero's composition when one looks at the pictorial space and the position of the building more closely. In doing so, it

37 Giovanni da Piamonte and Piero della Francesca, *Torment of the Jew*, 1452–1466
Fresco, 356 x 193 cm
San Francesco, Arezzo

Helena, the mother of Emperor Constantine, lets Judas spend days starving in a well in order to find out from him where the Cross is concealed in Jerusalem. With the aid of a block and tackle, the thugs pull Judas out of the cistern as he is now willing to reveal his secret. A smartly dressed higher official is grasping Judas by the hair. On a piece of paper on his hat is the inscription: *prudentia vinco* (I will conquer you through wisdom).

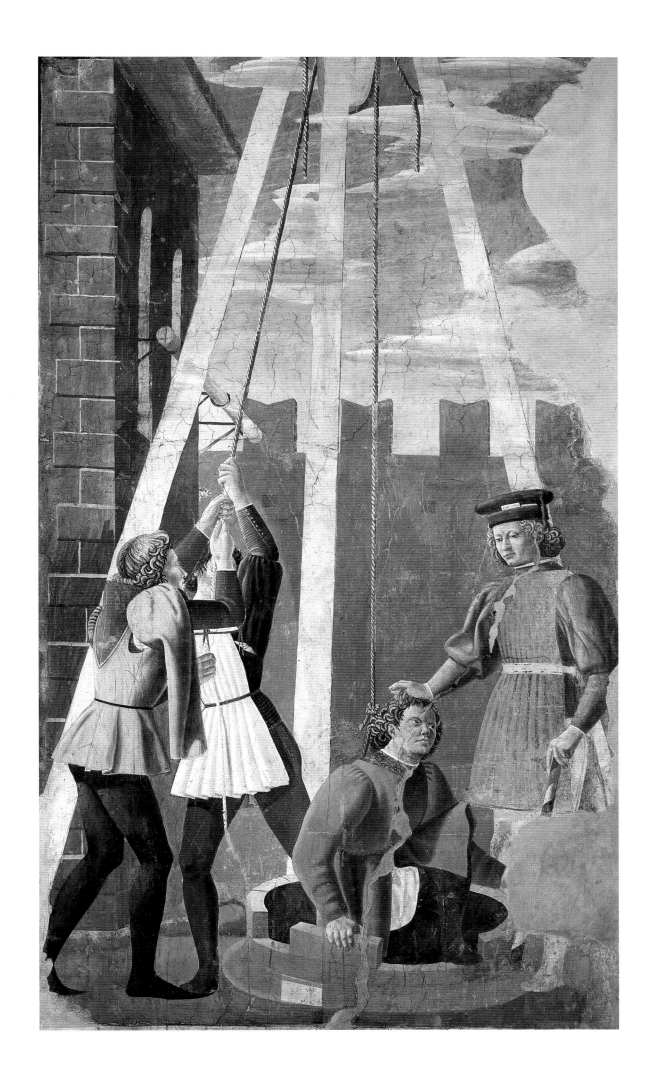

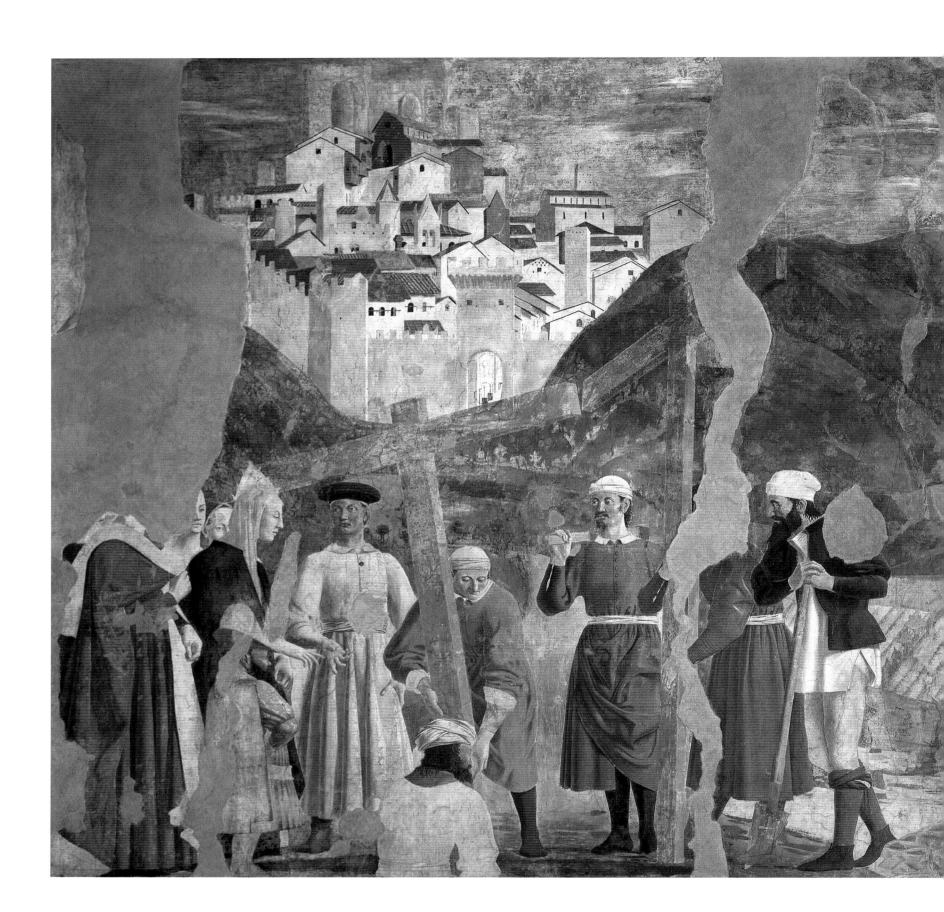

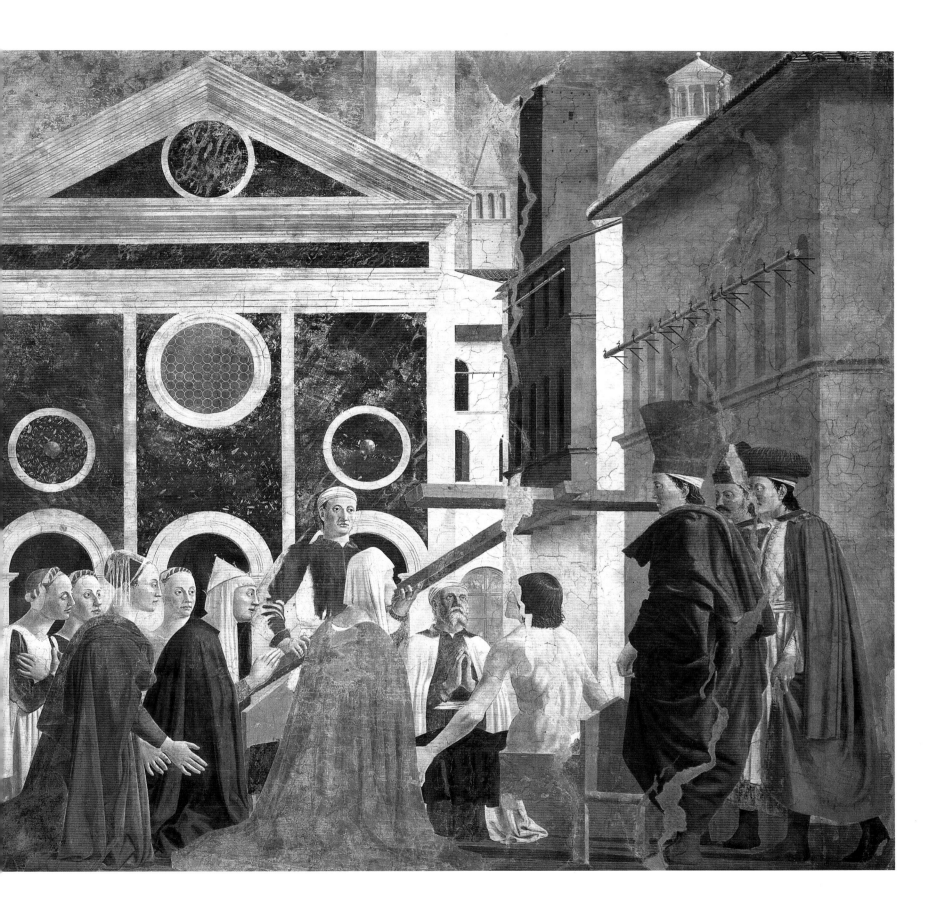

38 *Discovery and Proof of the True Cross*, 1452–1466
Fresco, 356 x 747 cm
San Francesco, Arezzo

In rural surroundings outside the city walls of Jerusalem, Helena and her court look on as the crosses on which Christ and the two criminals were once executed are uncovered. The proof of the Cross takes place in front of a city backdrop. The pictorial spaces in which the two scenes take place are separated from each other by the lofty temple. The True Cross is recognized by means of its miraculous ability to bring a dead man to life. Deeply moved by the miracle, the noble ladies have sunk to their knees. The muscular rear view nude of the resurrected youth is structured using a detailed play of light and shadow. The temple in the background, which is decorated with marble cladding, is reminiscent of the architectural plans of Leon Battista Alberti. Its entrance arches frame the heads of the ladies-in-waiting in Helena's entourage. The foreshortening of the Cross and the staggering of the buildings highlight the spatial arrangement of the scene.

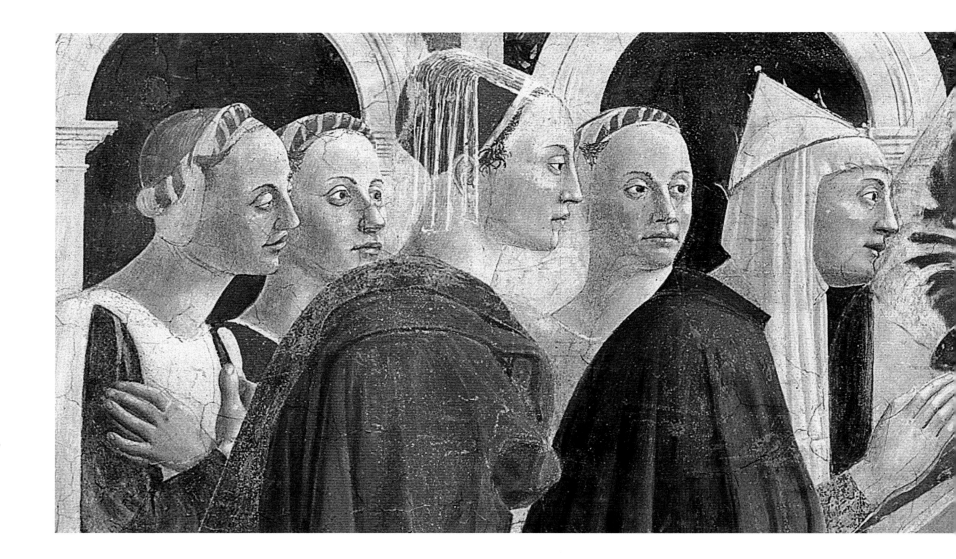

becomes clear that it is firmly grounded in neither one nor the other half of the picture. This lack of spatial certainty is entirely deliberate: the scenes move past the observer without visual or intellectual interruptions. Paradoxically, it is precisely this spatial confusion which enables one to read the picture as a logically chronological sequence of scenes.

Meanwhile, the turbulent story of the Cross has still not drawn to an end: in AD 615, the Persian king Chosroes steals the relic. Heraclius, the conqueror of Byzantium, decides to take up the battle to win it back.

The *Battle between Heraclius and Chosroes,* which took place in the summer of AD 628 on the Danube, is depicted in the lower left register as a counterpart to the battle of Constantine (ills. 41–45). The two frescoes are a pair of opposites: while the earlier scene has a calm horizontal change of rhythm, here the fight for survival is raging in a tightly packed formation across three quarters of the width of the fresco. In contrast to Constantine, who did not need to take part actively in

the battle, Heraclius is holding his lance ready to charge. Above the chaos soar the flags and standards whose emblems have symbolic meanings. The goose is a symbol of vigilance, the eagle of the holy Empire, the lion of energy, royal power, strength and courage. The scene is dominated by the banner of the Cross in the center – the only one that is not intersected by any other and that is undamaged – above the throng of bodies; the enemy banners, with the scorpion as the symbol of Judaism and the heads of Moors, are already in tatters.

The horses are similar to those of Uccello in the *Battle of San Romano* (ill. 10). It is possible that the motifs are derived from a real event: on 29 June 1440 the famous Battle of Anghiari, in which Florence was triumphant over Milan, took place close to the town where Piero was born.

The movement of the battle comes to an abrupt halt on the right of the fresco. Here there are two further pictorial elements to be seen: the throne of Chosroes, the site of his blasphemy, and the place of his execution. The counterbalance to the raised sword of the

39 (above) *Discovery and Proof of the True Cross* (detail ill. 38), 1452–1466

Helena is kneeling before the Cross in the posture that we are familiar with from the Queen of Sheba. The parallel is a reference to the typological correspondence of the two women as wise seers. They recognize the purpose of the Cross and have a positive influence on its changeable fate.

40 (opposite) *Discovery and Proof of the True Cross* (detail ill. 38), 1452–1466

Two pictorial figures are just in the process of recovering the second of the three crosses. The figure seen from behind in the foreground is only depicted as a half-length figure, like a bust. A man is standing with his lower body in the hollow from which the crosses are being brought out. The man with the red headgear is possibly a self-portrait of Piero della Francesca.

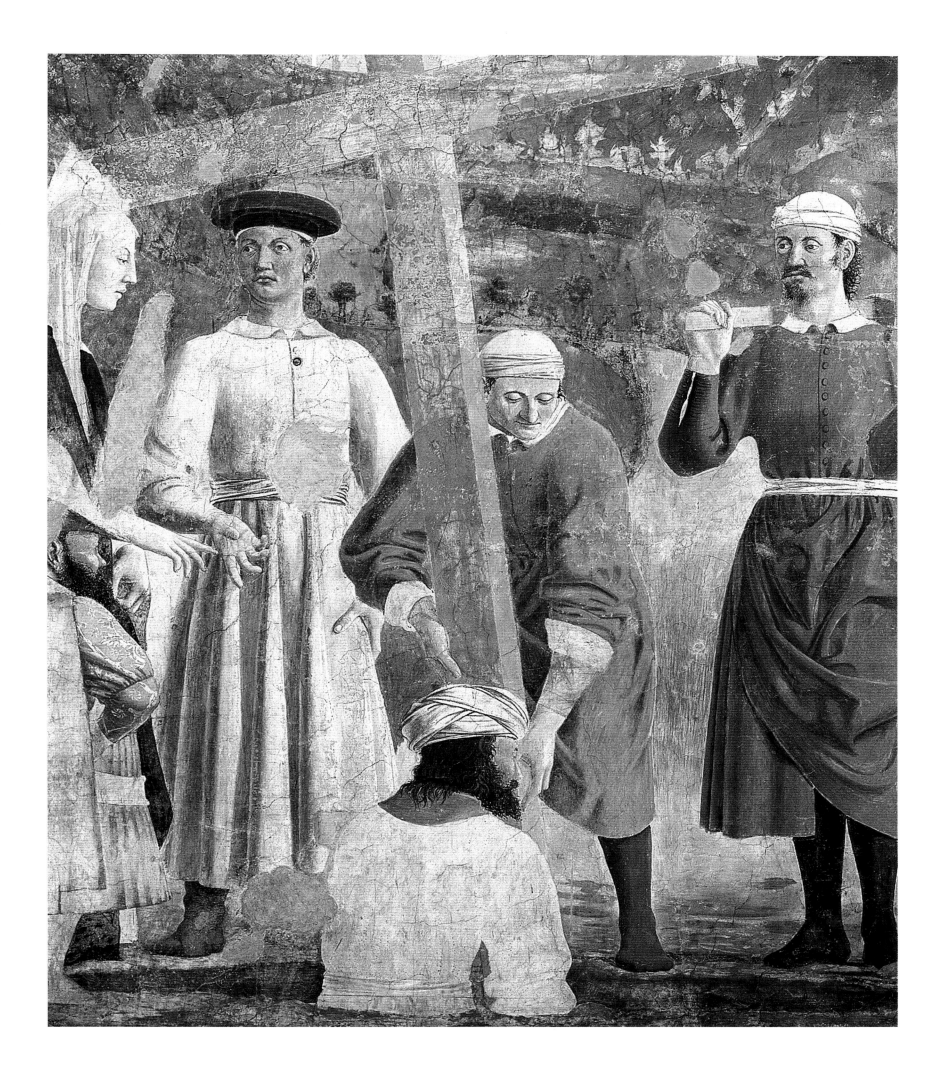

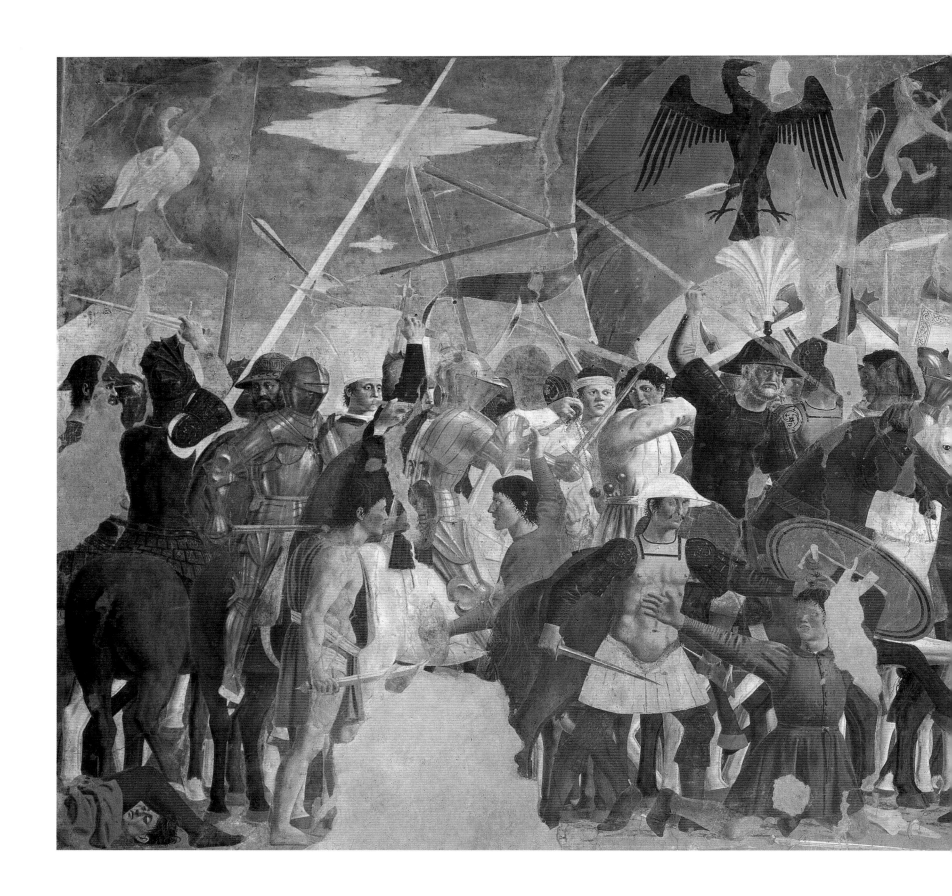

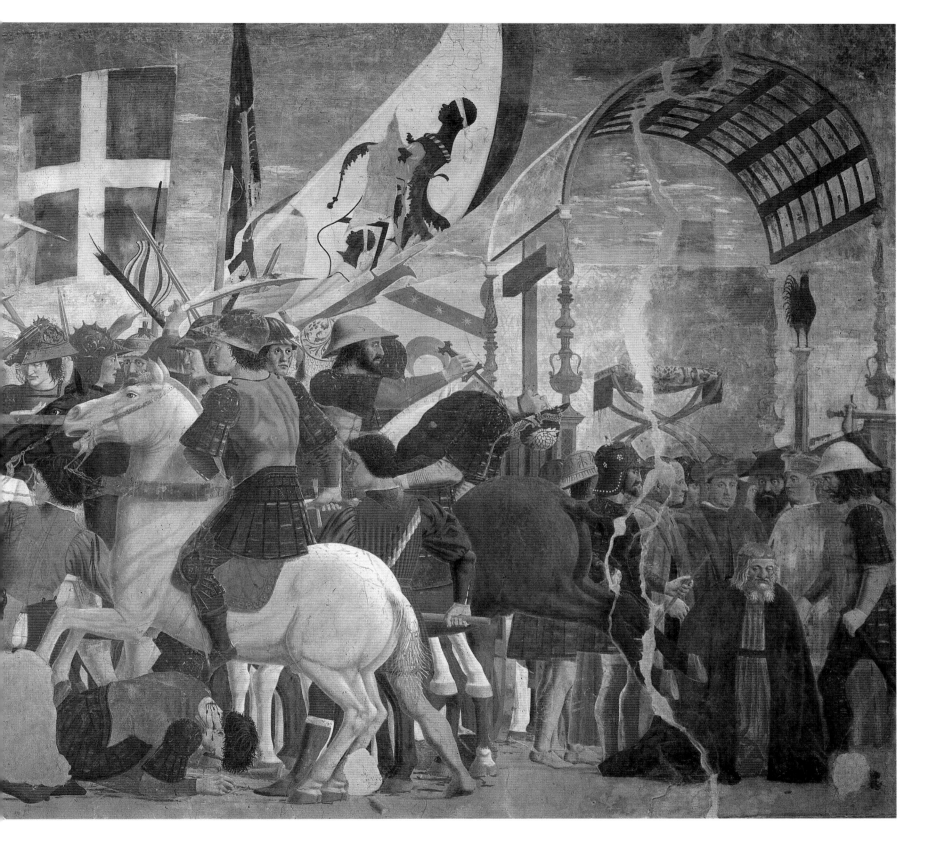

41 *Battle between Heraclius and Chosroes*, 1452–1466
Fresco, 329 x 747 cm
San Francesco, Arezzo

The fresco combines three locations: that of the battle, the blasphemy and the execution. In the battle between the conqueror of Byzantium and the king of the Persian Sassanids, the Christians have not yet been victorious, but the motif of the flag in the centre shows that victory is not far away. On the right side of the picture, the execution of the defeated Chosroes is taking place; it is carried out in front of the very throne on which he allowed himself to be venerated as God the Father with the stolen Cross (left) and a cockerel (right).

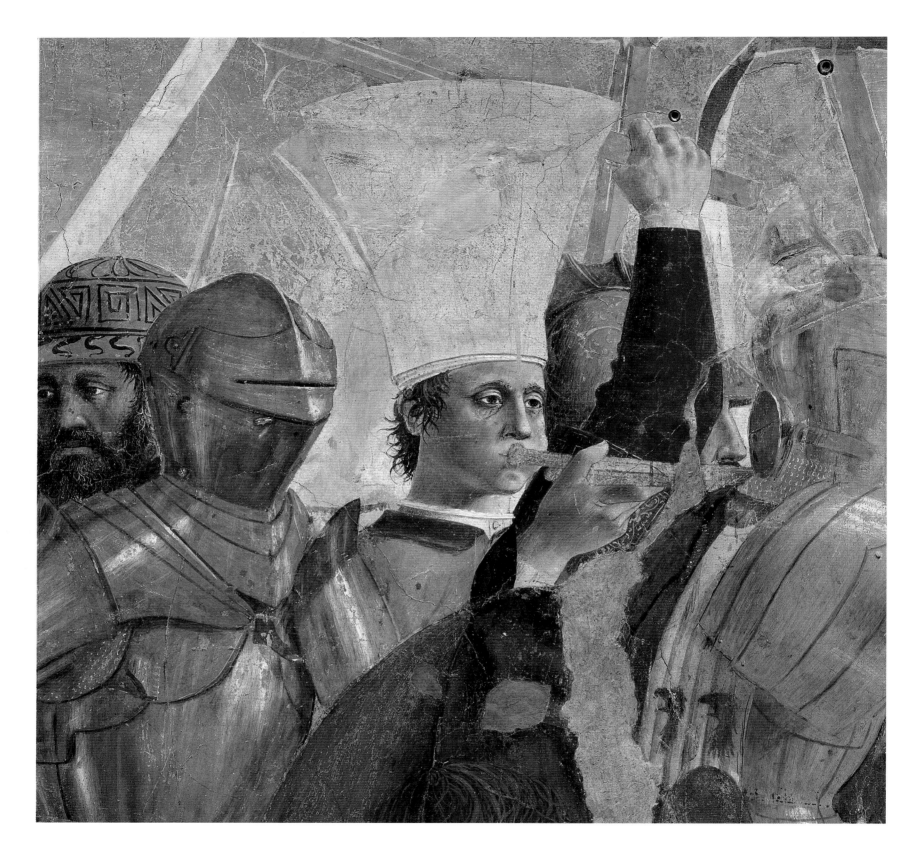

42 *Battle between Heraclius and Chosroes* (detail ill. 41),
1452–1466

It is easy to see in this detail what importance color, form and light
have in Piero's art: while the metal suits of armor are clearly picked
out by their highlights, the head-dress of the trumpet blower
appears as a geometrical white surface which is nonetheless
emphasized by his green and red garment and the red sleeve that is
raised next to him.

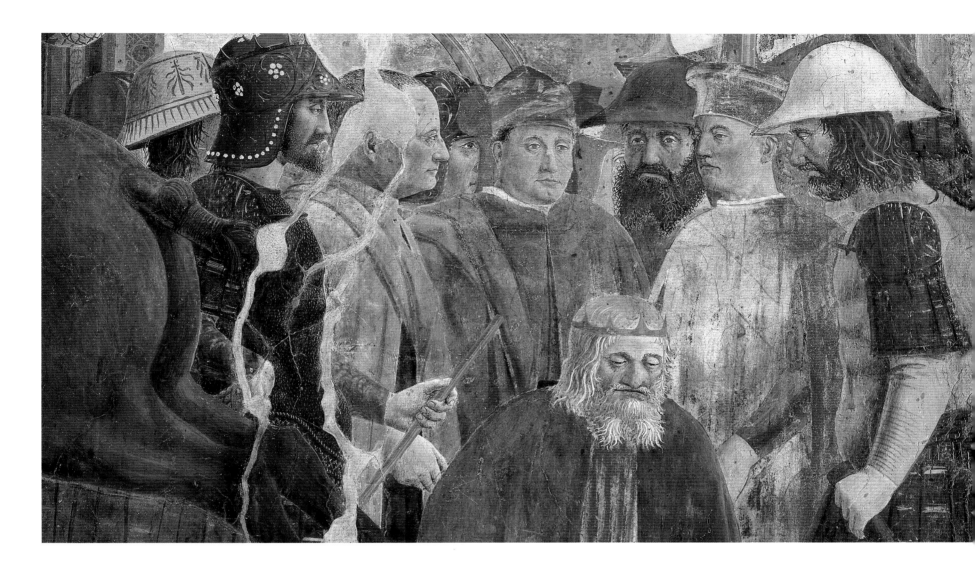

43 *Battle between Heraclius and Chosroes* (detail ill. 41), 1452–1466

The execution of Chosroes is also witnessed by three men in contemporary dress: they are members of the Bacci family, who by their presence are symbolically and determinedly opposing any attack on Christianity. The Persian king has the same features as God the Father – possibly a symbol of his presumption in allowing himself to be venerated as a god.

executioner on the right edge of the picture is the hoofs of the bucking horse, which overlaps the execution scene on the left and contributes to the already mentioned compositional connection of different scenes. The hoofs and the hand of the executioner form a diagonal line at the center of which is the head of Chosroes.

The coherence of the arrangement is impressive: every detail is a composition complete in itself, which loses none of its quality even when seen as a detail. This is what makes the frescoes so modern in our eyes. As in most of Piero della Francesca's paintings, there is also much here which cannot be precisely placed. Everything seems crowded together, all the spaces are filled with layers of bodies and part of horses. Numerous isolated body parts, all carefully modelled, make clear what happens in battle: people hack each other to pieces. And in the very midst of the bloody battle, black holes open up as silent points of focus: they are the staring eyes of the figures. Even when killing, the faces show a peculiar

lack of emotion. But there is a deeper meaning to this frequently negatively evaluated expression: these people are doing and suffering what needs to be done and suffered. What is happening are the unavoidable events of the *Heilsgeschichte*, the story of God's grace, to which the changing fate of the Cross itself bears witness. The individual and his feelings are of secondary importance compared to this.

These exciting action sequences are followed by the last scene in the narrative, which is a more peaceful epilogue: it is the *Exaltation of the Cross* (ill. 46). In the top left lunette, several events are once more combined in a single scene. According to the legend, the appearance of an angel prevents the emperor from making a triumphal entry into Jerusalem, and Bishop Zacharias warns him to have a more humble attitude. Heraclius enters the Holy City without pomp and once again raises the Cross on Calvary.

The entry is commemorated in the religious festival of the raising of the Cross. This scene, which is of great

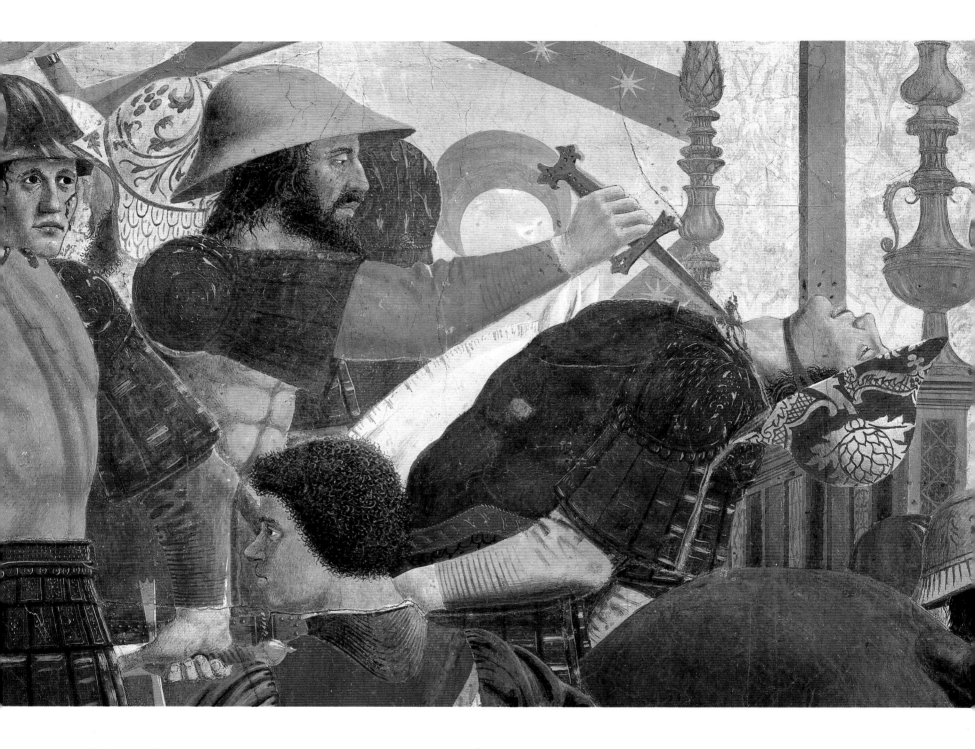

44 (above) *Battle between Heraclius and Chosroes* (detail ill. 41), 1452–1466

The gruesomeness of the battle is depicted without pathos; the son of Heraclius stabs a Sassanid to death without the slightest expression of inner turmoil. Remarkably, the battle dress of the two figures is designed in a similar way both in terms of form and color. This means that it is not all that easy to distinguish between friend and foe.

45 (opposite) *Battle between Heraclius and Chosroes* (detail ill. 41), 1452–1466

The shield and leggings of this warrior are an example of the way in which the artist alternately opposes colors – in this case red, green and white. Piero was possibly prompted to do this by his study of heraldry, which he took up at an early stage of his artistic development.

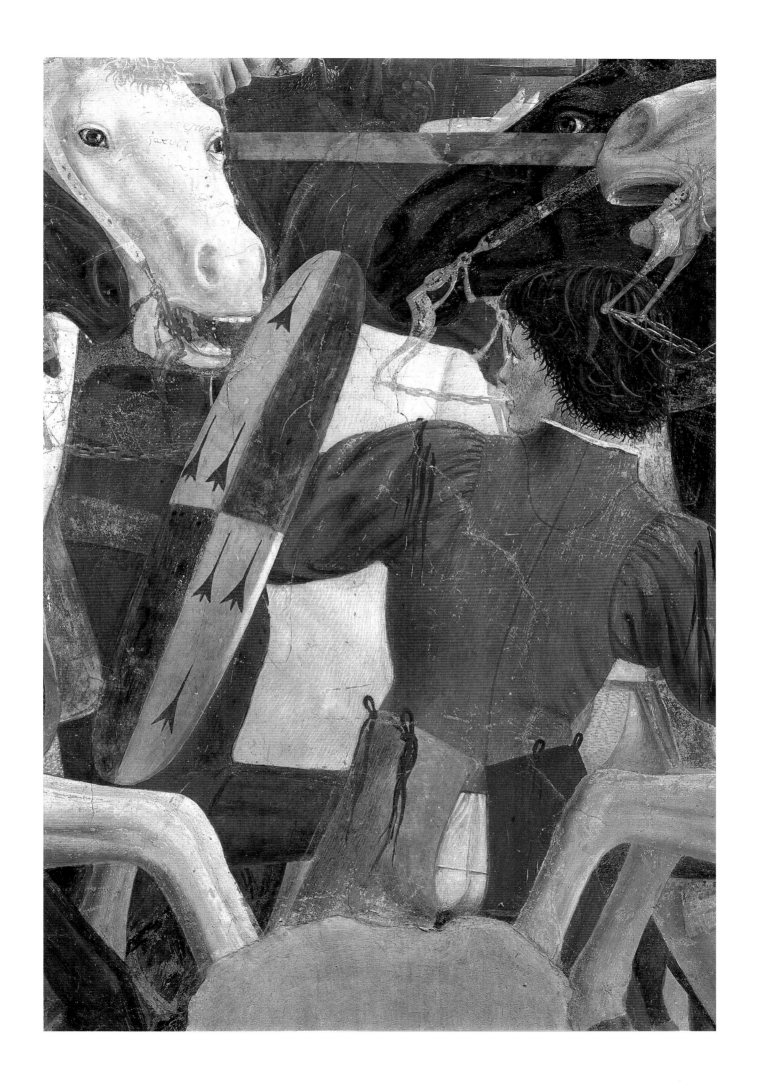

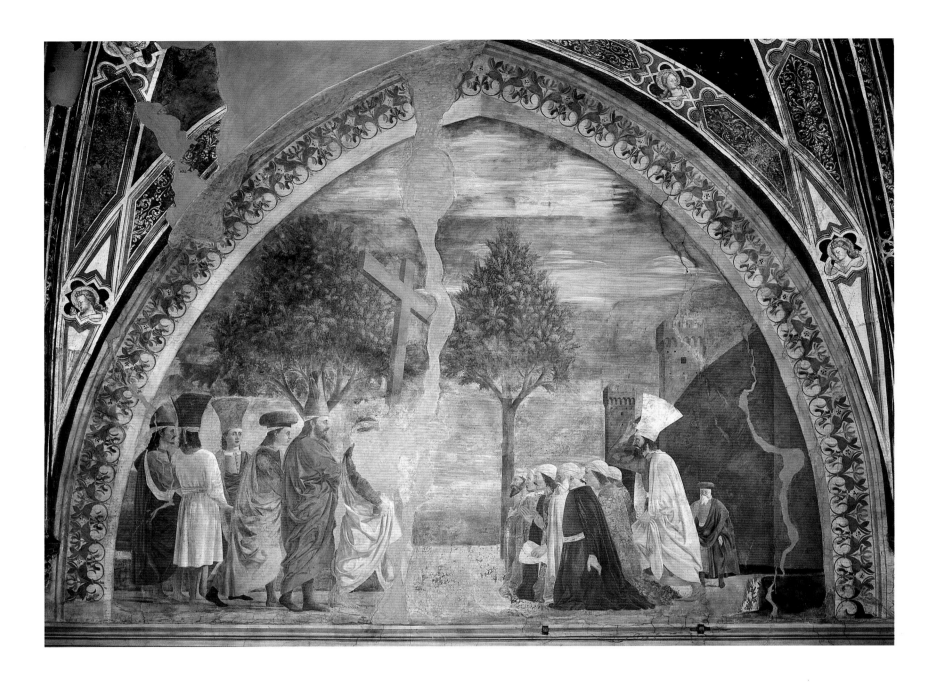

46 *Exaltation of the Cross*, 1452–1466
Fresco, 390 x 747 cm
San Francesco, Arezzo

After the recapturing of the Cross stolen by Chosroes,
Heraclius carries it into Jerusalem, barefoot, just as Christ
once walked to Golgotha. Even outside the city walls
some believers are already hurrying up to him and
kneeling in reverence in order to adore the relic. In order
to make the scene look like a record of a passing moment,
one of the two figures on the right edge of the picture is
just taking off his hat, and another is hurrying up.

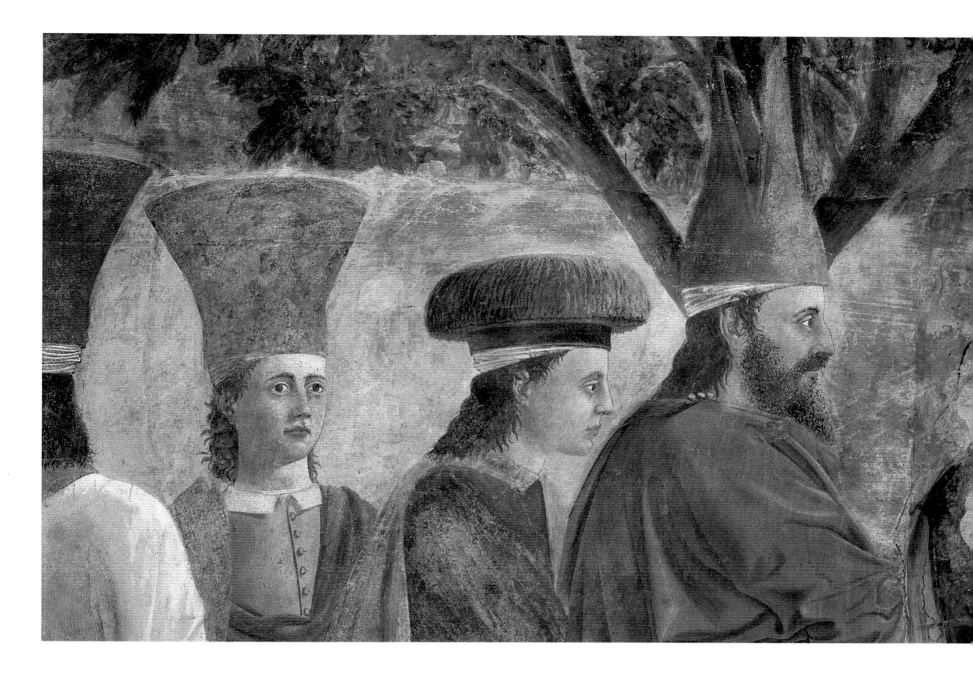

liturgical, historical and spiritual importance, is placed opposite the first episode in the cycle. The grief of Adam's descendants corresponds to the reverence of the faithful before the instrument of divine salvation, the Cross.

The legend of the True Cross tells of the power of the Wood that would not let itself be used by Solomon, that helped Constantine to gain victory without a fight, that brought a dead man back to life, that forced humility upon Heraclius, etc. It tells of the unalterable fulfilment of a prophecy. As was generally customary in cycles of frescoes, prophets from the Old Testament are also part of the pictorial program in Arezzo. While these are normally restricted to frames and border areas, and appear proportionately smaller than the figures in the main frescoes, here Piero depicts them in the same scale as the other cycle figures (ills. 49, 50).

In Early Renaissance art, religious subject matter and purposes generally predominated – classical subjects were extremely rare. Nonetheless a development can be

observed where this is concerned. In the Middle Ages, even secular themes were given a religious guise if it was not possible to avoid depicting them. Now practically the opposite was becoming true: religious themes were being increasingly secularized.

Though the life hereafter was no less important in the Early Renaissance than in the Middle Ages, it was conveyed to the faithful in art using attributes of this life, the purpose being to make it more comprehensible and vivid.

The winged Cupid on the left pilaster, a figure from antiquity, corresponds to the person living in a Christian heaven on the right pillar (ills. 52, 53). He is similar to *St. Julian*, a fresco by Piero della Francesca for the apse of the church of Sant'Agostino in Sansepolcro (ill. 54).

Vasari mentions other works that Piero produced in Arezzo, but only one example of these still remains: it is the fresco of *St. Mary Magdalene* in the city's cathedral (ill. 55). It was presumably created during the last phase of work on the fresco cycle, in the years between 1460

47 *Exaltation of the Cross* (detail ill. 46), 1452–1466

Heraclius is accompanied by high dignitaries. Directly behind him stands Bishop Zacharias. Piero became familiar with the imposing cylindrical head-dresses in 1439 at the Council in Florence, at which numerous Greek emissaries were present.

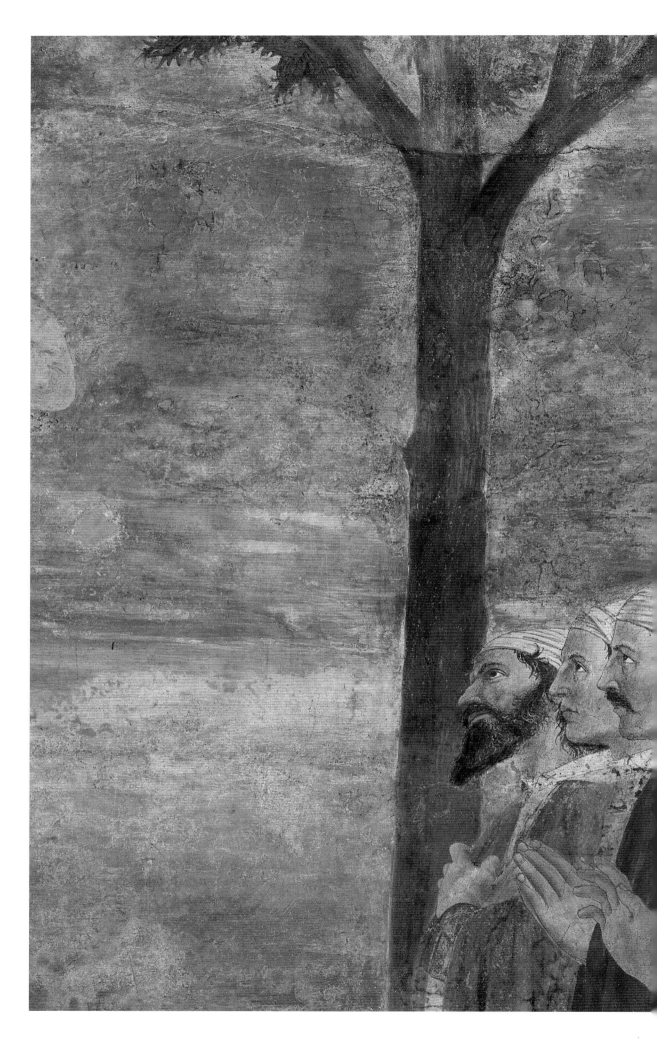

48 *Exaltation of the Cross* (detail ill. 46), 1452–1466

The row of men praying, all with their heads at the same height, draws our attention to the individual representation of the different faces. It gives the artist the opportunity to put into practice the perspectival composition of the human head, the theory of which he discussed in his treatise "De Prospectiva Pingendi".

The light hat that the figure on the right is about to take off contrasts with the red tower. The latter is structured according to the laws of perspective, with one side facing towards and the other side facing away from the light, so that there is at least a suggestion of its spatial size. The hat next to it has been incorporated into the picture as a purely geometric motif.

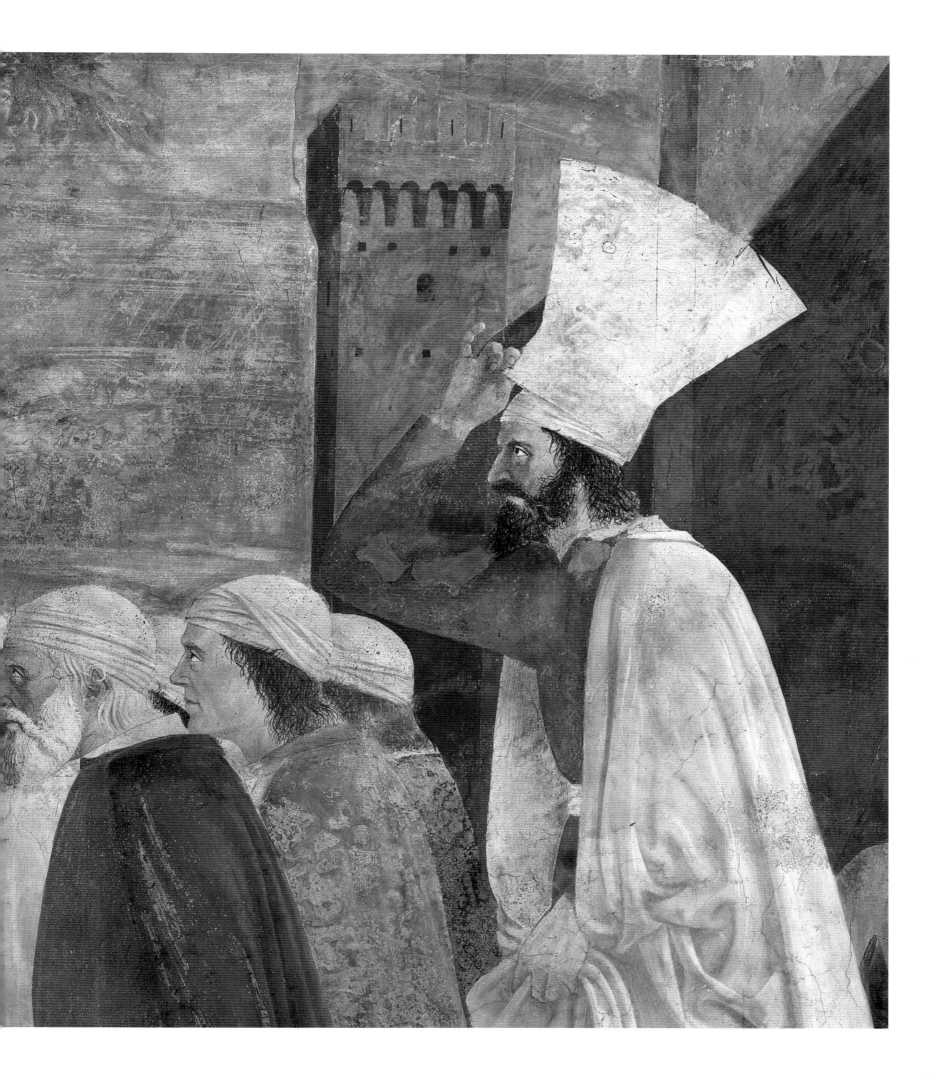

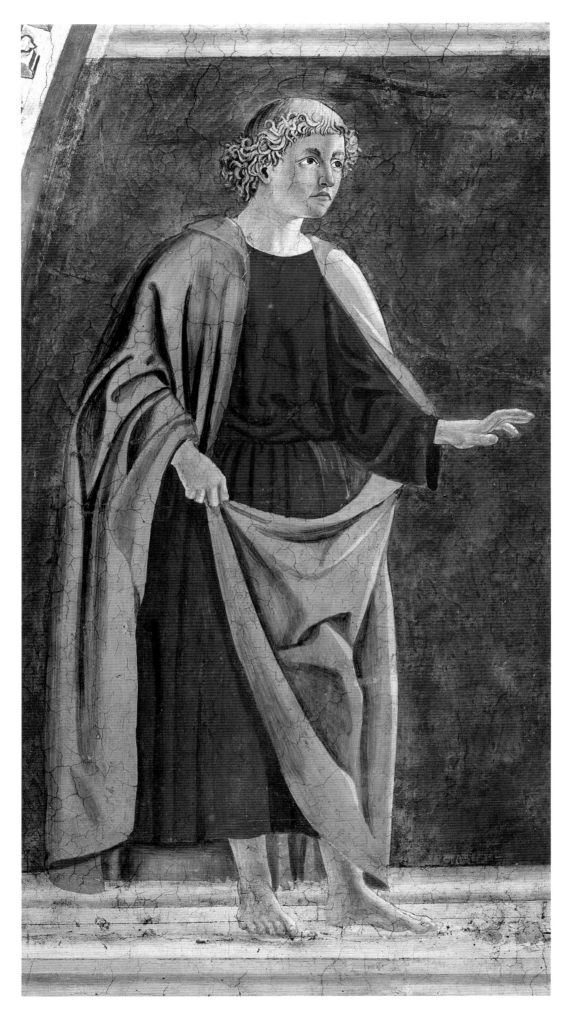

49 (left) Giovanni da Piamonte
Prophet, possibly Ezekiel, 1452–1466
Fresco
San Francesco, Arezzo

In the Middle Ages, the prophet Ezekiel's vision of the shut gate, the *porta clausa* (Ezekiel 44:1–2), was one of the most popular symbols of Mary. This is perhaps the reason why the prophet is positioned above the *Annunciation*, especially as a locked gate is visible behind Gabriel. The painting technique of Piero's assistant Piamonte clearly differs from that of the master.

50 (opposite) *Prophet, possibly Jeremiah*, 1452–1466
Fresco
San Francesco, Arezzo

The ray of light emanating from the window on the left imitates a natural source of light in the choir. The prophet is holding a banderole in his hand and is looking across at the blonde youth in the *Death of Adam*. In his prophecies, Jeremiah spoke of the branch of righteousness which Yahweh raised unto David, causing it to flourish like the shoot which was planted in Adam's mouth.

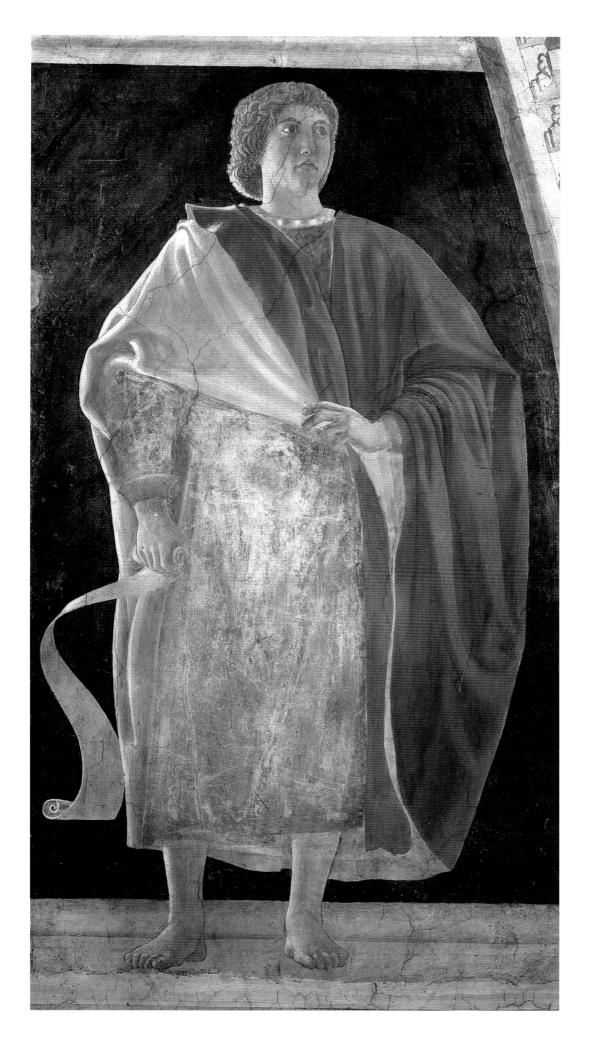

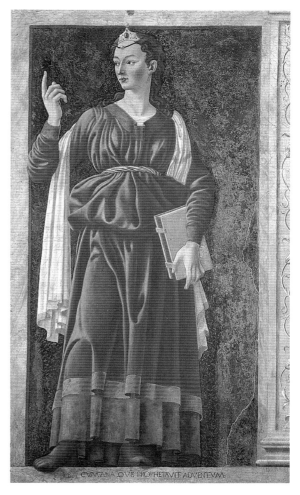

51 (above) Andrea del Castagno
Sibilla Cumana, ca. 1448
Fresco, 245 x 165 cm
Galleria degli Uffizi, Florence

The figure of the Sibyl of Cumae, from the cycle of portraits of
Famous Men and Women by Castagno in the Villa Carducci, is
similar to the prophet in Arezzo. She is placed equally freely in front
of a dark background and is also wrapped in softly modelled
garments whose folds skillfully reflect the light.

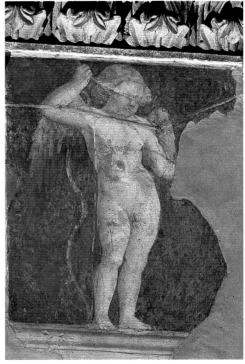

and 1466. The sinner Mary Magdalene covered the feet of Christ with her tears of repentance, dried them with her hair and then anointed them. The skillfully portrayed folds of her garment both surround and accentuate the three-dimensional core of the figure. The brilliance of the light gives the pictorial space an enchanted atmosphere as of pale moonlight. The crystal ointment jar acts as an additional source of light, like a lamp. The gentle beauty of the saint is fascinating, as is her smooth youthful neck, the delicate dimples around her lips, the gracefully lifted eyebrows and the high, noble forehead. The delicate but clear color of her garment, which appears to project from the surface, reminds us once again of the coloring of the frescoes by Domenico Veneziano, as well as works by Antonello da Messina which Piero would have been able to see in Rome.

The garment of the *Madonna del Parto* (ills. 56 – 58) in the church of Santa Maria a Nomentano in Monterchi, a further masterpiece by the artist, is structured in a much more restrained manner. The fresco of the pregnant Mary and two angels was possibly created when Piero traveled to Monterchi in 1459 for the funeral of his mother. Piero's interest in symmetrical picture design is made particularly clear by this picture. The two angels who are holding open the flaps of the tent were drawn from the same cartoon. Their correspondence is lessened by the complementary contrast of red and green. The choice of a tent as the scene – as in *Constantine's Dream* in Arezzo – is derived

from numerous motifs of Madonnas of Mercy and tents in the field of Aretine painting before Piero, and there is also an entirely pragmatic background to it: the round shape of the tent is easy for the observer to categorize from a volumetric point of view. Within the framework of school education in the Early Renaissance, a large role was played by two types of calculation in particular: measuring and arithmetic. This was necessary as there were no general compulsory units for currencies, weights and measures. Every quantity or the volume of each container had to be calculated seperately. As a result, the ability to estimate was taught particularly thoroughly; this involved dividing objects up into regular geometric volumes such as cones, cylinders and the like. This also caused artists to fall back on a formal standard repertoire that would be spatially comprehensible to the mathematically rather untrained observer.

There is, however, another way of interpreting the tent motif which does not require any sort of additional knowledge. The pregnant Mary is protecting Christ in her body just as the tent is protecting her, and the Mother of God's dress is unlaced over her rounded stomach just as the tent is open. The angels who are holding the flaps of the tent to either side are looking at us. It is no accident that their eyes are at the same level as Mary's hand, which is resting on her stomach.

The *Resurrection* in Sansepolcro was also created in the 1460s, during the period of work on the frescoes in Arezzo: it is an innovative work which at the same time displays an entire series of traditional

52 (above left) *Angel*, 1452 – 1466
Fresco
San Francesco, Arezzo

This gentle face is similar to that of St. Julian (ill. 54) and other portraits of young men in Piero's work. It is placed in front of the same marble background as that of the Christian knight. This angel is a heavenly warrior joining the battle against Maxentius. The disc in the foreground is a shield of the type carried by the archangel Michael when he assisted St. Francis of Assisi.

53 (above right) *Cupid*, 1452 – 1466
Fresco
San Francesco, Arezzo

Cupid – naked, eyes blindfolded, entirely the classical pagan symbol of love – is, in the truest sense of the word, packing it all in: he is pushing his arrow back into the quiver. Now the Christian God of Love is triumphant. The ancients, despite their wisdom, seem to be blind.

54 (opposite) *St. Julian*, 1454 – 1458
Transferred fresco, 130 x 80 cm
Pinacoteca Comunale, Sansepolcro

In accordance with tradition, the religious knight is not depicted in armor but as an elegantly clad young man. The effects of light and shadow are carried out meticulously, as is shown by the treatment of the folds in the material in particular. The green marble background could also be a representation of the distant heavens.

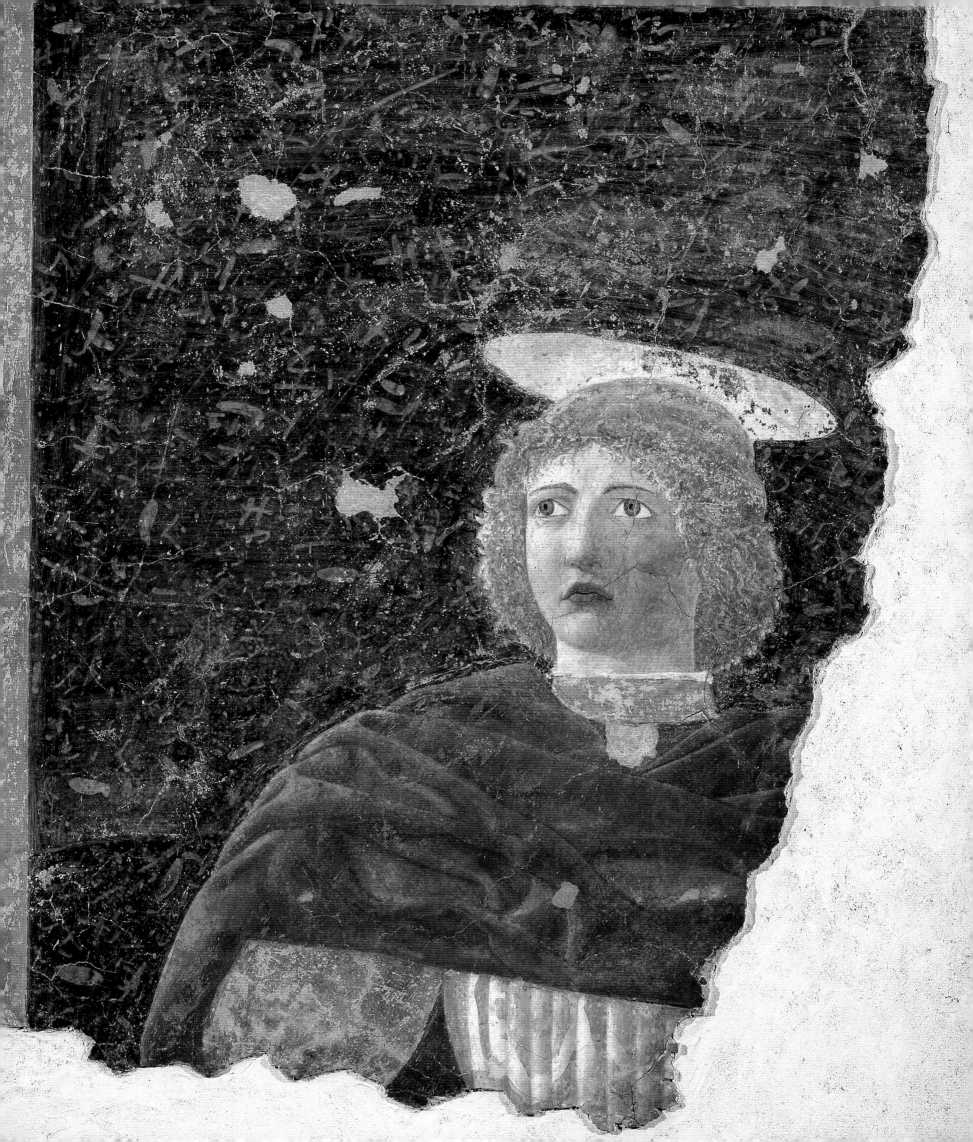

55 (left) *St. Mary Magdalene*, 1460–1466
Fresco, 190 x 105 cm
Duomo, Arezzo

Her eyes lowered, Mary Magdalene is standing under an arch in front of a balustrade. If it were not for the fall of the folds across the base of the socle, one would even be able to say that the saint was architecturally framed like a figure in a niche. Behind her is open sky. Her three-dimensionally modelled garment in the complementary colors of green and red is folded back, and her hair is falling across her shoulders in soft strands. In her hand she is holding a glass ointment jar which is shining as if lit from within.

56 (opposite) *Madonna del Parto*, 1455–1465
Fresco, 260 x 203 cm
Santa Maria a Nomentano, Cappella del Cimitero, Monterchi

The pregnant Virgin is standing under a round damask tent whose flaps are being held up in a strict symmetry on the left and right by two angels who were drawn from the same cartoon. The future Mother of God is wearing a plain blue garment and pointing, with a peculiar gesture, to her bulging body in which the Savior is growing.

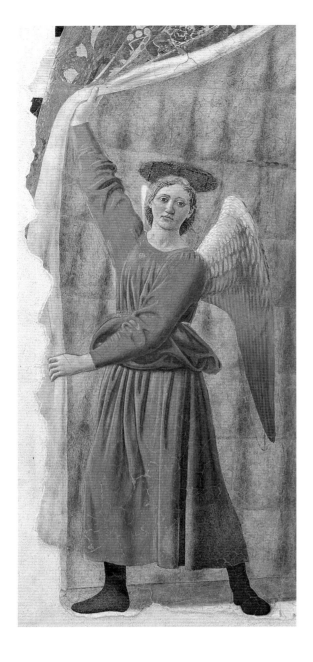 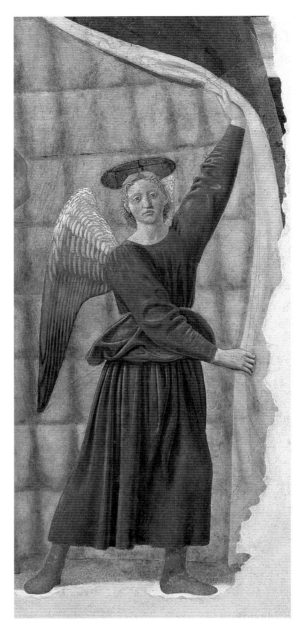

57, 58 (left) *Madonna del Parto* (details ill. 56),
1455–1465

The angel on the right of Mary, just like his mirror
reflection on the right, is looking straight out of the
picture. He is drawing the observer into the scene – he is,
after all, opening the tent for him.

elements (ills. 59–61). The transition from winter to spring, from death to life and from sleep to waking – presented in an exemplary manner in the contrast between the sleeping guards and the risen Christ – is an ancient symbol. It corresponds to the archaic symbolism of the yearly natural cycle of growth and fading, which already played an important part in pagan mythology, such as the Greek myth of Persephone. This analogy connects the supernatural miracle to the normal course of nature. On the other hand, Piero uses the perspectival construction to depict the Resurrection as something incomprehensible, belonging to a higher sphere: the

Resurrection has been incorporated into the scene like the events on a stage, and is bordered to the left and right by an illusory architecture with fluted columns. The figure of Christ is emphasized by the low level of the horizon. It forms the precise central axis of the composition. There is a frontal view of Jesus' features, which are modelled in a pronounced three-dimensional manner. Remarkably, the fresco was not painted in a sacred location, but in a state room for the city administration of Sansepolcro. The reference to the theme is obvious: San Sepolcro means "holy sepulcher".

59 (opposite) *Resurrection*, 1450–1463
Fresco, 225 x 200 cm
Pinacoteca Comunale, Sansepolcro

While the Roman guards are sleeping, Christ has been
brought back to life. He is standing with one foot on the
edge of the sarcophagus, in the posture of an emperor,
and is about to step out of it. He is holding a banner with
the sign of the Cross aloft and is seen in a frontal view
looking out of the picture. The hilly landscape in the
background is in two parts: on the left the trees are bare,
but on the right new life has already begun and the
branches are covered in green.

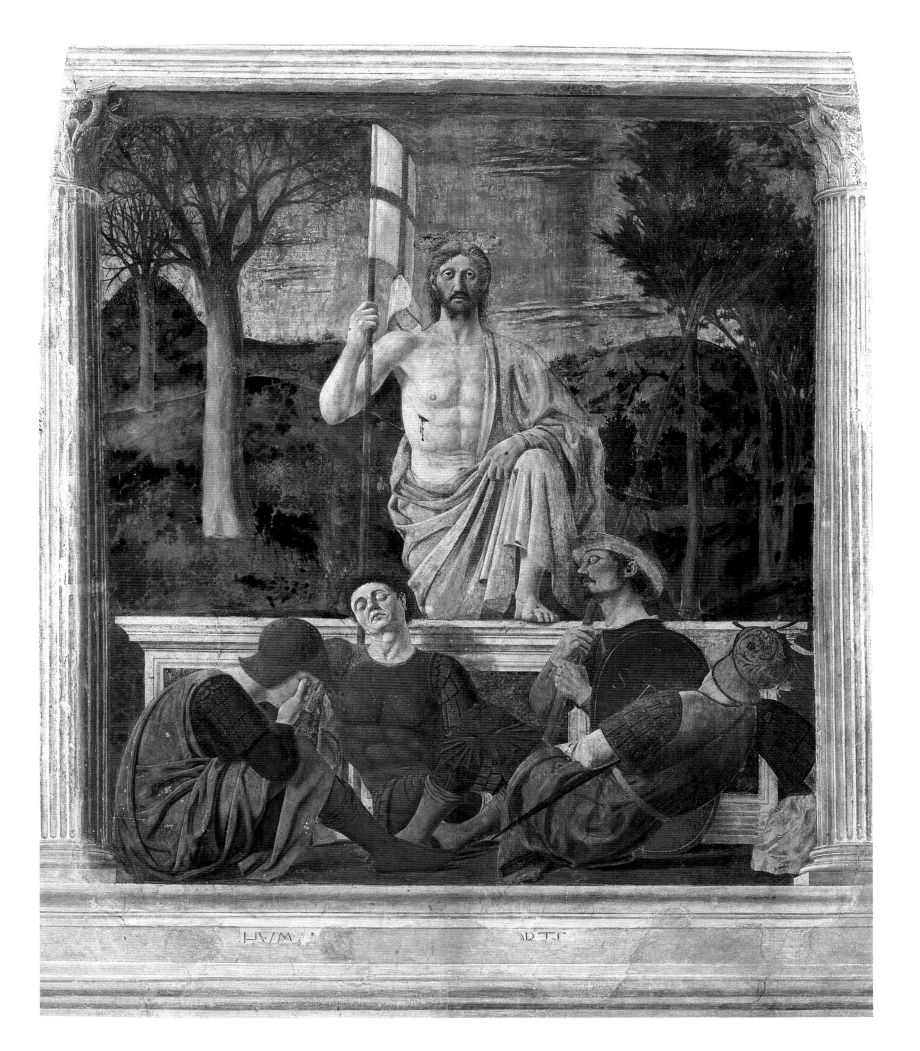

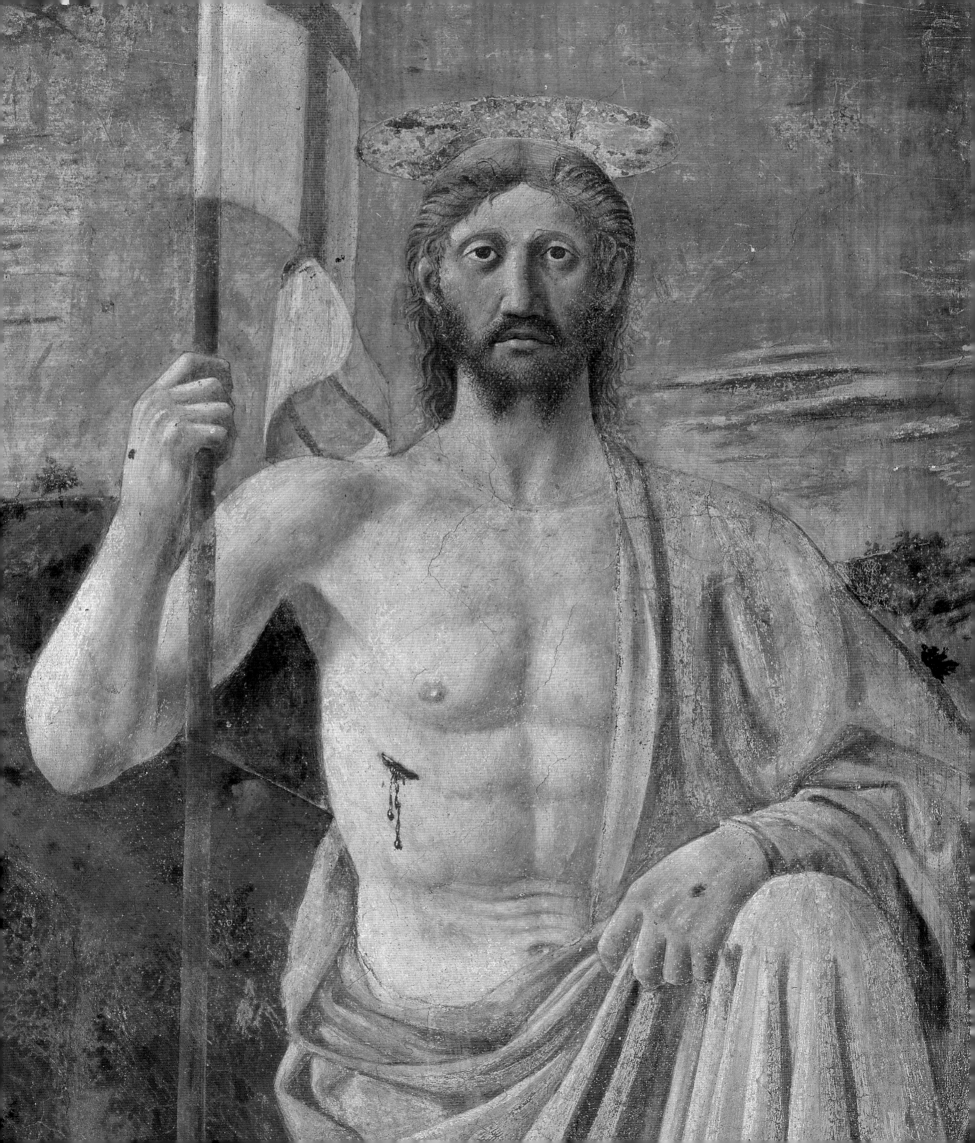

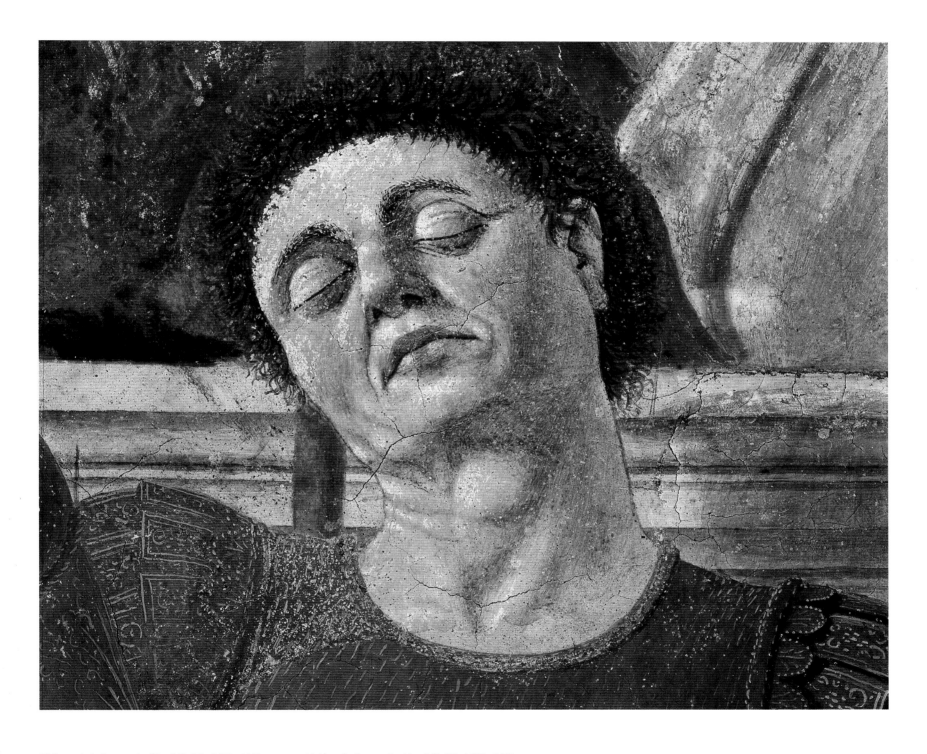

60 (opposite) *Resurrection* (detail ill. 59), 1450–1463

There is very little sign of any perspectival foreshortening
in the head of Christ. Piero has deliberately made this
decision in order to emphasize the face of the Son of God
and, as it were, remove its need to conform to earthly laws.

61 (above) *Resurrection* (detail ill. 59), 1450–1463

It is thought that the sleeping soldier whose head is
resting on the edge of the sarcophagus is a self-portrait of
Piero della Francesca.

62 (above) Andrea del Castagno
Last Supper, 1447–1449
Fresco, 470 x 975 cm
Cenacolo di Sant'Apollonia, Florence

Castagno creates an extremely artistic variation of a
discreet palette of beige, rust red, hazelnut brown and
cold green and blue shades in the marble cladding of the
space and the garments of the disciples. The uniting color
is a gray tone that is laid over all the other colors and
makes the materials slightly iridescent. The coloring and
graphic style almost turn the composition into an abstract
ornament.

63 (opposite) Leonardo da Vinci
Virgin and Child with St. Anne, ca. 1510
Mixed technique on panel, 168 x 112 cm
Musée du Louvre, Paris

Mary is sitting in the lap of her mother Anne. In her arms
she is holding the Christ Child who, in a premonition of
the Passion, is playing with a little lamb. The gentle,
intimate atmosphere is supported by the *sfumato*, the
gradual softening of the contours. This method is based
on the recognition that the use of muted colors and tone
values, which dissolve the forms, in a manner of speaking,
is a way of further increasing the illusion of three-
dimensionality.

In addition to the geometric construction, color was the way
in which the depth of a space was depicted: the relationship
of the various brightness values to each other indicated the
position of a body or surface within the space.

In the 14th century, artists used a gradual and even
darkening of the space: the darker the colors were, the
further into the background the object being depicted was.
In the 15th century, this principle was reversed by the use
of so-called aerial perspective: the increasing lightness and
indistinctness in the background of the pictorial space
corresponded to the natural atmospheric change in color.

During the course of the Cinquecento, color was
increasingly freed of its functional limitations. For centuries,
the material value of the pigments and the iconographical
significance of the color had been at the fore. The central
figures in a religious scene had to be depicted in suitably
valuable colors. The colors to be used, in particular rare and
expensive blue and red shades, were set down precisely in
the conditions in the contracts. Since the Middle Ages,
colors had had symbolic meanings. These symbolic values
played a major role in heraldry from the 13th century: colors
were arranged hierarchically or corresponded to a particular
character.

During the following period, both artists and
theoreticians argued more and more frequently in favor of
a more liberal treatment of color. Between 1440 and 1465
an artistic trend had become established in Florence whose

treatment of color was characterized by the term *pittura di
luce* (light painting). Its proponents were in favor of a picture
composition based on color values and, in the
contemporary dispute over which was more important,
drawing *(disegno)* or color *(colorare)*, favored the latter
view. Domenico Veneziano, Fra Angelico in his late works,
Paolo Uccello, Andrea Castagno and Piero della Francesca
did not just use color as a medium of reflected light, but
used the "light values" of certain colors to illuminate the
picture. This step, following Alberti's theories, was both a
reversion of the magnificent coloring of the Trecento and
an innovation. Alberti postulated that color was dependent
on the illumination of the object and not an unalterable
property connected to it. In his treatise on painting, he
pleaded for diversity in color and defined four original colors
from which all further shades were to be developed: red,
sky blue, green and the ash color *bigio* – a grey that was
used instead of white to lighten and highlight colors. In the
first half of the Quattrocento, it was indeed mostly grey that
was used to lighten colors and form the transition between
different colors (ill. 62). In the second half of the century,
brown tones then predominated, which were used
particularly in the work of Leonardo da Vinci as a main color
tone in his characteristic *sfumato*, or blurred outlines (ill.
63). Towards the end of the 15th century, brightly colored
shades were increasingly rejected in favor of the contrast of
light and dark – the so-called *chiaroscuro*.

WORKS FOR THE COURTS OF RIMINI AND URBINO

The ruler of Rimini – in the center of an asymmetrical composition – is seen in a profile view, kneeling before St. Sigismund. The Burgundian king, who was one of the first to convert to Christianity, is holding the insignia of his power – the ball and scepter – in his hands. The scene has an architectural frame. In the foreground on the right two symmetrically arranged dogs are lying down, and the colors of their coats contrast. The space is decorated with garlands and crowned with the royal house's coat of arms. On the right a tondo with a view of the Malatestian fortress has been incorporated.

All of Piero della Francesca's works considered so far are based on Christian themes. They were mainly located in churches and were, as a result, accessible to all.

From an early point, though, princes were interested in engaging the much-famed artists for their own private purposes. After the first works for Lionello d'Este in Ferrara, Sigismondo Pandolfo Malatesta in Rimini entrusted Piero with the production of portraits. Commissions from royal courts meant fame and money, though the rulers' standards of payment frequently left much to be desired. On many occasions, however, it was precisely those princes that were most reliable in this respect who, in political matters, lacked any sense of morals whatever. The ruler of Rimini was said to behave in much this manner.

The church of San Francesco in Rimini was the traditional burial place of the Malatestas. Between 1447 and 1450, Sigismondo had it changed into a dynastic temple, the Tempio Malatestiano. The architect he engaged was none other than Leon Battista Alberti, and it is probable that Piero got to know him in person on this occasion.

The works of this architect, who was primarily an architectural theoretician rather than an architect, were distinguished by the synthesis of classical motifs, which Alberti, with archaeological interest and a thorough acquaintance with classical literature, had studied in the Roman ruins. The influence Alberti had on Piero is clearly felt in the fresco in the chapel of St. Sigismund. As an example, the pilasters in the background are fluted with five grooves instead of the six we are familiar with from Masaccio's fresco of the *Trinity* (ill. 4) or the buildings of Brunelleschi. It was Alberti who had considered the axis of symmetry – that fifth fluting. The fresco of *Sigismondo Malatesta before St. Sigismund* (ill. 64) is dated 1451. At first sight the unusual arrangement of the composition is impressive. Allowing the gaze to wander across the picture from the lower edge to the top, the space appears to be framed by the architectural elements, adorned with flowers, and one enters the pictorial space as through a portal. If, however, the eye moves from top to bottom, the space appears to topple over. The upper edge, which at first appears to be in the foreground, is being carried by the pillars in the

background. In this way the artist creates an interesting sense of spatial drama.

In addition, the fresco is brought to life by the tense relationship between the evident asymmetry and the illusion of symmetry which is achieved by positioning the figure of Malatesta almost exactly in the middle between the pilasters. The goal is to structure the center in an asymmetrical composition. In the discussions of art historians it has almost become a topos to use Jan van Eyck's *Madonna and Child with Chancellor Rolin* as a comparison, as in that work an analogous composition was used for the picture. Here, Piero constructed a clever spatial situation which requires the observer to look more closely at the work. The monumental nature of the composition and the calm statuesque character of the figures are an indication of the frescoes to come in Arezzo.

The portrait of the prince that is now kept in the Musée du Louvre (ill. 65) has a surprisingly diminished appearance. It is possible that a medal created by Matteo de' Pasti was used as the model for both portraits of Malatesta.

The tyrannical ruler of Rimini was not the only prominent prince to make use of Piero's services. Far more extensive were the works he produced for Federico da Montefeltro in Urbino. On account of his education, the duke was held in high esteem and had the reputation of being a prudent and level-headed regent. His court was in active artistic contact with Flanders, and in addition to works of art, Flemish artists also came to Urbino. For example, Justus van Gent was active there between about 1460 and 1475. It is not certain when Piero first worked for the duke of Montefeltro. Vasari writes that Piero stayed in Urbino during the reign of a "Guidobaldo Feltro", but this is probably a mistake and he is likely to have meant Guidantonio, who was in power before 1443. There is, however, no proof that Piero stayed in Urbino at such an early stage. In the year 1453 he may have spent some time at the court of the Montefeltros on the way back from Rimini to Sansepolcro. However, the works that have been preserved date from a later period. One clue to the chronology is provided by the *Diptych Portraits of Federico da Montefeltro, Duke of Urbino, and of his Wife,*

Battista Sforza (ills. 66–67). Battista died in 1472 and her portrait was created posthumously. The portrait of the duke was probably completed by about 1465. The painter has boldly placed the profiles of the portrayed figures in front of the highly detailed landscape, in this way achieving an extreme sense of depth and an accentuation of the figures in the foreground. It was recently discovered that if the landscapes on the front and rear sides of the diptych are joined together, the result is a broad landscape panorama. In order to do this, though, it is necessary to raise the portraits on the front side, which have no inscriptions, to the levels of the triumphal processions, so that the horizons of the landscapes match. Then the landscape in the portrait of Federico continues through the triumphal procession of his wife (ill. 68) and the portrait of Battista to the triumphal procession of her husband (ill. 69). The continuous landscape in the background of the pictures corresponds to the panorama which one can see from the west tower of the Palazzo Ducale in Urbino – across the flowering ducal properties between the Metaurus and Foglia rivers. The observer therefore has to walk around the work in order to gain this impression. In this way it becomes clear that the diptych is an early example of panorama paintings such as we are familiar with from art north of the Alps, such as Jan van Eyck's *Ghent Altarpiece* (completed in 1432).

In about 1470 there are records of two occasions on which Piero and Federico could have met: in 1469, Piero stayed in Urbino in order to negotiate the completion of an altar painting for the Corpus Domini brotherhood, begun by Uccello, and in 1470 Federico visited Sansepolcro. These possible contacts have suggested that the *Flagellation*, one of Piero's most famous paintings, could have been produced during this period and commissioned by Federico (ills. 70, 73, 74).

We know that this is an original work by Piero. It is signed along the base of the throne on which Pilate is sitting: OPUS PETRI DE BURGO SCI SEPULCRI. The theme of the Flagellation is primarily familiar within the context of cycles or depictions on predellas. The only other occasions on which it appears in isolation are in a work by Luca Signorelli, one of Piero's students (*Flagellation*, 1475–1480, Pinacoteca di Brera, Milan), and in a series of eight drawings by the Venetian artist Jacopo Bellini (ca. 1400–1470/71) in the Musée du Louvre (ill. 71).

No other work by Piero is surrounded by such a range of controversial interpretations, and it is worth considering them in more detail. The usual starting point for suggested interpretations is the three figures in the foreground on the right, and their relationship to the scene of the Flagellation which is taking place in the background on the left. The question is whether the figures at the front have a significance which is connected with the event behind them. The composition of the picture, with larger figures in the foreground, was not unusual in the Early Renaissance: the new knowledge about perspective gave rise to new practices for highlighting figures that were important to the work's subject matter. While the perspective used in

the Middle Ages made figures larger or smaller according to their significance, one effect of the perspectival explorations of the Renaissance figural repertoire was that the figures in the foreground increasingly took on the roles of commentators, witnesses and mediators between the observer and the events in the picture. Placed large at the front edge of the picture, they indicate the main event which is taking place further back and which, because of foreshortening, is depicted on a clearly smaller scale. The function of the architecture was to give a scale to the proportions.

There is a diverse and complex spectrum of suggestions and arguments. As a result, a few examples should suffice, though they will be touched on rather than discussed in detail. Is the grouping of the three people part of the tradition of the disputation that is recorded in mystery plays and the liturgy of Holy Week? Does the group personify the repentance of Judas? In that case, the question which is immediately suggested is: where are the thirty pieces of silver which would make it possible to identify one of the figures as Judas? Are the three figures high priests who are refusing to enter the prætorium in which Christ is being flagellated out of fear that they will be defiled? Or are those depicted contemporaries of Piero?

Though there are a variety of suggestions, they are connected by a common premise. All the ideas are based on the notion that both groups of figures are contained in a homogeneous space. That it is nothing of the sort is made clear by a diagram (ill. 72) which reconstructs the ground plan and elevation of the *Flagellation*. According to this, the groups are placed in different spaces. How would one have to approach the picture if one were, in addition, to assume that the work was also presenting us with different eras?

Nonetheless, there are connections between the figures and the pictorial spaces. The diagonal line of the coffered ceiling, when extended and continued by the entablature over the door, passes through the head of Christ and leads to the right foot of the left figure in the foreground. This direction from top left to bottom right corresponds to one on the other side running in the opposite direction. The line from the edge of the roof, which is supported by corbels, runs through the head of the young man, just like the diagonal that runs through Christ's head, and ends at the left foot of the thug on the right. As a result, the two pictorial spaces are not only related to each other, but two of the figures are even emphasized. Christ and the youth are the central figures within a group of three. Their naked feet are placed in a similar position and both are the same distance away from the central column – the dominant element in the structure of the space. Such a relationship was surely deliberate. This leads to the assumption that the pictorial space was invented for the picture surface. As a result, the picture is not a projection of a space that really exists.

A central theme of the *Flagellation* is light, or to be more precise, the way in which Piero uses it to structure the figures and architecture. On the right the relationships are simple. The meeting of the three figures

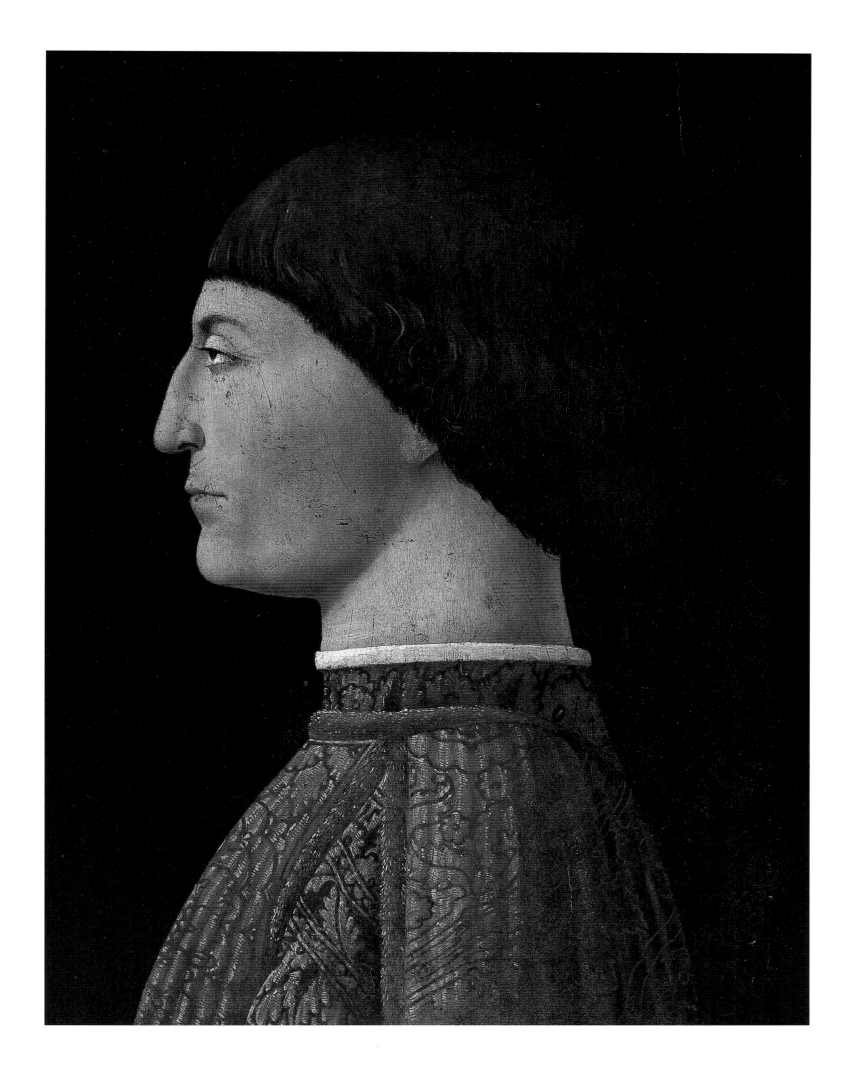

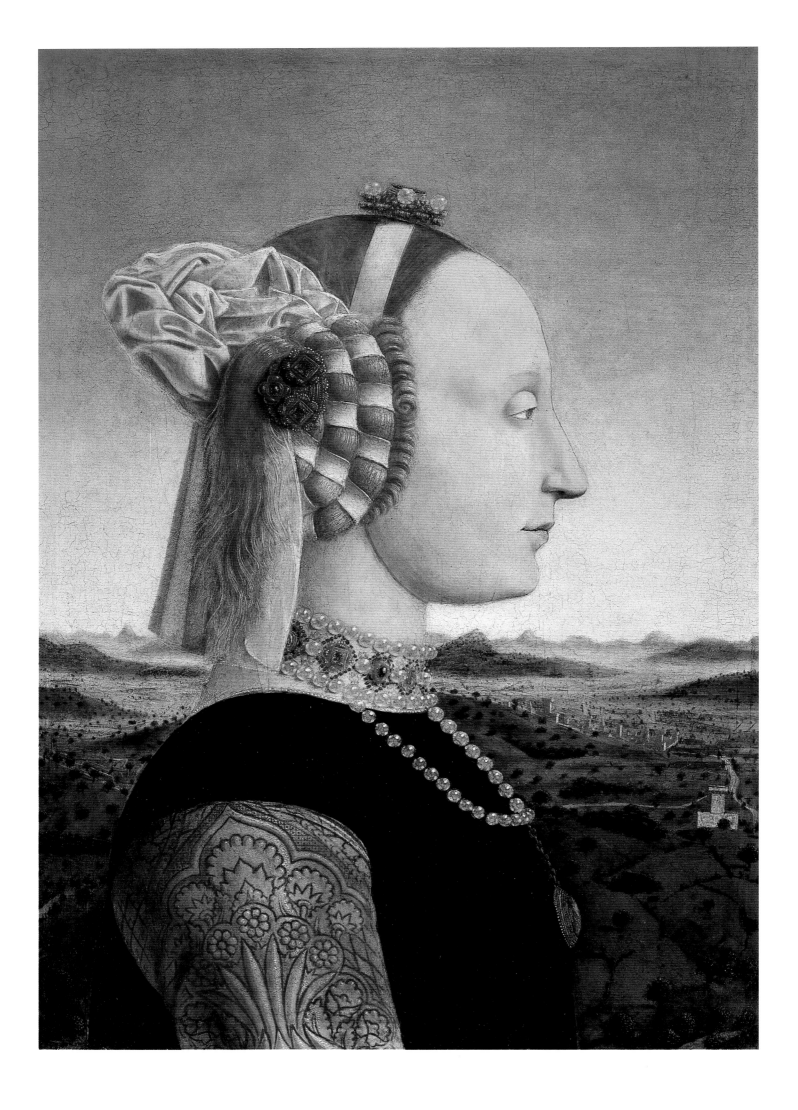

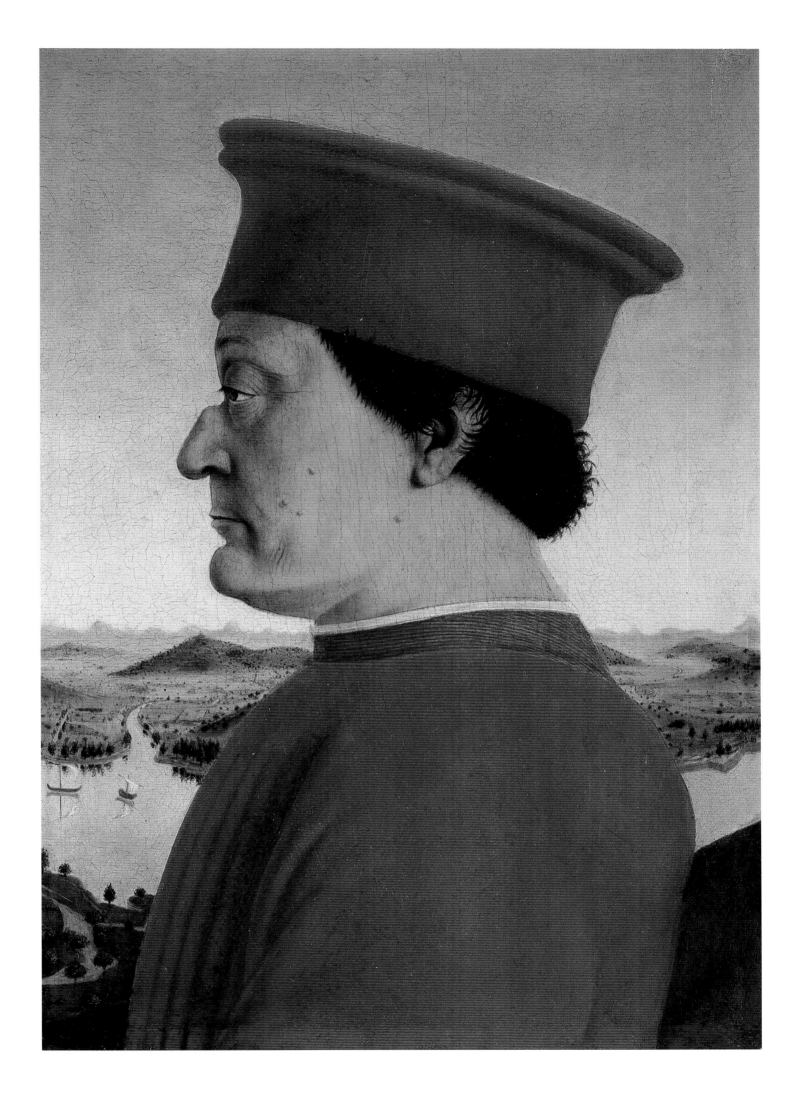

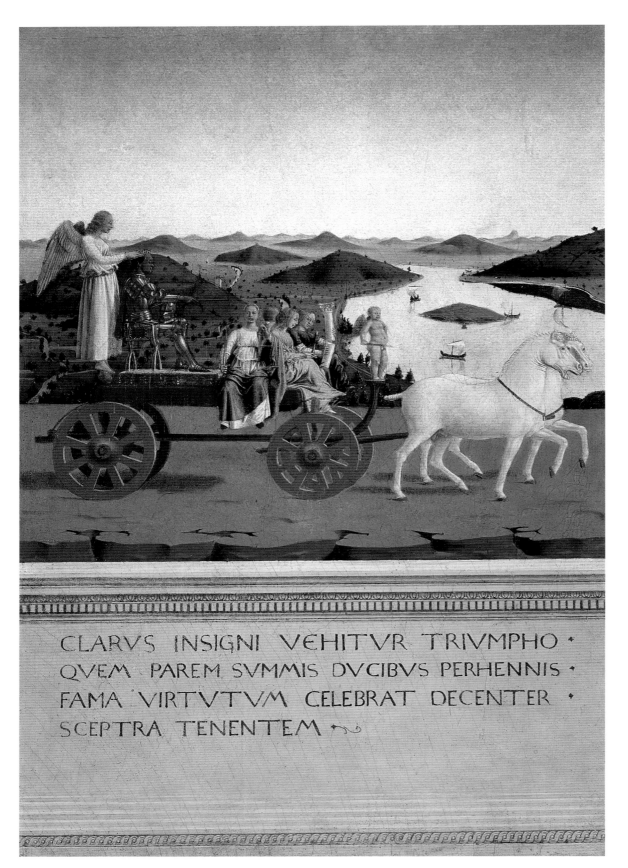

CLARVS INSIGNI VEHITVR TRIVMPHO ·
QVEM PAREM SVMMIS DVCIBVS PERHENNIS ·
FAMA VIRTVTVM CELEBRAT DECENTER ·
SCEPTRA TENENTEM ᵔ

68 *Allegorical Triumph of Federico da Montefeltro,*
ca. 1465
Reverse of diptych (ill. 67)
Oil on panel, 47 x 33 cm
Galleria degli Uffizi, Florence

The rear side of the portrait is decorated with a triumphal
procession. Federico is being crowned with a laurel
wreath by Victory, like an emperor in Roman depictions
on triumphal arches. At the front of the carriage sit
personifications of the four cardinal virtues (Fortitude,
Justice, Temperance and Prudence). Cupid is driving the
pair of grays. The duke is carrying the scepter of his
power, and further emphasis is given to his princely
virtues by an inscription in Latin capitals.

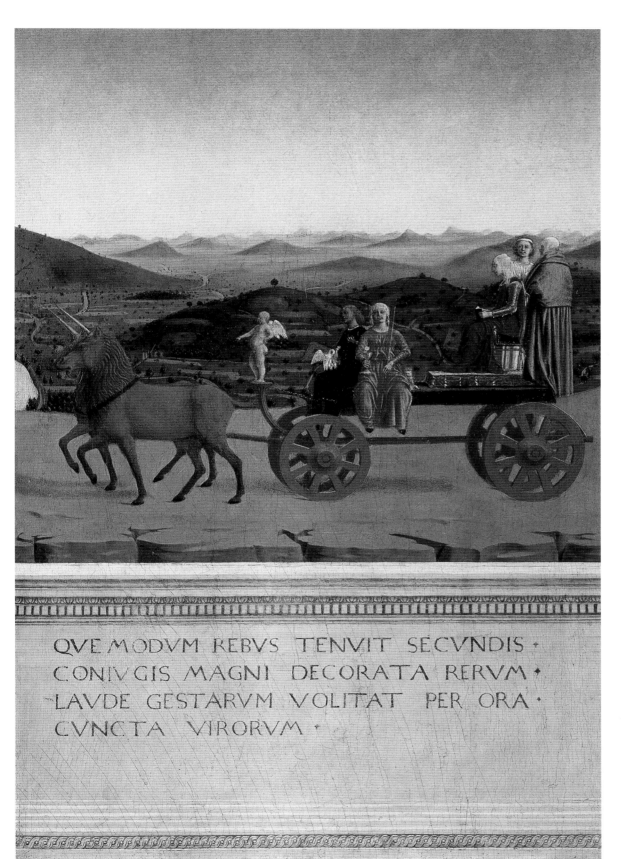

QVE MODVM REBVS TENVIT SECVNDIS ·
CONIVGIS MAGNI DECORATA RERVM ·
LAVDE GESTARVM VOLITAT PER ORA ·
CVNCTA VIRORVM ·

69 *Allegorical Triumph of Battista Sforza*, after 1472
Reverse of diptych (ill. 66)
Oil on panel, 47 x 33 cm
Galleria degli Uffizi, Florence

In contrast to the duke, who is shown in full armor, Battista is reading a small book as a reference to her contemplative way of life. She is accompanied by four Virtues. On the lap of Caritas, the virtue of charity, sits a pelican as a symbol of maternal self-sacrifice. The Latin inscription praises the modesty of the duke's wife. Further symbols of her purity are the unicorns pulling the carriage.

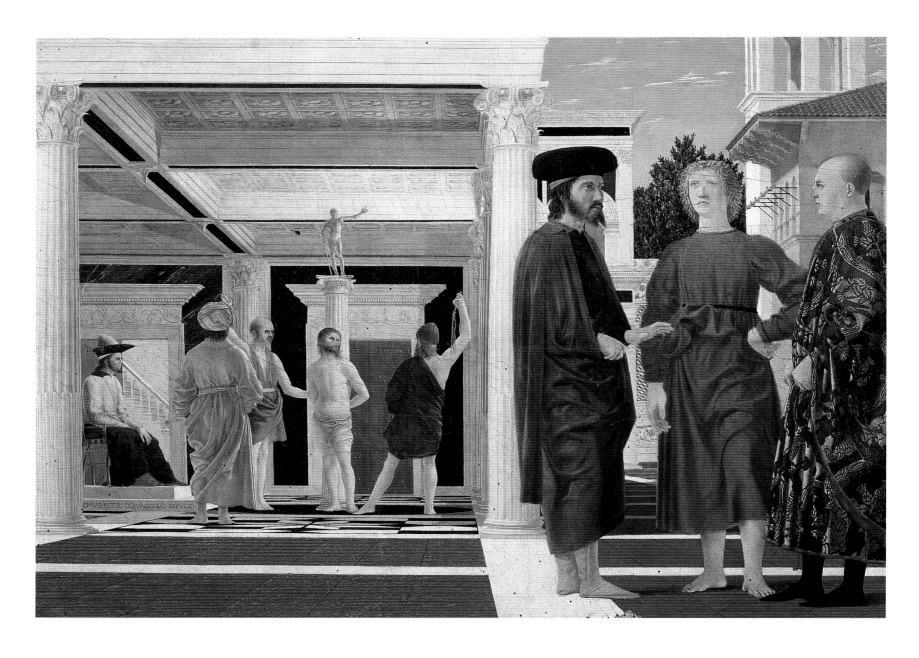

70 *Flagellation*, ca. 1470
Mixed technique on panel, 58.4 x 81.5 cm
Galleria Nazionale delle Marche, Urbino

The composition consists of two scenes which are clearly separated
from each other. At the front of the picture on the right, three
smartly dressed men are standing in the open on a sundrenched city
piazza. In the background of the picture on the left, Christ is being
flagellated before the eyes of Pilate in an interior whose formal
language cites the classical vocabulary. An observer wearing a turban
has his back turned to the viewer.

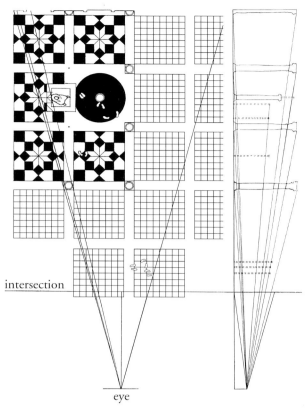

intersection

eye

takes place in daylight. The light is falling on them from the left, as is proven by the shadows on the right. On the left, in contrast, the relationships are more complicated, for there are evidently several sources of light here. The door behind Pilate is open and we can see out onto a staircase which is brightly lit. Light is falling on Christ's body from the right. There must therefore be another source of light between the columns, roughly at the level of the elbow of the thug dressed in green. This assumption is justified by the bright and shadowy areas of the coffers on the left. In addition, there must be a third source of light. This is certainly suggested by the shining coffer in the center of the right row. But where is it situated? The extremely skillful way in which Piero handles the light in the picture is also shown by the garment of the man wearing the turban and the highlights on the ornamental door mountings to the right behind Christ. The artist is no less rational in this than he is in the composition of the perspective.

According to a source dating from 1839, the frame contained an inscription, no longer extant, which read: "convenerunt in unum" (the rulers take counsel together). This extract from the second psalm was traditionally used in the context of depictions of the Flagellation – usually in Books of Hours – and was part of the liturgy for Good Friday. Here the quotation could be interpreted with two meanings: in the rear part of the painting, Christ's enemies are gathering, and in the foreground the princes of Italy are gathered in order to oppose the threat to Christianity presented by the Turks. The policies of Federico in about 1470 were chiefly aimed at finally dissolving the estranged league of the

various Italian royal houses and founding a new one during the following years. By the spring of 1470, the prerequisites for a new Italian league had been fulfilled and the princes had "taken counsel together". All these aspects suggest that the *Flagellation* dates from about or after 1470.

The question of who commissioned the work is clearer in the case of the altar painting that Piero della Francesca produced for the duke. In the *Pala Montefeltro (The Madonna with Child, Angels, Saints and Federico da Montefeltro, Duke of Urbino)*, the prince himself is depicted in the traditional manner as a donor (ill. 75). Donors were normally placed at the edge of the picture amongst the worshippers praying to the main figure, and usually appeared in the picture in the complete regalia of their office with all the insignia of their power.

Piero must have started work on the painting before 1474, as Federico is depicted without the Order of the Garter that was conferred on him in 1474. The panel was probably produced as a commemorative picture before the death of the duke in 1482, in connection with the intention, never realized, to build a mausoleum in about 1472. The altar painting was completed some years after 1474 by the Spanish artist Pedro Berruguete.

The painting is a *Sacra Conversazione* (Mary surrounded by saints), a type of painting that was very widespread in Italian art from the 14th to the 16th century. Contrary to the first impression, created by the proximity of the frame to the painted architecture, the pillars at the sides are not at the front picture plane but further back. The space recedes right into the background and the Madonna is enthroned in the

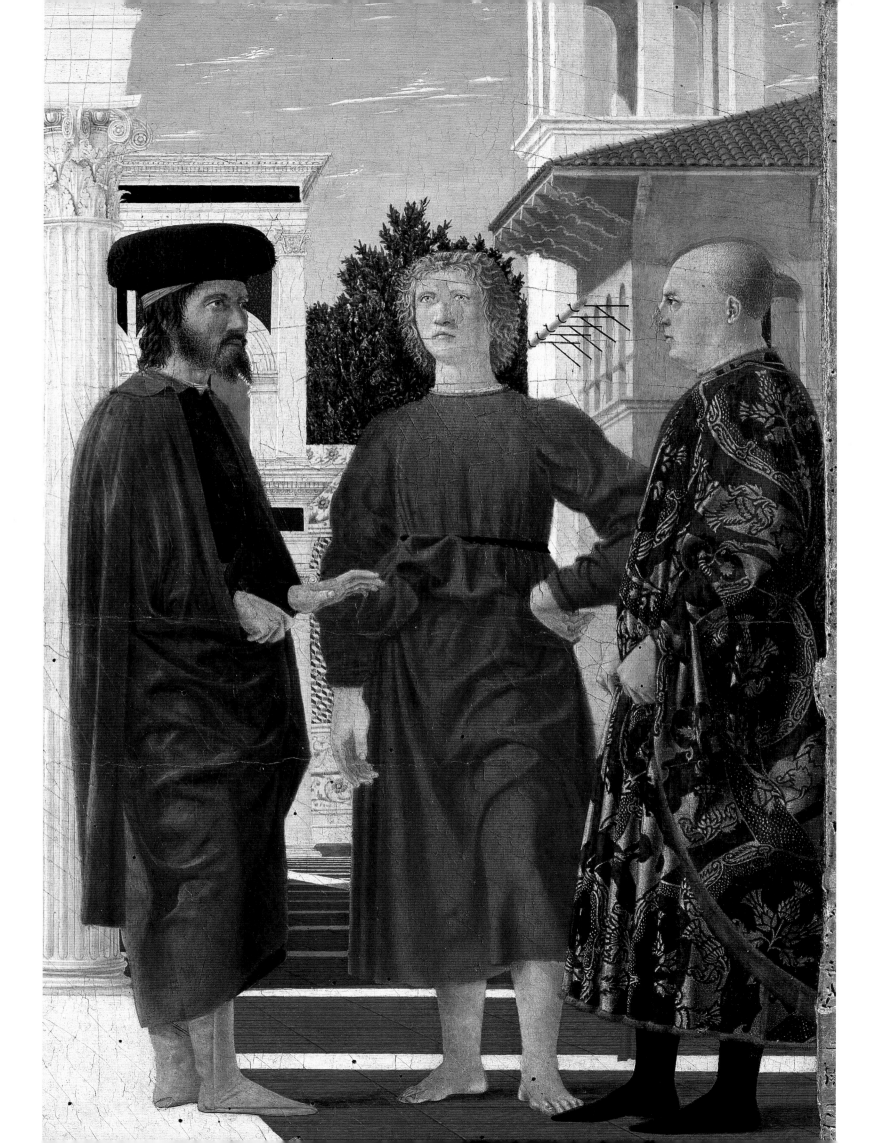

73 (opposite) *Flagellation* (detail ill. 70), ca. 1470

Despite a variety of suggestions, the problem of the identity of the three figures has still not been resolved. The dress and headgear of the man with the beard show him to be a Greek, and this could be a high dignitary. The figure opposite him is wearing a fur-lined damask garment and a red stole which falls from his shoulders down to his feet. Could this be a western authority? The barefoot figure in the center is in plain attire. The variety of the garments, the age differences and – in the case of two of the figures at least – the ethnic origins is striking.

74 (below) *Flagellation* (detail ill. 70), ca. 1470

Pilate is watching the torture that he has ordered. His hands, which he has washed to prove his innocence, are lying in his lap. The servants have raised their scourges in order to strike. The particular atmosphere of the scene is created principally by the lighting. No fewer than three sources of light can be identified: one on the staircase behind Pilate, one behind the columns on the right, and one in the central coffer on the right.

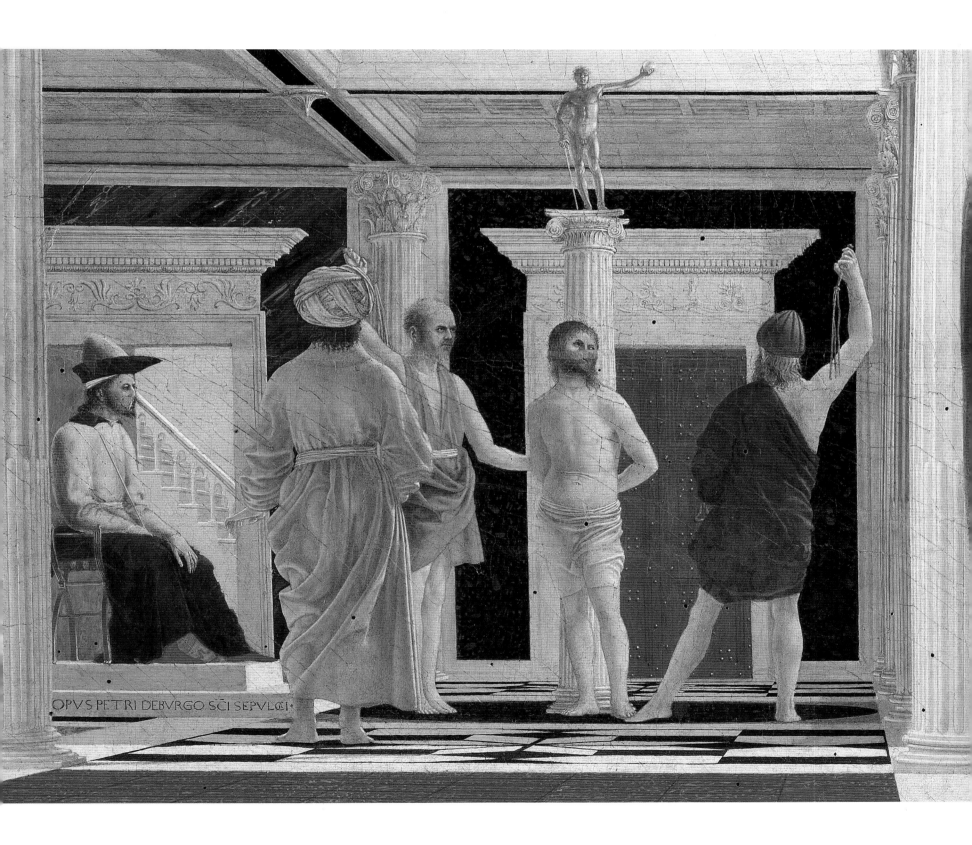

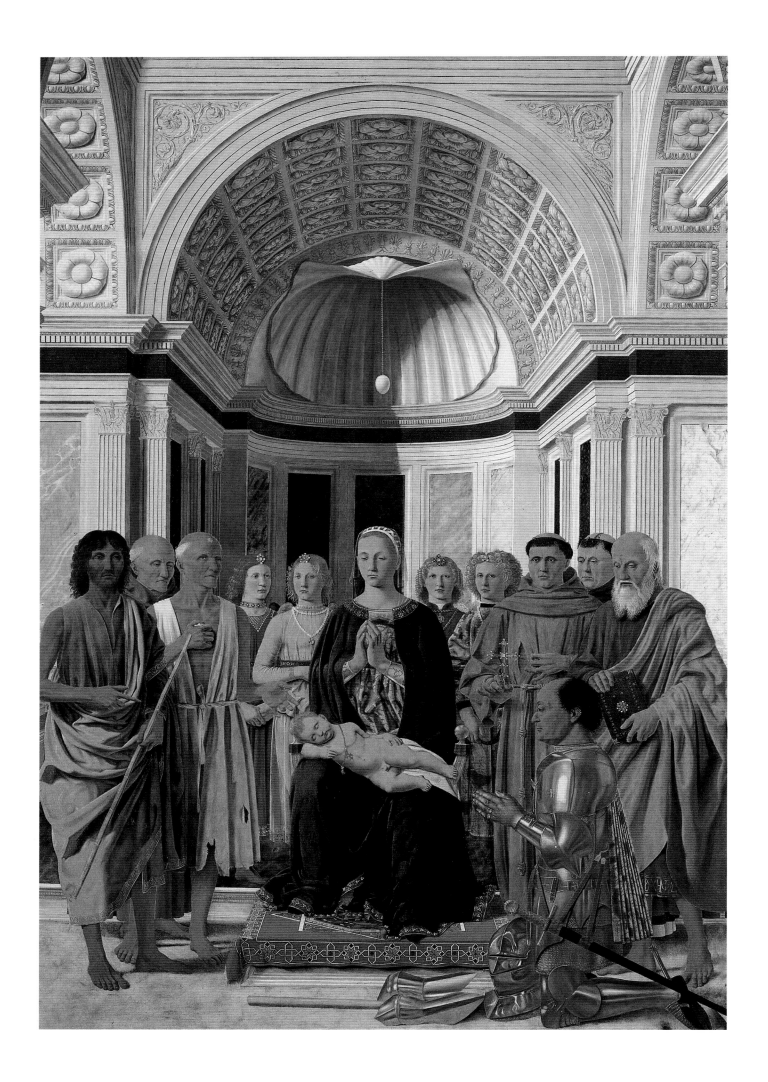

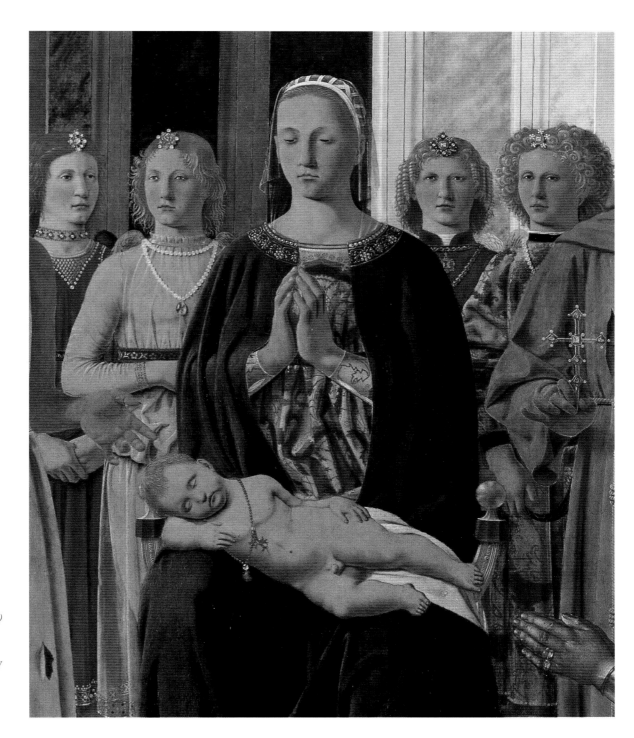

76 (right) *Pala Montefeltro (The Madonna with Child, Angels, Saints and Federico da Montefeltro, Duke of Urbino)* (detail ill. 75), 1469–1474

In the center of the painting is an opulently painted arrangement of decorative and ornamental forms. Worthy of note is the necklace of the angel on the far left and the cross that St. Francis is holding in his right hand. The duke's hands were painted by the Spanish painter Pedro Berruguete.

75 (opposite) *Pala Montefeltro (The Madonna with Child, Angels, Saints and Federico da Montefeltro, Duke of Urbino)*, 1469–1474
Oil on panel, 248 x 170 cm
Pinacoteca di Brera, Milan

The Mother of God is enthroned in front of a lavishly decorated apse from whose shell-shaped vault an ostrich egg is hanging. On her knees lies the sleeping Christ Child – an allusion to his future death on the Cross. The Virgin and Child are surrounded in a semicircle by the four archangels with St. John the Baptist, St. Bernardine of Siena and St. Jerome on the left and St. Francis of Assisi, St. Peter Martyr and St. John the Evangelist on the right. The donor Federico da Montefeltro, dressed in a commander's armor, is kneeling before her. He has removed his helmet and laid it on the floor next to him.

crossing, not the apse. In Masaccio's *Trinity* (ill. 4), the donors are placed outside the actual pictorial space, in front of Mary and St. John. In Piero's composition, in contrast, he not only includes the donor but also gives the observer the impression that he is standing in the church interior.

The *Pala Montefeltro* is composed in a monumental and, in terms of the repertoire of figures, an unusually lavish manner. It was conceived as a single panel, though comparable large panels by Flemish artists, such as Justus van Gent and Hugo van der Goes, were almost always the central pictures in a triptych. During the following years, this work by Piero would become the model for numerous altars in northern and central Italy.

The architecture has some common features with the church of Sant' Andrea in Mantua, begun by Alberti in about 1471, but – like the architecture in Masaccio's *Trinity* in Santa Maria Novella (ill. 4) – is probably a work of the artist's imagination. The number of rows in classical vaults, though, is always uneven. In this respect, in contrast to Masaccio and Alberti, Piero is modelling his work on antiquity. The apse is covered by a coffered vault and decorated with colorful marble cladding and detailed ornamentation.

All the saints bear the wounds of their martyrdom and the duke is also involved in their sufferings: his dented helmet is a hidden reference to the disfiguring loss of his right eye, though he suffered this as a result of vanity and foolishness during the course of an amorous escapade.

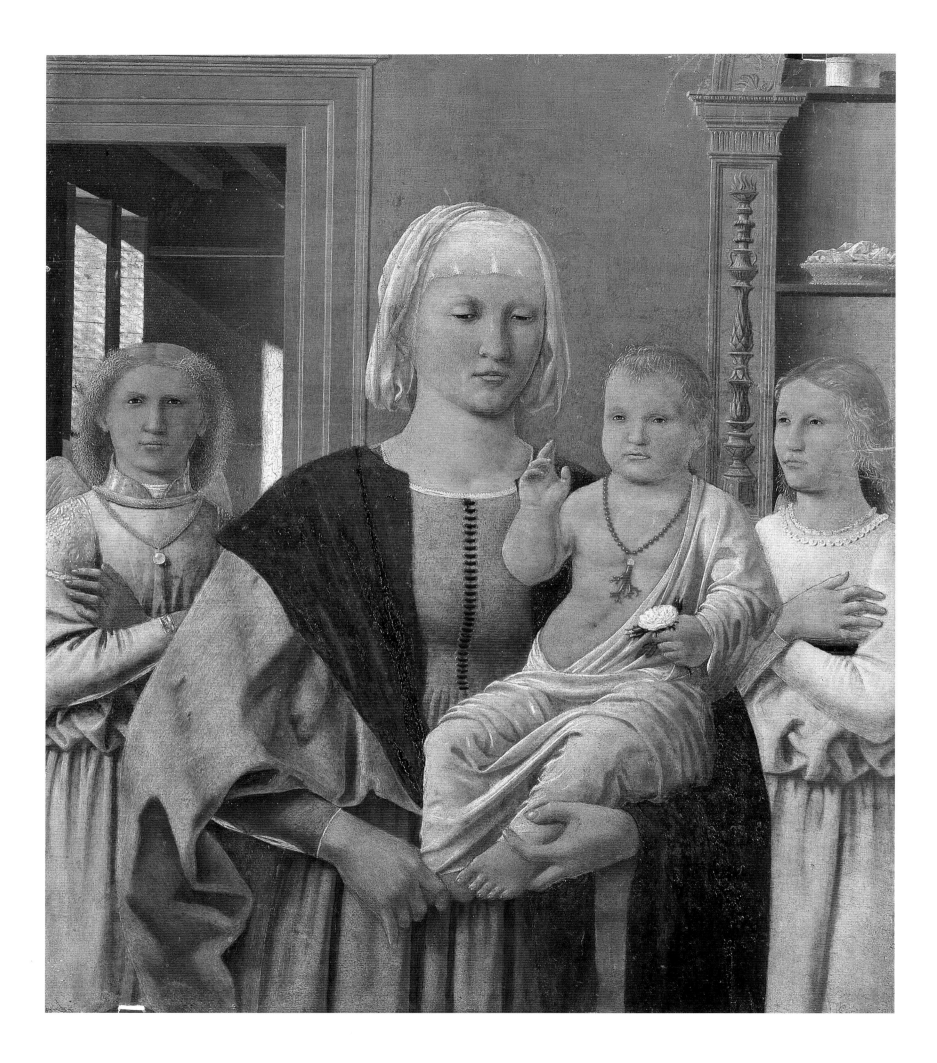

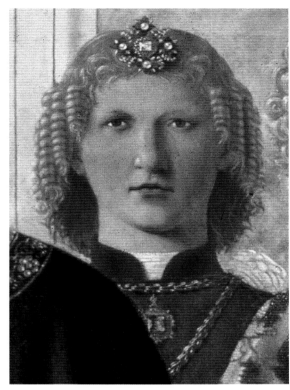

78 (right) *Madonna of Senigallia (Madonna and Child)*
(detail ill. 77), 1470–1485

The face of the angel to the left of Mary is the same as
that of the heavenly messenger to the right of the
Madonna in the *Pala Montefeltro* (ill. 75). It can be
assumed that both the angels that flank the Mother of
God here were copied by students of Piero's from the
Urbino altarpiece.

79 (far right) *Pala Montefeltro (The Madonna with Child,
Angels, Saints and Federico da Montefeltro, Duke of
Urbino)* (detail ill. 75), 1469–1474

The gentle features of the two angels immediately next to
Mary are strikingly similar to those of the angels' heads in
the *Madonna of Senigallia*. There they are simply depicted
the other way round.

77 (opposite) *Madonna of Senigallia (Madonna and
Child)*, 1470–1485
Oil on panel, 61 x 53.5 cm
Galleria Nazionale delle Marche, Urbino

The Madonna is a half length figure occupying almost the
entire area of the picture. Behind her, on the left and
right, stand two angels whose garments display the two
basic colors and determine the composition: gray and
salmon pink. The pink color is darkened to a shining
coral red in the dress Mary is wearing and the chain
which the Christ Child is wearing as a symbol of his
Passion. In the background, we can see into a room which
is being lit by sunlight flooding through the open
shutters. This gives the scene its own very intimate
character.

The egg in the apse is a complex symbol for the
Immaculate Conception, which would presumably
have only been familiar to experts on antiquity during
the 15th century. In classical Laconia, at the centre of
which was Sparta, the egg of Leda hung from the ceiling
of a temple. Leda, the wife of the Spartan king
Tyndareos, was a forerunner of Mary's. Leda's children,
Helen and Polydeuces, were fathered by Zeus, who
approached her in the form of a swan. During the
Annunciation, the dove of the Holy Spirit appears to
Mary and gives off those divine rays that turn the Virgin
into the Mother of God. The specific direction of the
light creates the illusion that the egg is floating right over
Mary's head, which, because it is hanging from the tip
of the shell in the apsidal niche in the background, is
impossible. Because of the highlight on its surface, the
egg, which should be in shadow in the apse, is brought
optically into the foreground of the picture.

The *Madonna of Senigallia (Madonna and Child)* (ills.
77, 78), a panel painting created between 1470 and
1485, is stylistically very similar to the *Pala Montefeltro*.

For this reason, the painting has been connected with
Piero's work for the Montefeltros. The work was
originally in the church of Santa Maria della Grazie in
Senigallia.

Despite the many common motifs, this depiction of
the Madonna is characterized by an entirely different,
more intimate character. For example, the view into the
back room is an allusion to Mary's bedroom in which
the incarnation of God took place. It can be found in
Florentine depictions of the Annunciation, such as those
of Masaccio, and later, of Fra Angelico and Filippo
Lippi.

There are also clear Flemish influences here: the
softness of the head veil, the shining curves of the pearls
and the sculptural highlights on the folds of material. In
addition, the picture section that Piero della Francesca
has chosen is remarkable, for it shows Mary and the two
angels as half length figures – cut off by the edges of the
picture. This makes the figures in the picture seem very
close to us, while at the same time there is no clue as to
the distance between them and us.

80, 81 Pedro Berruguete
Federico da Montefeltro and his son Guidobaldo (and detail),
1477
Oil on panel
Galleria Nazionale delle Marche, Urbino

This portrait once hung in the *studiolo* in the palace in
Urbino. The duke is depicted with all the insignia of his
power. He is wearing armor, an ermine cloak and the
Order of the Garter which was conferred on him in 1474.
He is absorbed in reading. His little son, the much
yearned for heir, is leaning against his knee. The chosen
picture section gives the scene a homely feeling.

In the Early Renaissance, the Medici family in particular
gained an important name as patrons of the arts. Cosimo
il Vecchio and Lorenzo il Magnifico especially distinguished
themselves in this field. But there were also larger and
smaller courts such as those of the Farnese family in Parma
and Rome, the Sforzas in Milan, the Gonzagas in Mantua,
and in particular the figure of Isabella d'Este-Gonzaga, the
Este family in Ferrara and Tivoli, the Malatestas in Rimini and
the Montefeltros in Urbino; they all contributed to the
creation of numerous artistic centres and artistic treasures
(ills. 66, 67).

In addition to the intention of increasing the fame of their
cities, there were other reasons which gave rise to this
patronage. One motive was surely the satisfaction of
possessing good things and being able to advise others in
questions of quality, and there was also the desire to leave
behind a magnificent and lasting memorial to oneself.
These reasons of prestige were why many non-expert rulers
brought artists to their courts. Taking an interest in art could
also be of use in politics and diplomacy: it was from the
Church that the princes adopted the principle of convincing
people by visual means. In addition, investment in the
sciences and arts was considered to be a peaceful measure:
as long as the rulers were concentrating on the fine arts,
they would not be making war. Artists frequently took on
the roles of companion and escort on long military
campaigns. Always at the forefront was the pleasure and
personal intellectual edification of those in power. Rulers
such as the Medicis, Montefeltros and Isabella d'Este-
Gonzaga were, for that reason, extremely interested in art,

educated and well-read. Their patronage was characterized
by intelligence, tolerance and independence from the
Church. However, the following of religious rules in the
Early Renaissance was so obligatory that the question of
personal faith was almost irrelevant. Furthermore, the
princes were sponsors of humanism, literature and music.
Poets valued them as knowledgeable critics. Literary figures
such as Bembo, Bandello, Ariosto and Tasso dedicated their
books to them. As clients for works of the fine arts, they
usually not only chose the artist but also determined the
theme to be depicted in the work, leaving it to experienced
advisors in literary and humanist matters to work out the
fine detail of these themes. The artists were then restricted
more or less closely to this program, the *invenzione*, as they
were known. The rulers furnished studies for themselves
and had them decorated with intarsias and extensive cycles
of paintings (examples include the *studioli* in Urbino and
Mantua), and here they studied the most important classical
written works. They either read them in the original or
commissioned translations into Italian. They frequently also
produced their own hand-written copies of rare writings
and, in this way, founded important libraries and
academies. Their root is in the schools of princes, such as
the *Casa Giocosa* in Mantua directed by Vittorino da Feltre,
an institution which can certainly be considered proof of
the conviction that the successful governing of a state was
linked to a suitable level of education. As a result, this school
produced many of the important princes and patrons of the
Early Renaissance.

The Great Altar Paintings

82 *Polyptych of the Misericordia*, 1444–64
Mixed technique on panel, ca. 273 x 330 cm
Pinacoteca Comunale, Sansepolcro

The traditionally constructed altarpiece is comprized of three main panels, five pediment panels, framing scenes on either side – including the monogram of the Compagnia della Misericordia – and a predella showing scenes from the Passion. The *Annunciation* is spread across two pictures on either side of the *Crucifixion*. On the panel next to the archangel Gabriel, St. Romuald is depicted. St. Francis appears on the panel next to Mary. In the side panels on the left are St. Jerome, St. Anthony of Padua and probably St. Arcanus, and on the right are St. Augustine, St. Domenic and probably St. Egidius.

During the Renaissance, the altar painting enjoyed a special position. The fact that artists worked mainly on this type of picture meant that it was here that stylistic changes, which involved a certain liberation from the liturgical purpose of the picture, were most conspicuously manifest. A successful composition came to be more important than the work's functional purpose. It is, however, not possible to speak of Renaissance works as not being intended for a special purpose, as can be said of art in the modern sense.

The large altar paintings in many sections that Piero della Francesca produced also show that the painter was gradually freeing himself from traditional restrictions and prescriptions and working towards an independent pictorial conception.

In his first altarpiece, the *Polyptych of the Misericordia* (ills. 82–91), Piero was still tied down to the precise restrictions in the contract with the Compagnia della Misericordia in Sansepolcro. Piero was commissioned to produce the polyptych on 11 June 1445, and was to finish it within the space of three years. There was an additional condition that he should repair all damages that might appear over the space of ten years. Further, he was required to use certain materials: " … gilded with fine gold and painted with fine colors, in particular with ultramarine blue" – at the time one of the most expensive pigments. The conditions would, however, prove to be superfluous, for it took twenty years for the work to be completed, and the brotherhood repeatedly issued reminders in vain. On the one hand this was caused by the numerous other commitments that Piero had undertaken. In addition, the painter had the reputation of working very slowly – a circumstance which the brotherhood had possibly hoped to influence by including the above mentioned stipulation. Proofs of payment suggest that the major part of the polyptych was produced after 1459. As early as the 17th century the altar was dismantled, so that the form that the polyptych now presents is a reconstruction of the original condition.

Piero discreetly integrated the new perspectival effects into the traditional iconography in which the Madonna of Mercy, being a more important figure, appeared larger than the believers gathered under her cloak. The motif of the Madonna of Mercy is derived from a custom of the Middle Ages: if victims of persecution appealed for help to high-ranking women, they could be granted asylum "under her cloak". The arrangement of those in need of help is remarkable: a group of three on the left and right, and a couple at the front with space between them. One might well think that this space is being left open for the observer. The black surface on which the kneeling figures are placed is constructed according to the laws of perspective. The vanishing point lies between the two front figures. This gives us a second reference to the position the observer should take up. This is at eye level with the two figures.

The hems of the garments, which protrude into the panels with saints on the right and left, create a connection between the central picture and the side panels. This unites the individual parts of the polyptych optically into one great panel. The number of circular and conical elements in the head, crown, nimbus and cloak of the Madonna reflects Piero's interest in basic geometric shapes. In addition, they unalterably fix the figure of Mary in the format of the picture panel. In the end, she belongs to two spaces: the religious one, manifested in the gold background behind her, and the secular one: she is sharing the floor with those under her protection and serves as an element connecting them with the life hereafter.

The panel showing St. Sebastian and St. John was presumably the first to be produced. From about 1350 onwards, the preferred way of depicting St. Sebastian, who was an auxiliary saint during the Plague and later a patron saint of the brotherhoods of archers, was naked except for a loincloth and shot full of arrows – during the Early Renaissance this provided artists with a welcome opportunity to create an anatomical study (ill. 85).

Here, St. John is not wearing furs, but is depicted in the characteristic posture of a preacher. At the age of 30, St. John was preaching and baptizing in the desert of Judea and along the banks of the Jordan. In the early Quattrocento, the Baptist was venerated as the patron saint of Florence and the saint who helped with throat ailments.

The depiction of St. Bernardine gives an indication of the dating of the panel (ill. 86). St. Bernardine of Siena

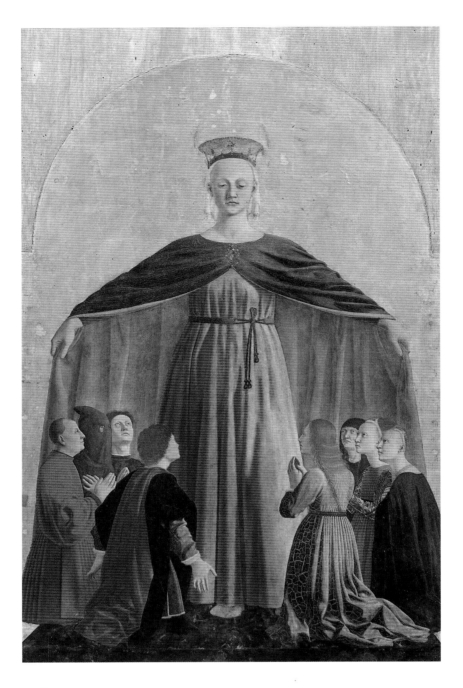

83 (left) *Madonna of Mercy*, 1444–1464
Main panel of the *Polyptych of the Misericordia*
Mixed technique on panel, 134 x 91 cm
Pinacoteca Comunale, Sansepolcro

Mary has taken those recommended to her care under the protection of her widely stretched cloak. She is depicted over life-size and towers above the other figures. The cord around her waist is tied into the shape of a cross.

84 (opposite) *Crucifixion*, 1444–1464
Pediment panel of the *Polyptych of the Misericordia*
Mixed technique on panel, 81 x 57 cm
Pinacoteca Comunale, Sansepolcro

The mother of the crucified Christ is raising her hands in a gesture of pain, and St. John has also thrown his arms back in an expressive pose. Both the dramatic character of this vocabulary of gestures, and the bowed head of the crucified Christ, which appears to be directly between his shoulder blades, display Piero's artistic proximity to Masaccio.

was canonized in 1450 and in the picture is already wearing a halo. He is a real historical figure and from 1438 was the vicar-general of the Observants, a branch of the Franciscan order, which is why he is depicted wearing a Franciscan habit and carrying a rectangular panel. His gaunt face is in keeping with the type of face in a portrait by the Sienese artist Pietro di Giovanni d'Ambrogio, which was presumably produced posthumously in 1444, as was a series of other portraits of the monk.

The predella scenes of the *Entombment* and *Resurrection* are allusions to the work of the brotherhood in caring for the sick and burying the dead. Piero della Francesca left the Florentine painter Giuliano Amidei to create them, though his style did not come up to the quality of Piero's panels. For example, in the *Entombment*, Amidei chose a rather well-worn form of iconography: during the Renaissance, the original Bible text was normally used and a more realistic burial in a rocky tomb or cave was depicted (ill. 89).

In contrast to the *Misericordia* altarpiece, in the *Polyptych of Sant'Antonio* it is the heterogeneity of the components that is remarkable. Piero started the work for the monastery of Sant'Antonio shortly after his stay in Rome in about 1460 (ills. 92–101).

Here too, Piero did not follow Alberti's demand that gold backgrounds should be painted rather than produced using gold leaf. The polyptych is painted on an embossed gold background. Gold leaf backgrounds were not signs of splendor and wealth: gold, a shining bright metal, symbolized the rays of the Holy Spirit. It is possible that in this instance Piero was inspired by Iberian models which he had seen in Rome, which attempted to achieve an intensive interaction between the colors of the figures and the gold background.

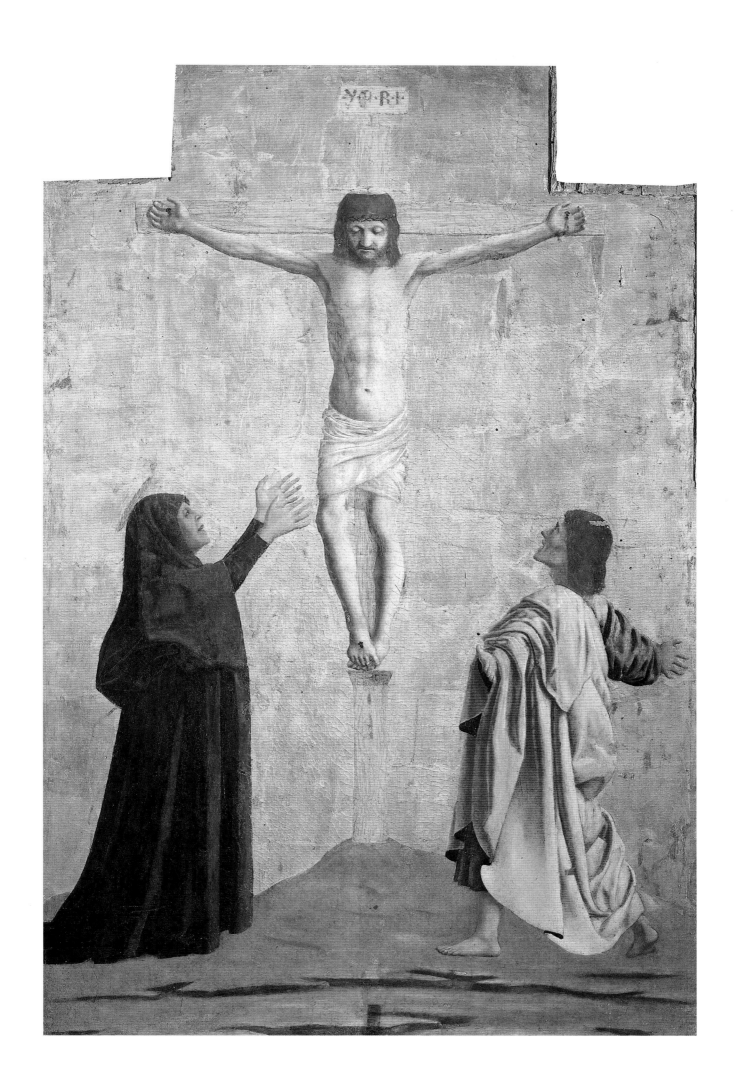

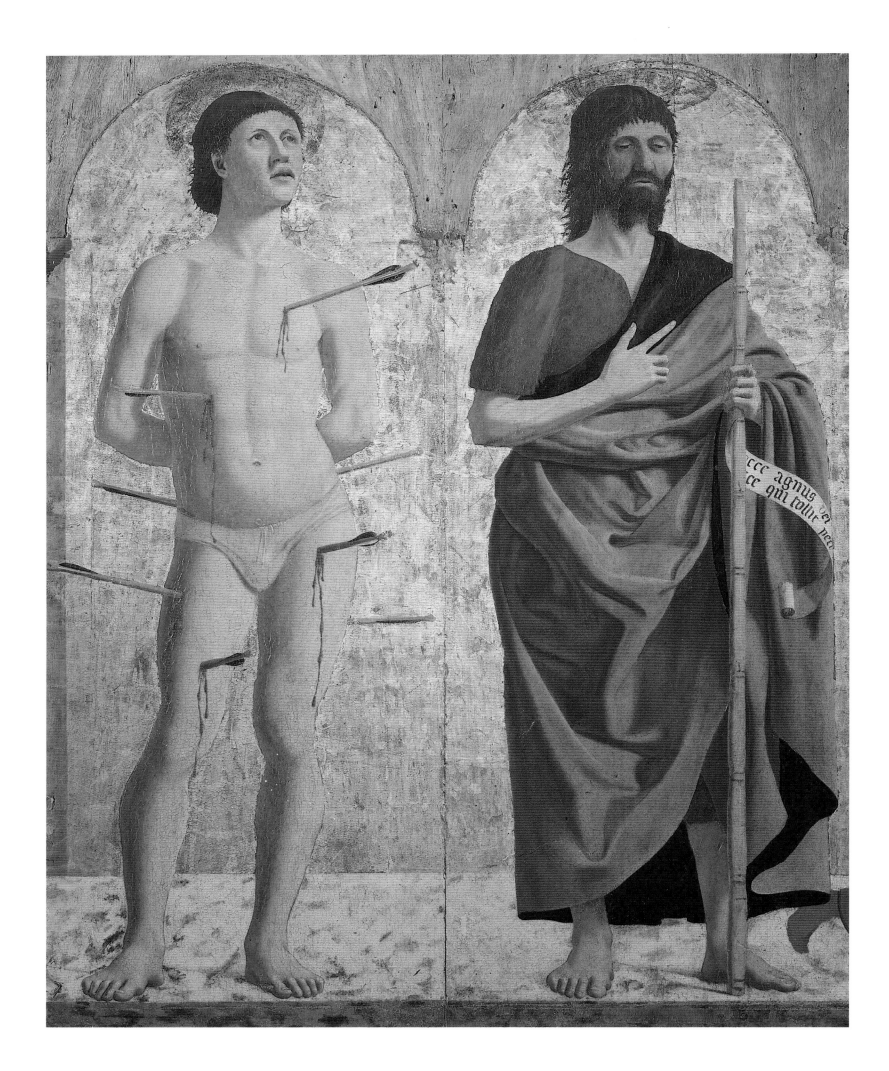

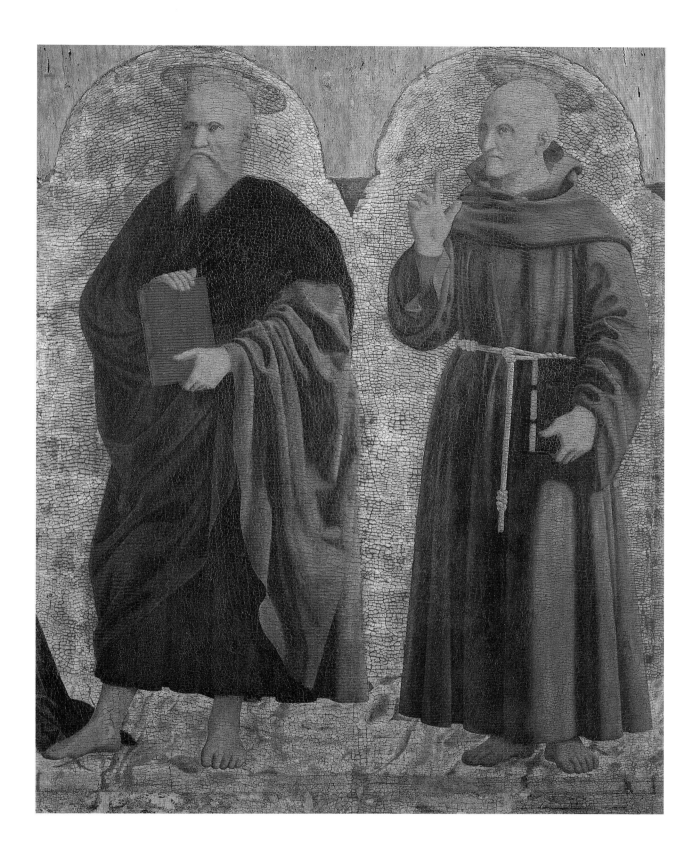

85 (opposite) *St. Sebastian and St. John the Baptist*, 1444–1464
Left side panel of the *Polyptych of the Misericordia*
Mixed technique on panel, 108 x 90 cm
Pinacoteca Comunale, Sansepolcro

The Roman officer Sebastian was martyred by being shot at by
Numidian archers. In addition to his importance as an auxiliary saint
during the Plague, in the Early Renaissance the saint was mainly
popular amongst artists because he gave them the opportunity to
produce a comprehensive anatomical depiction. In Christianity, St.
John the Baptist is considered to be the predecessor of Jesus of
Nazareth. He is normally depicted with the attributes of the staff,
garment of hair and the lamb (of God).

86 (above) *St. John the Evangelist and St. Bernardine of Siena*,
1444–1464
Right side panel of the *Polyptych of the Misericordia*
Mixed technique on panel, 109 x 90 cm
Pinacoteca Comunale, Sansepolcro

St. John the Evangelist is identified by his beard and book. The
Franciscan St. Bernardine of Siena (1388–1444) was canonized in
1450 and it was not until after that date that he could be depicted
with a halo. He was first portrayed in the Franciscan habit
immediately after his death, a portrayal which was to spread rapidly
throughout Italy.

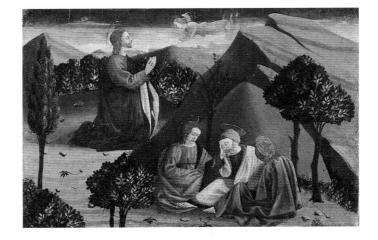

87 Giuliano Amidei
Jesus in the Garden of Gethsemane, 1444–1464
Outer left predella panel of the
Polyptych of the Misericordia
Mixed technique on panel, 22.5 x 40 cm
Pinacoteca Comunale, Sansepolcro

After the Last Supper, Jesus, who can see that the end is
nigh, visits this place on the Mount of Olives to pray.
According to the accounts in the gospels of Matthew
(26:36–46) and Mark (14:32–42), he was accompanied
only by Peter, John and James the Great. While Christ
was praying and wrestling with his fear of death, his
disciples were repeatedly overcome by a need to sleep.

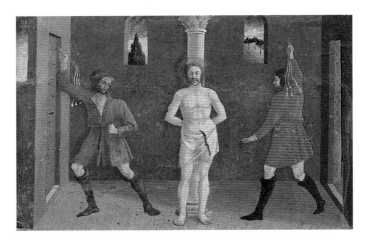

88 Giuliano Amidei
Flagellation, 1444–1464
Inner left predella panel of the
Polyptych of the Misericordia
Mixed technique on panel, 22.5 x 40 cm
Pinacoteca Comunale, Sansepolcro

After washing his hands, Pilate orders that Jesus should be
flagellated. In Roman law, this torture was the
preliminary to crucifixion. Christ is clad only in a
loincloth and tied to a column. Two thugs are beating
him with scourges. His face shows no sign of pain.

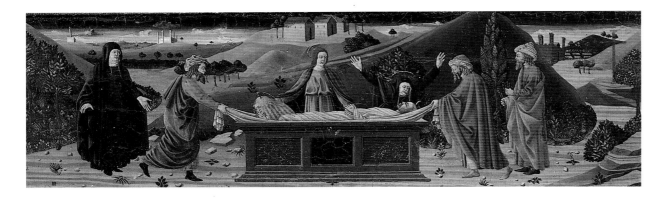

89 Giuliano Amidei
Entombment, 1444–1464
Central predella panel of the
Polyptych of the Misericordia
Mixed technique on panel, 22.5 x ca. 85 cm
Pinacoteca Comunale, Sansepolcro

Nicodemus and Joseph of Arimathea are placing the body
of Christ, wrapped in a shroud, into a sarcophagus. In
Italian painting, additional figures frequently appear in
this scene. Here, in addition to Mary and St. John the
Evangelist, two further figures are visible. At the fore is
the motif of passionate mourning and weeping.

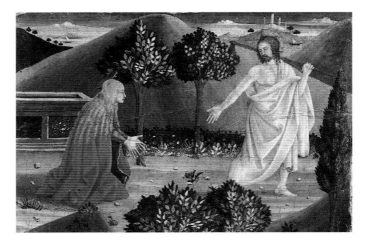

90 Giuliano Amidei
Noli me tangere, 1444–1464
Inner right predella panel of the
Polyptych of the Misericordia
Mixed technique on panel, 22.5 x 40 cm
Pinacoteca Comunale, Sansepolcro

Mary of Magdala, called Magdalene, has witnessed the
Resurrection of Christ. She is kneeling, her arms
outstretched, in front of the sarcophagus while Christ
moves away from her. The common Latin title of the
motif corresponds to the command Christ issued to
Magdalene: Touch me not!

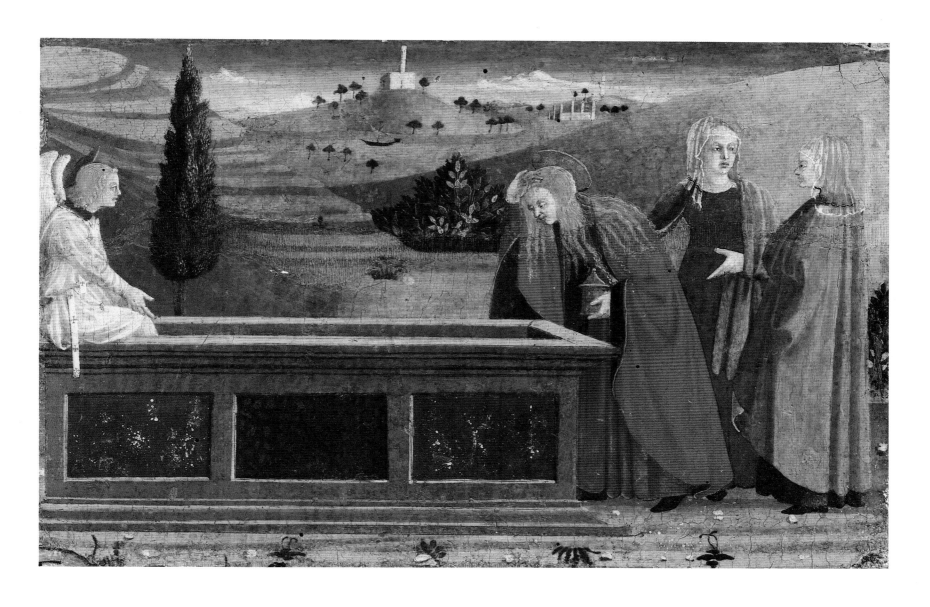

91 Giuliano Amidei
The Women at the Tomb, 1444–1464
Outer right predella panel of the
Polyptych of the Misericordia
Mixed technique on panel, 22.5 x 40 cm
Pinacoteca Comunale, Sansepolcro

On the third day after the Crucifixion, the women found that
Christ's tomb was empty. They express their astonishment in
gestures of amazement. On the left edge of the sarcophagus an angel
is sitting, and he tells them about the Resurrection and instructs
them to tell others about it.

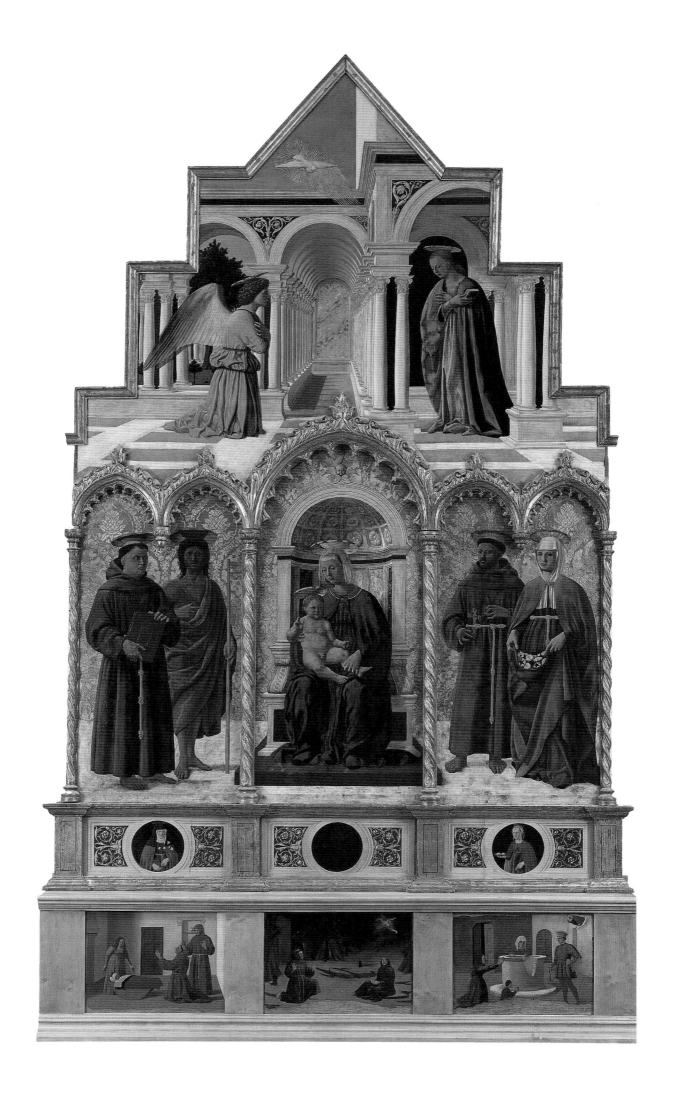

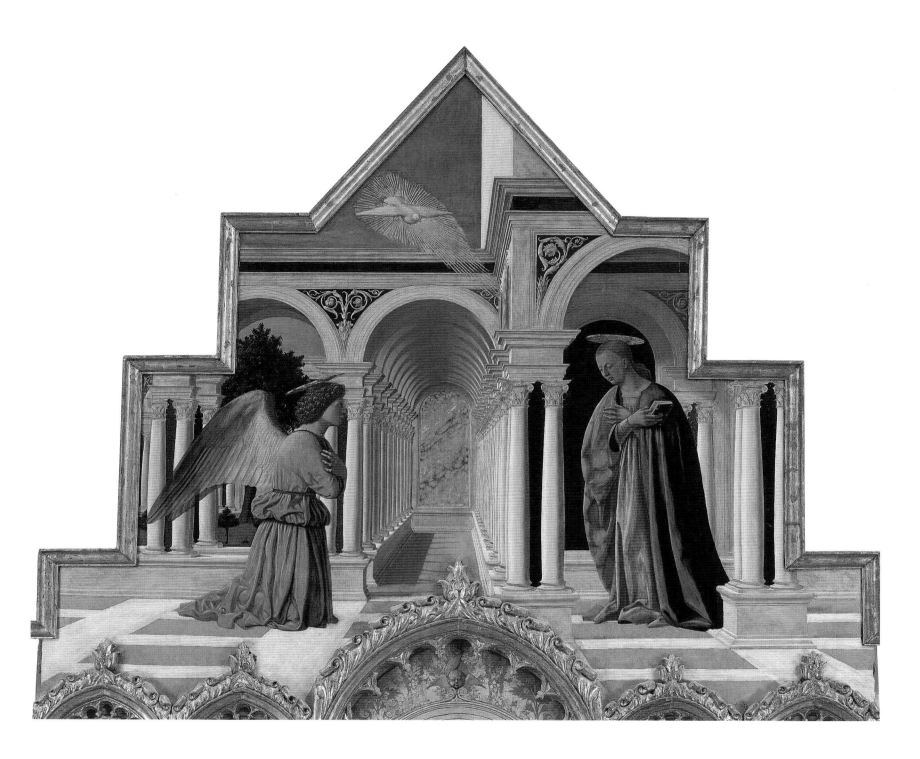

92 (opposite) *Polyptych of Sant'Antonio*, 1460–1470
Mixed technique on poplar panel, 338 x 230 cm
Galleria Nazionale dell'Umbria, Perugia

Stylistically, this altarpiece fits in between the
Misericordia altar and the Sant'Agostino altarpiece. It
combines the traditional Gothic construction of the
polyptych with a Renaissance predella and a clever
perspectival construction to the pediment, a new way of
creating illusory architectural spaces.

93 (above) *Annunciation*, 1460–1470
Pediment panel of the *Polyptych of Sant'Antonio*
Mixed technique on poplar panel, 124 x 194 cm
Galleria Nazionale dell'Umbria, Perugia

Gabriel is kneeling respectfully opposite the Virgin. The
two are separated by a long columned passage which ends
with a wall whose marble grain almost looks like a piece
of sky. Seen from above, Mary is standing outside the
arch; when seen from below, she is standing beneath it.

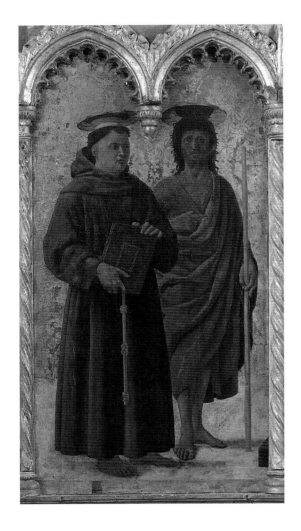

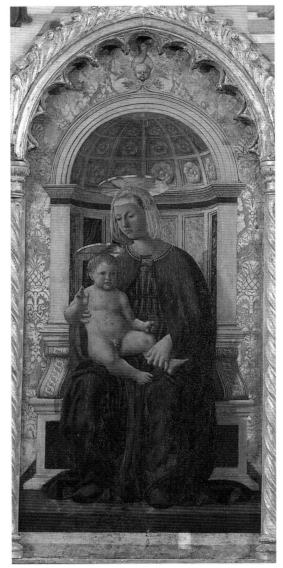

94 *St. Anthony of Padua and St. John the Baptist*, 1460–1470
Left main panel of the *Polyptych of Sant'Antonio*
Mixed technique on poplar panel, 124 x 62 cm
Galleria Nazionale dell'Umbria, Perugia

The relics of St. Anthony were transferred from Arcella to Padua
in 1263. In 1424, the pilgrimage church of Sant'Antonio was
completed, in which the relics were to be kept. The saint is
dressed in a Franciscan habit and in his hands he is holding a
book which stands for his familiarity with the Holy Scripture.
St. John the Baptist is pointing with a typical gesture – an
extended index finger – at his attribute, the staff, and in
extension at the Christ Child.

95 *Madonna and Child*, 1460–1470
Central main panel of the *Polyptych of Sant'Antonio*
Mixed technique on poplar panel, 141 x 65 cm
Galleria Nazionale dell'Umbria, Perugia

The architecture of the Madonna's throne – the coffers in the
vault decorated with rosettes and the walls with their marble
cladding – is reminiscent of the apse in the *Pala Montefeltro*,
which was created between 1469 and 1474 (ill. 75).

96 *St. Francis and St. Elizabeth*, 1460–1470
Right main panel of the *Polyptych of Sant'Antonio*
Mixed technique on poplar panel, 124 x 64 cm
Galleria Nazionale dell'Umbria, Perugia

In 1224, the crucified Christ appeared to St. Francis in the
shape of a seraph. From then on, he also bore the stigmata of the
Savior in sympathy. St. Elizabeth of Thuringia, the daughter of
Andrew II of Hungary, took a basket full of bread to the needy,
despite the fact that it was forbidden. When she was stopped on
the way and asked what was in her basket, she opened it and all
those checking could see were roses.

97 (above left) *St. Clare*, 1460–1470
Left tondo in the upper predella of the
Polyptych of Sant'Antonio
Mixed technique on poplar panel
Galleria Nazionale dell'Umbria, Perugia

In 1212, St. Clare of Assisi founded the Order of St. Clare together with St. Francis and was canonized in 1255. She is wrapped in a brown Franciscan habit with a rope belt and cowl or headscarf. In her hands she is holding a book and flower.

98 (above right) *St. Agatha*, 1460–1470
Right tondo in the upper predella of the
Polyptych of Sant'Antonio
Mixed technique on poplar panel
Galleria Nazionale dell'Umbria, Perugia

St. Agatha rejected the advances of the Roman consul Quintian, for which she suffered cruel martyrdom during the reign of Decius. During the course of it, her breasts were cut off and in many pictures she is shown carrying them on a plate.

The exploration of perspective in the spaces here goes considerably further than in the *Misericordia* altarpiece, and the main panels are devised to look more alike. The little plaster columns dividing the panels were not added until a later date. The heads of the figures are reflected in the golden discs, foreshortened according to the laws of perspective, of the saints' haloes.

The *Annunciation* scene is particularly remarkable (ill. 93). The medieval gold background has given way to a Renaissance architecture. Between Mary and Gabriel is a line of columns and arches leading into the background. The vanishing point is at the center of the marble arched window, and that is where all the compositional lines of the architecture meet. The Virgin is depicted in a state of *Humiliatio*. People in the 15th century distinguished various phases in the Annunciation. Submission preceded excitement, contemplation and inquiry.

The predella depiction of the *Stigmatization of St. Francis* (ill. 100) is also interesting. The change of color values in different lighting conditions was tried out in numerous night scenes in Renaissance painting. Monochrome night scenes such as the *Stigmatization* were, however, relatively rare even amongst academically experienced artists. One example would be the expulsion from the Garden of Eden in the background of Fra Angelico's 1434 *Annunciation* in Cortona.

The artist's third great altarpiece, the Sant'Agostino polyptych for the church of Sant'Agostino in Sansepolcro, can no longer be reconstructed completely. The individual panels with depictions of saints that have survived were grouped, within a frame set down in the contract, around a lost depiction of the Madonna. Four large and two smaller remaining panels were surely meant to form part of the altarpiece. They now form part of various collections (ills. 102–107).

Piero signed the contract with the Augustinian order as early as 1454. The date therefore overlaps with that of the Sant'Antonio altar. The Sant'Agostino polyptych is normally given a somewhat earlier date, about 1454–1469. Here Piero decided not to use a gold background. The figures, like that of *St. Mary Magdalene* (ill. 55), are placed freely in front of balustrades and against the sky. The paintings are characterized by intensive color effects and the precise reproduction of the appearance of the materials in garments and the marble grain. The effects of lighting and precise detail show the influence of Flemish naturalism.

Sections of the vestments of *St. Augustine* – the gold threads in the garment, the decoration on the miter and, in particular, the transparent crystal crosier – are meticulously produced (ill. 102). His pluvial, which is lavishly decorated with pictures, is similar to that of *St. Louis of Toulouse* (ill. 108) on a severely damaged fresco in Sansepolcro, which very recent research suggests was probably dated 1460 by Piero himself and is stylistically very similar to the frescoes in Arezzo. A famous contemporary depiction of St. Louis exists in Florence: it is the bronze statue by Donatello, created in about 1420 and now in the Museo di Santa Croce. The features of the archangel Michael, in contrast, are similar to those of the angel in the *Pala Montefeltro* (ill. 75). As St. Michael was frequently assigned to the Madonna in early Christian painting, it is possible that he at one time flanked a corresponding central panel. On the right at the edge of the picture are pieces of blue material – possibly part of Mary's robes – and a socle can be made out on which a valuable brocade material is gathered.

The depiction of the aged St. John the Evangelist contrasts with his usual depiction as a young man, for instance that in the *Crucifixion* in the *Misericordia* polyptych. Apart from his red cloak, however, the piece of socle on the left edge of the picture also suggests that this figure can be identified as St. John. The disciple, who was particularly close to Christ, frequently appears together with Mary. Here he may have been placed to her left. The central panel of the altar has been lost, so that the overall composition is unclear.

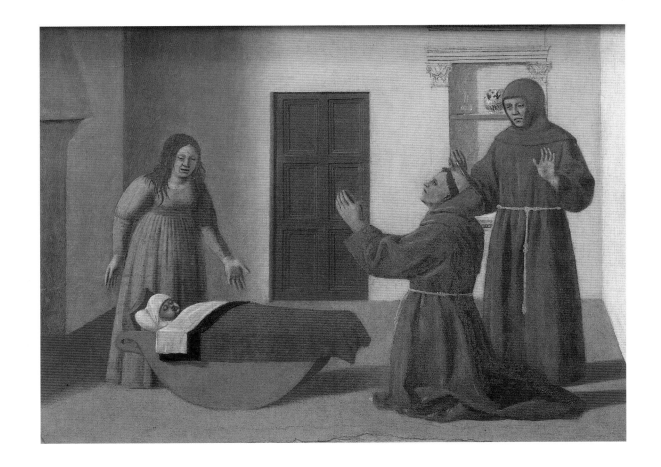

99 *Miracle of Sant'Antonio*, 1460–1470
Left panel in the lower predella of the
Polyptych of Sant'Antonio
Mixed technique on poplar panel, 36 x 49 cm
Galleria Nazionale dell'Umbria, Perugia

St. Anthony, accompanied by another Augustinian
hermit, brings a child back to life.

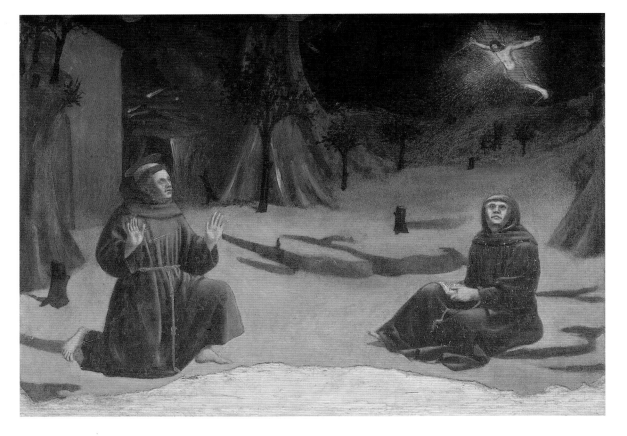

100 *Stigmatization of St. Francis*, 1460–1470
Central panel in the lower predella of the
Polyptych of Sant'Antonio
Mixed technique on poplar panel, 36 x 51 cm
Galleria Nazionale dell'Umbria, Perugia

St. Francis receives his stigmata as the crucified Christ
appears to him. This depiction is one of the few
monochrome night scenes in the Early Renaissance.

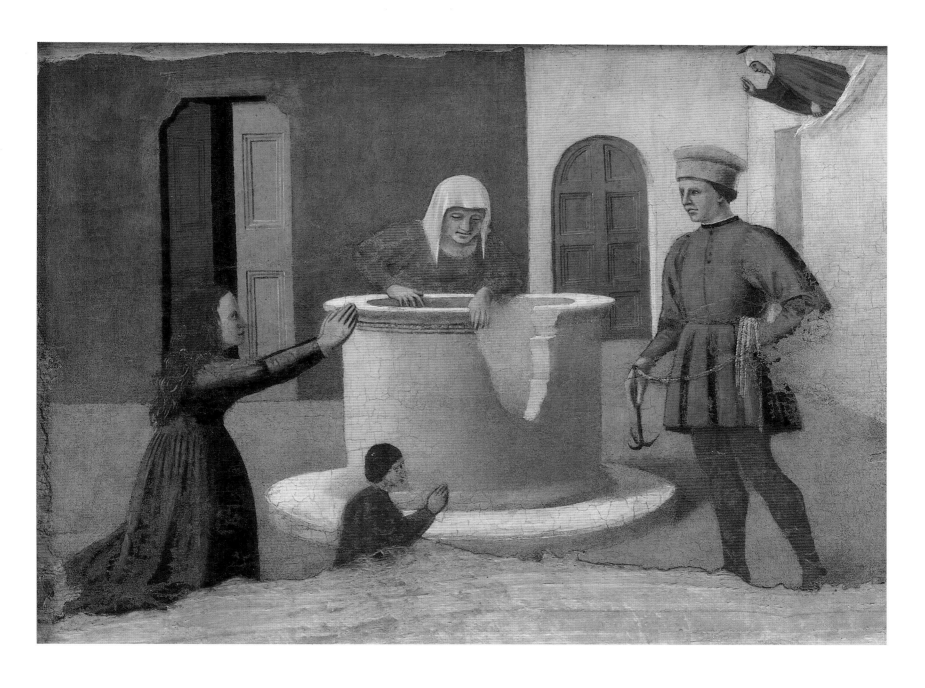

101 *Miracle of St. Elizabeth*, 1460–1470
Right panel in the lower predella of the
Polyptych of Sant'Antonio
Mixed technique on poplar panel, 36 x 49 cm
Galleria Nazionale dell'Umbria, Perugia

St. Elizabeth rescues a child who has fallen down a well.
From the right a man with a grappling hook and some
rope is coming to her aid.

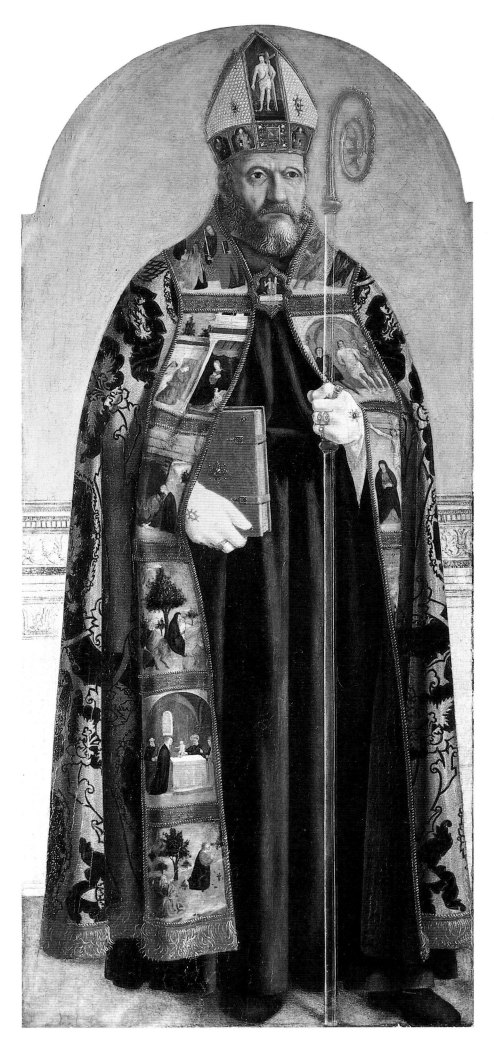

102 *St. Augustine*, 1454–1469
Panel of the Sant'Agostino altarpiece
Mixed technique on panel, 133 x 60 cm
Museu Nacional de Arte Antiga, Lisbon

St. Augustine was one of the four great Fathers of the
Church – a scholar converted late in life, whose writings
"De Trinitate" (On the Trinity) and "De Civitate Dei"
(The City of God) had a decisive influence on church
history in the Middle Ages. On the saint's pontifical
chasuble, scenes from the life of Jesus are depicted in
remarkably detailed precision.

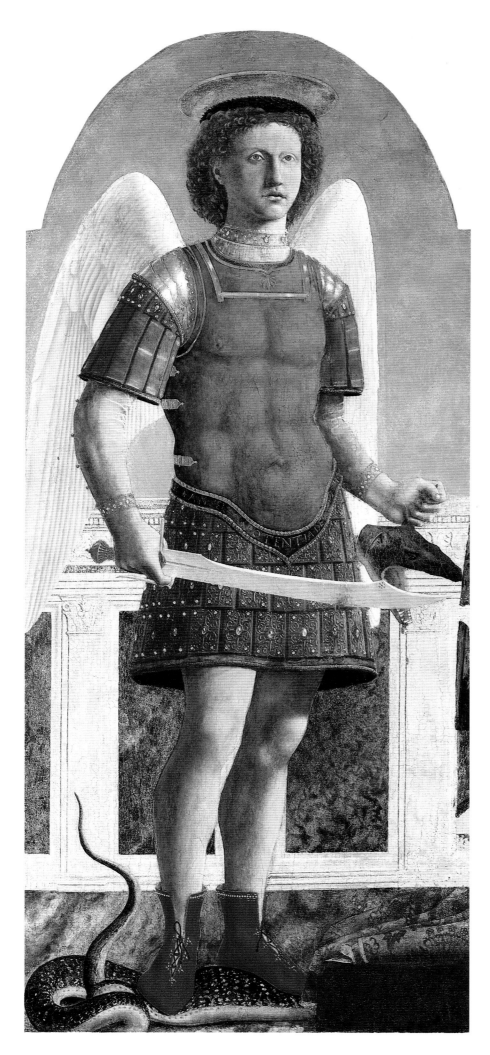

103 *Archangel Michael*, 1454–1469
Panel of the Sant'Agostino altarpiece
Mixed technique on panel, 133 x 59.5 cm
The National Gallery, London

The winged dragon killer is depicted as a youthful hero.
He is holding the monster's head in his left hand and his
sword, which he has used to cut it off the carcass, in his
right. He is standing on the dragon's body with both feet.
The color of the shining blue breastplate and scarlet
buskins is remarkable, as is the wealth of little highlights
on the metal and the precious stones that stud the armor.

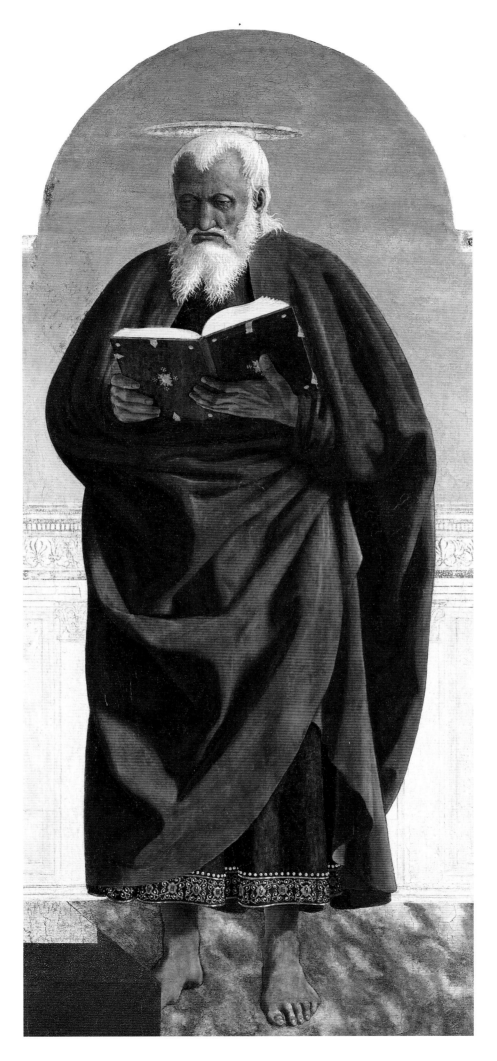

104 *St. John the Evangelist*, 1454–1469
Panel of the Sant'Agostino altarpiece
Mixed technique on panel, 131.5 x 57.8 cm
The Frick Collection, New York

St. John is wearing a gleaming carmine red robe which forms an intensive contrast with the sky blue of the background. His physiognomy is similar to that of God the Father and the Persian king Chosroes in the frescoes in Arezzo. Remarkably enough, the Evangelist is depicted as a bearded old man. While during the Middle Ages he was usually depicted as a young man, in Italy during the 15th and 16th centuries there were occasional examples of the contrary.

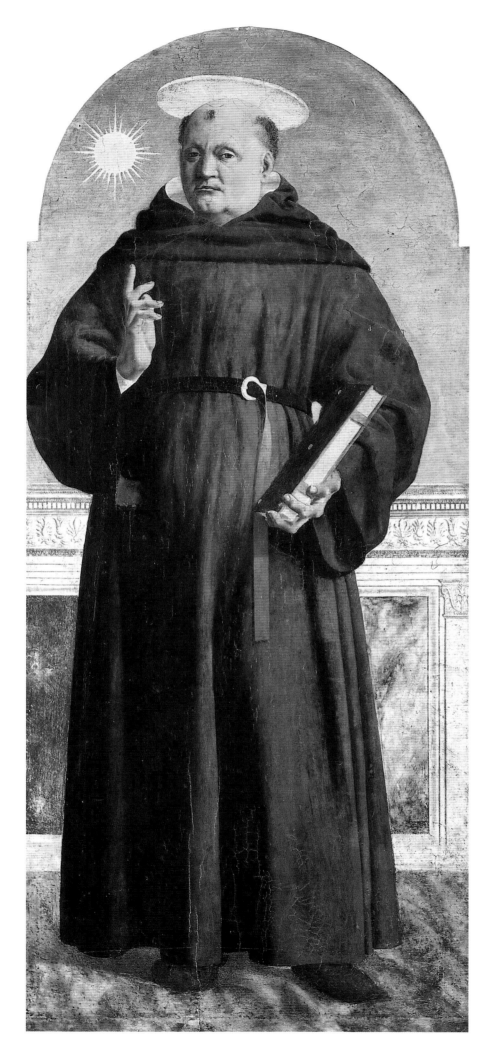

105 *St. Nicholas of Tolentino*, 1454–1469
Panel of the Sant'Agostino altarpiece
Mixed technique on panel, 136 x 59 cm
Museo Poldi Pezzoli, Milan

The saint, who was canonized in 1446, is wearing the
black habit of an Augustinian hermit, belted with a
leather strap, and carrying a book as an attribute. There is
a considerable difference in the color of this panel and the
cleaned painting of *St. John the Evangelist*.

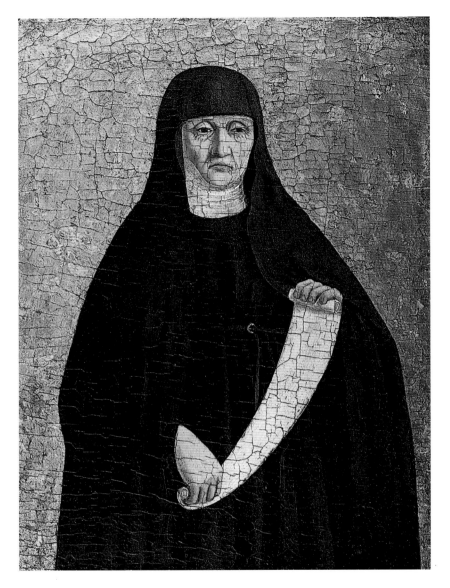

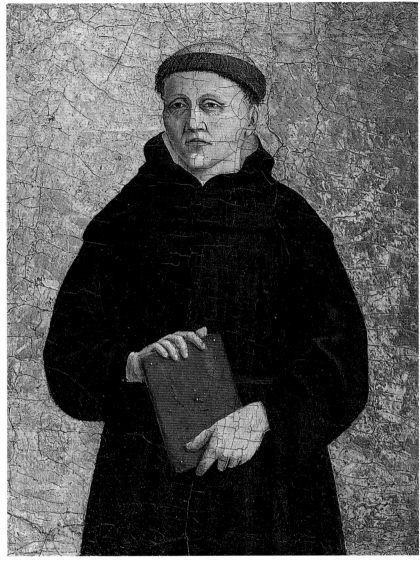

106 *St. Monica*, 1454–1469
Panel of the Sant'Agostino altarpiece
Mixed technique on panel and gold background,
39 x 28 cm
The Frick Collection, New York

In most pictures, the cloak worn by the mother of St.
Augustine is drawn up over her head, and she is holding a
banderole.

107 *Augustinian Saint*, 1454–1469
Panel of the Sant'Agostino altarpiece
Mixed technique on panel and gold background,
39 x 28 cm
The Frick Collection, New York

The black cloak with the belt and cowl show the figure to
be a member of the mendicant order of Augustinian
hermits, founded in 1256.

108 (opposite) *St. Louis of Toulouse*, 1460
Fresco, 123 x 90 cm
Museo Civico, Pinacoteca Comunale, Sansepolcro

The son of King Charles II of Naples renounced his rights
as the first-born and entered the Franciscan Order. He
died in 1297 at the age of only 23, shortly after he was
ordained as archbishop of Toulouse. He is normally
depicted in his bishop's vestments – in this case with a
particularly richly decorated pluvial.

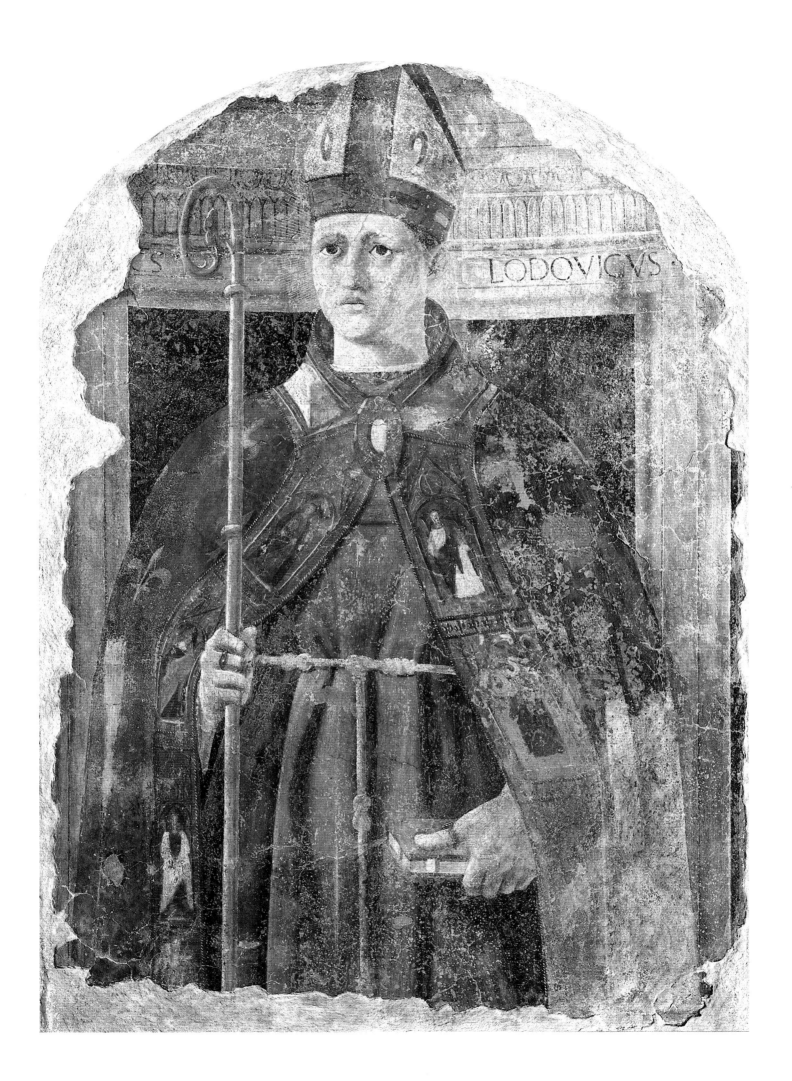

Both in the Trecento and the early Quattrocento, it was the altarpiece in several parts with an architecturally designed framework that predominated. The term *pala*, in contrast, describes a Renaissance panel with one picture surface, a rectangular picture format and frame, with pilasters on either side, a crowning architrave and a supporting predella.

The transition from the Gothic polyptych in several parts to the single panel Renaissance *pala* took place only slowly. The framework was increasingly pushed into the background in favor of the standardization of the picture surface. A technical change gave the initial impetus to this new conception of the picture. At first it had been customary to attach the so-called *legnaiolo*, the interior frame in several sections, to the base of the picture, and then to put this framework together to form the overall composition. From about 1430 onwards, it became customary not to attach the *legnaiolo* until afterwards, so that to a certain extent it became an independent part of the picture. This also explains why many examples no longer exist. While rectangular panels were no original invention of the 15th century, it was only during the course of the first quarter of the Quattrocento that the entire picture surface was used to the full in order to make a complicated spatial sequence comprehensible in terms of perspective within the picture. The invented architecture in the picture gradually took precedence over the architecture of the frame. At the

109 Filippo Lippi
Annunciation, ca. 1440
Tempera on panel, 175 x 183 cm
San Lorenzo, Cappella degli Operai, Florence

This painting is clearly divided into two by a painted architecture: on the left, raised above the main scene by a step, appear two angels. One is looking at the observer, the other at the angel Gabriel, who is kneeling in the right half of the picture before Mary. She is amazed at his words and depicted in a state of *Conturbatio* (confusion). The irregular arrangement of the foreground continues into the background: the row of houses on the left is dark, that on the right light. The formal deviation of the painting from other depictions of the Annunciation is possibly due to the function of the picture as a decoration on a cabinet for an organ or relics.

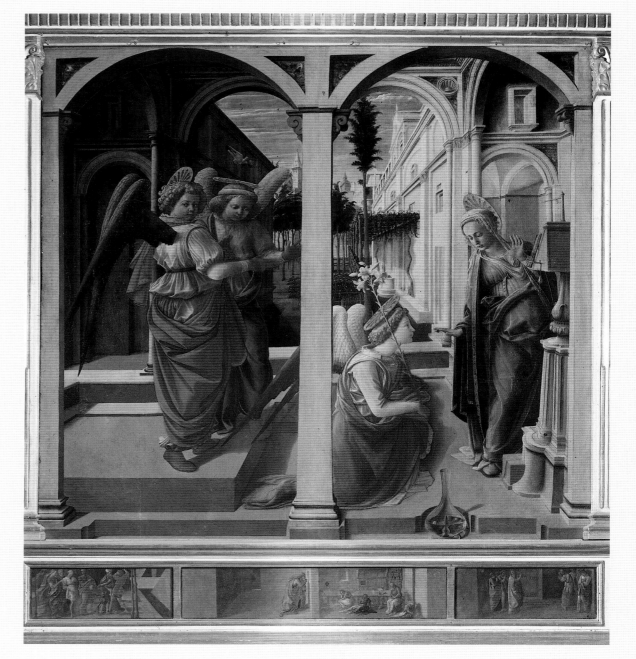

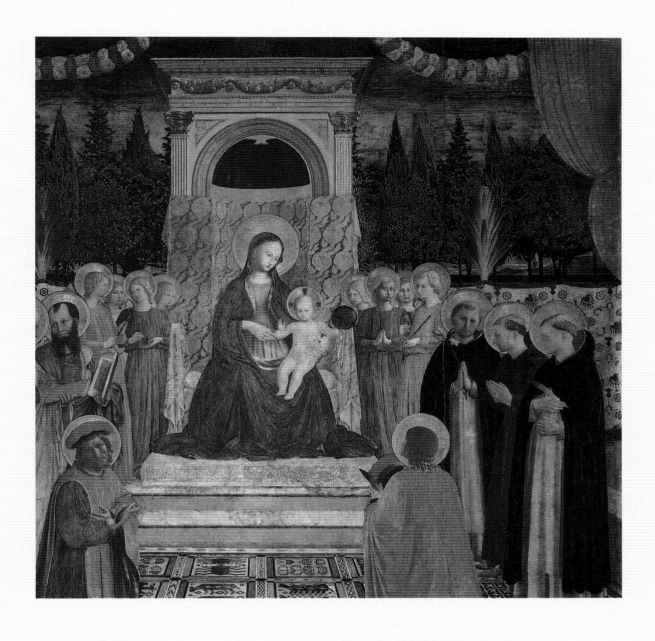

110 Fra Angelico
Madonna and Child with Angels and Saints, 1438–1443
Tempera on panel, 220 x 227 cm
Museo di San Marco, Florence

The painting, created for the high altar in San Marco, is one of the artist's main works. The Madonna is sitting with the Christ Child on a throne behind which is a richly decorated carpet. Corresponding to it is another carpet which separates the entire scene from the landscape in the background, whose trees are arranged along noticeably parallel lines. To the left and right of the throne a group of angels is standing, with three saints in front of them on either side. In the foreground, two more saints are kneeling: the one on the left is facing out of the picture, the one on the right is looking towards Mary and the child.

same time, the relationship between the picture and the real architectural surroundings in which it was to be placed became increasingly close.

One trend-setting step in the development was made by Lorenzo Monaco in about 1420–1425 in the Bartolini Chapel in the Florentine church of Santa Trinità. He introduced a framework which surrounded the three panels of the triptych on all sides. The picture surface was undivided and related to the frescoes surrounding the altar. The dimensions and color of the figures were conceived in such a way that the wall paintings served, as it were, as side wings for the altar. But this work was still a typical Late Gothic creation.

A genuine innovation was Filippo Lippi's *Annunciation* (ill. 109), dating from about 1440, in the Cappella degli Operai in San Lorenzo in Florence. As a result of the architectural work of Brunelleschi, the location of the altar painting and

its rectangular form without pinnacles was determined by the architecture of the chapel interior.

Even more refined relationships between the *pala* and architecture can be found in Fra Angelico's main altarpiece in San Marco in Florence, which was produced between 1438 and 1443 (ill. 110). This work was one of the first panel paintings to be based on a consistent application of central perspective. It was erected in the polygonal choir which Michelozzo had added when the church was extended by the Medicis. Fra Angelico repeated the motifs of this monumental piece of architecture in the Virgin's throne. In addition, this Renaissance *pala* presents us with a cleverly constructed program which, on a scale which had rarely occurred before that time, included references to the donor, and the order for which it was created, in addition to the religious subject matter.

PIERO'S LAST WORKS

111 *Madonna and Child Enthroned with Four Angels*,
1475–1482
Mixed technique on panel, 117 x 78 cm
Sterling and Francine Clark Art Institute, Williamstown,
Massachusetts

The Mother of God is surrounded by four angels and
enthroned on a folding chair which is raised by a socle
decorated with rosettes. Its counterweight is the lavishly
decorated entablature in the background. In her right
hand Mary is holding a rose, and the Christ Child on her
left knee is reaching out to the flower with his hands. The
angel dressed in red on the right edge of the picture is
looking at the observer and guiding him into the scene.

We know nothing definite about the people who
commissioned the last remaining works by Piero della
Francesca.

In addition, the attribution of the *Madonna and
Child Enthroned with Four Angels* (ill. 111) is also
disputed. The panel has been described as a spiritless
compendium of "Piero quotations" which was almost
certainly produced by a student or copyist, but it has
also been seen as a mature late work, particularly because
of the numerous typical Piero motifs. In the figure of
the right angel, whose function is that of a *festaiulo*,
Piero is turning full circle back to one of his earliest
works, the *Baptism of Christ*. The balanced relationship
of the architecture and figures, which is composed to be
strictly proportional, also suggests that this work is an
original.

The arrangement of the *Nativity* (ill. 112) is much
freer. It can serve as an example of Piero's late style. Many
motifs in the composition are drawn from Flemish
models, above all the naked Christ Child who is lying
on a section of Mary's cloak directly on the ground. This
representation of the Nativity is a mysterious picture. It
is surely not just the condition of the painting that
contributes to this impression. It appears to be
incomplete, but was probably merely cleaned too
forcefully. On one side is the group of five angels who
are united not only by their lute playing and singing but
also by a compositional element. The heads of the
figures are at the same level. In art history such a
composition is called isocephaly. This, what one might
call the Italian part of the picture, is brought face to face
with a northern part which is characterized by realistic
details instead of harmony. The ox and ass have formed
part of the depiction of the birth of Christ from a very
early date, the 3rd century. Their presence is derived
from the words of the prophet Isaiah: "The ox knoweth
his owner, and the ass his master's crib: but Israel doth
not know, my people doth not consider" (1:3). Here,
the ass is braying as if trying to outdo the music made
by the choir of angels. As conspicuous as his wide open
mouth is the raised hand of one of the shepherds. From
time immemorial he has been seen as a representative of

mankind awaiting salvation. His hand – reddish in front
of the greenish brick wall – and the gesture with which
he is pointing up to heaven make an impression on the
mind. Joseph is sitting to one side of his wife and child.
He has crossed one leg over the other and is, as if it were
the most natural thing in the world, showing us the
naked sole of his right foot. Mary appears as if detached
from all this, devoting her attention to her child
exclusively.

In early examples of Christian art the stable – or the
inn – is normally only indicated as the place where the
birth took place by means of a brick rear wall. What is
conspicuous about Piero's construction of the stable is
the fact that the upper edge of his roof does not run
parallel to the top edge of the picture. This fact can be
connected to observations about the pictorial space.
Given the way the stable is depicted, it must be standing
diagonally in the space. On the other hand, there is a
remarkable counterbalance to this factor: the Christ
Child who is lying on the ground parallel to the bottom
edge of the picture. The old world, which was ruinous
and does not particularly inspire confidence, can finally
pass away, the new life has begun.

It is stated that Piero della Francesca gradually lost his
sight during the last years of his life. However, this
blindness cannot have progressed very rapidly, for the
artist continued to be capable of writing down his
theoretical knowledge in three treatises.

Piero's pamphlet on applied mathematics, "Trattato
del Abaco" (On the Abacus), is the earliest
chronologically, as it includes examples of its application
that reappear, arranged more systematically, in the
other two treatises. "De Prospectiva Pingendi" (On
Perspective in Painting) was dedicated by Piero to his
patron Federico da Montefeltro. This dates the treatise
to the time before 1482, which was the year when the
duke died. In 1485, he dedicated the treatise "De
Quinque Corporibus Regularibus" (On the Five
Regular Bodies) to Guidobaldo da Montefeltro, the son
of Federico. It was published posthumously by Luca
Pacioli in the appendix to his "De Divina Proportione"
(On the Divine Proportions) in 1509.

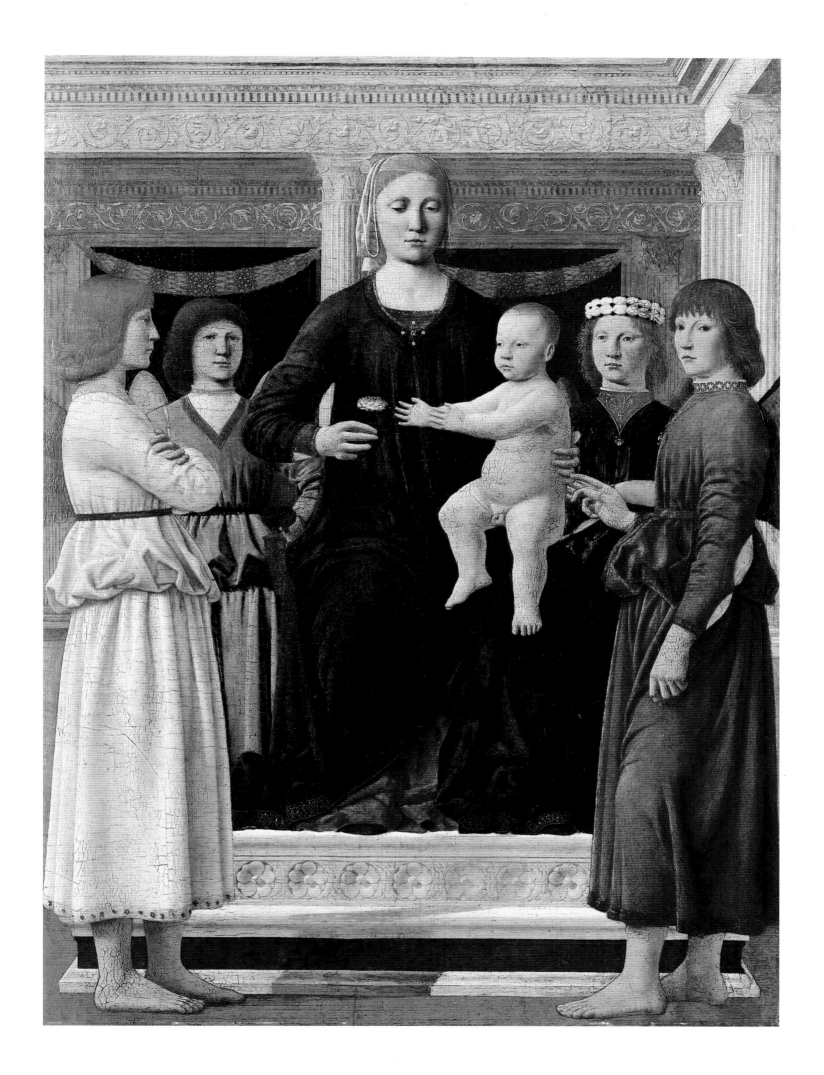

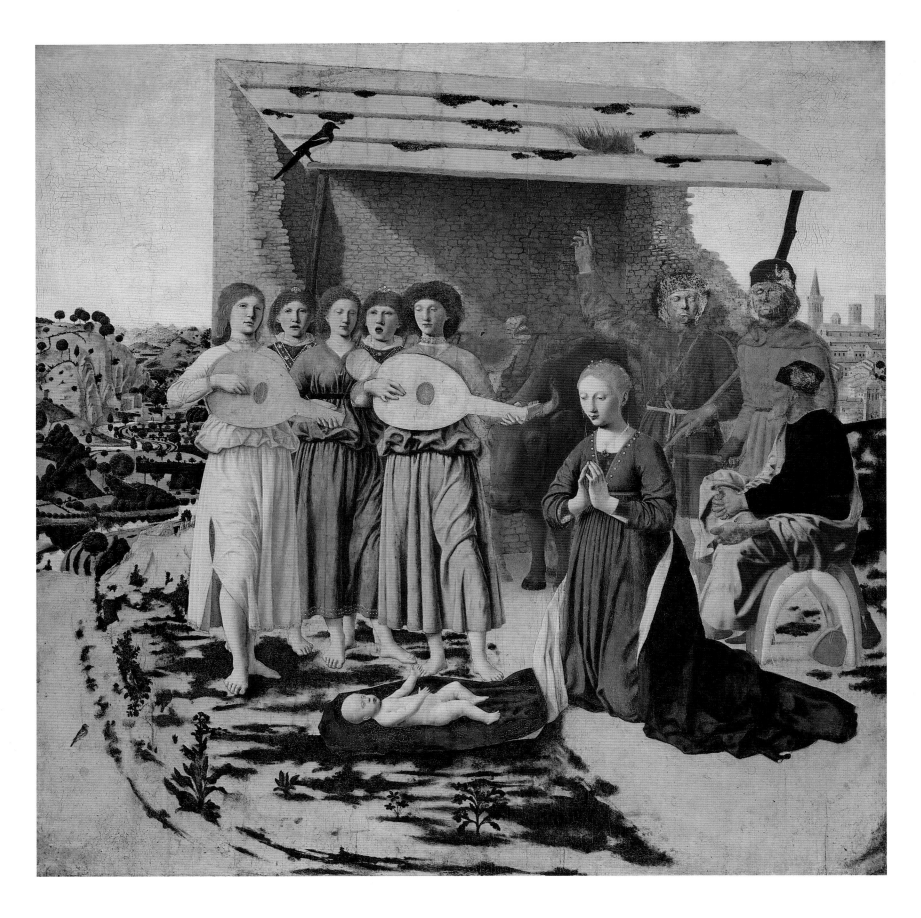

112, 113 *The Nativity* (and detail), 1470–1485
Oil on panel, 124 x 123 cm
The National Gallery, London

Mary is kneeling in adoration in front of her child, who is lying on the ground at the front on a section of her cloak. At her left, a group of five angels is singing and playing lutes, and on the right two shepherds are arriving on the scene. One of them is stretching out his hand to point to the sky. In front of him, St. Joseph is sitting relaxed on a saddle. The scene is concluded at the rear with a ruined stable behind which, on the left, is a view of a landscape and, on the right, a view of a city, presumably Sansepolcro.

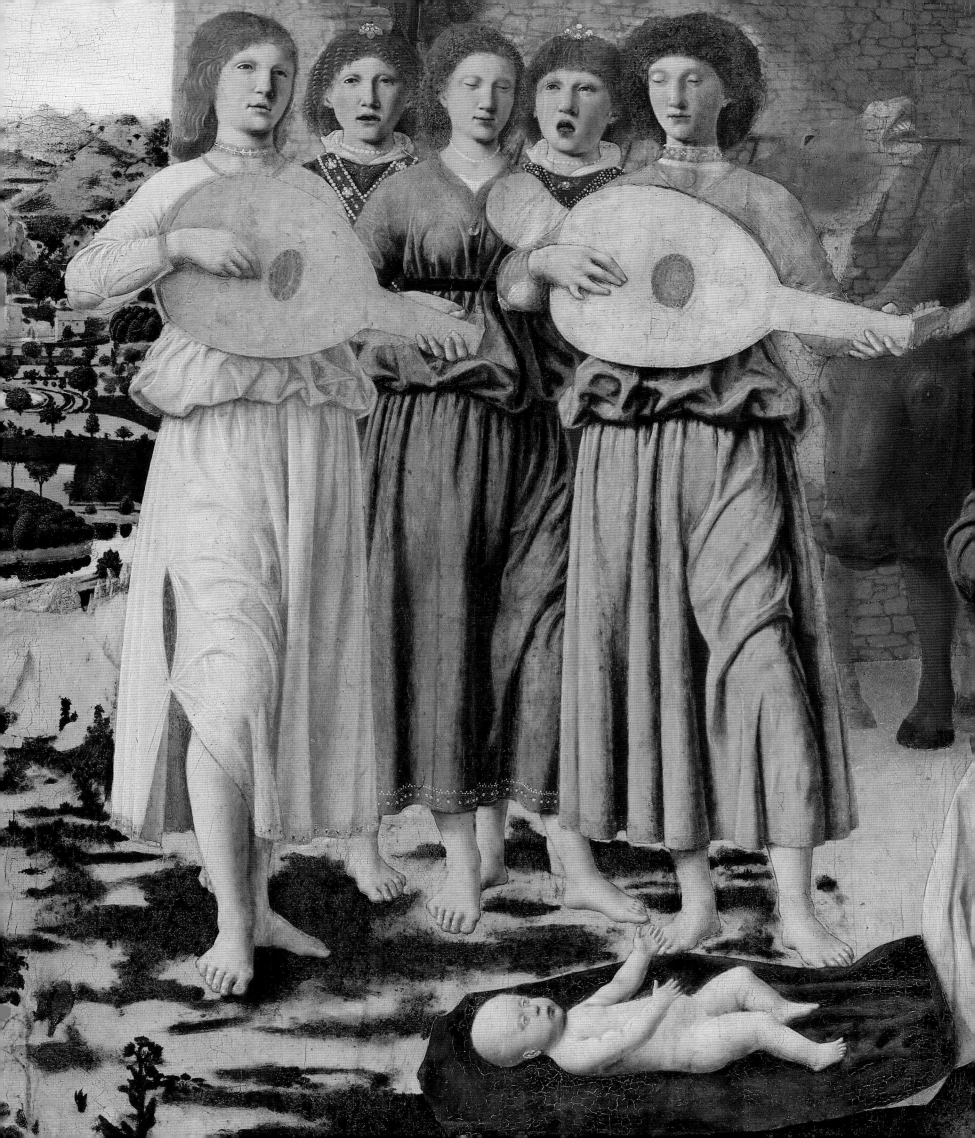

THE ART OF PIERO DELLA FRANCESCA: AN EVALUATION

114 *Discovery and Proof of the True Cross* (detail ill. 38), 1452–1466

The view of the city is not composed according to the laws of perspective. Instead, Piero joins various bordering areas of color in such a way that they can be compared with, and related to, each other. The angles of the three roof gables that tower up one behind the other on the left, for example, are more obtuse than the church gable. This, in turn, is red like the balconies on the houses.

In his descriptions of the lives of the most important Italian artists ("Le vite de' più eccellenti architetti, pittori et scultori italiani"), which first appeared in 1550, Giorgio Vasari (1511–1574) of course also included Piero della Francesca. Although he was aware of the importance of Piero's academic studies in particular and referred to them emphatically, he was surely also aware of his artistic quality: "besides excelling in the sciences mentioned above, [he] also excelled in painting."

The fact that Vasari repeatedly mentions Piero's theoretical studies on geometry and perspective is due entirely to the fact that during the lifetime of the art historiographer they had lost none of their validity.

One of the fundamental aspects of Quattrocento culture in Italy appears to have been the continually spreading predominance of visual perception. The fundamental changes in the ways of seeing things clearly dominated, at least from the middle of the century, all other possible ways of perceiving reality. The new visual sensitivity brought about a predominantly figurative culture which depicted its determining symbols and values, as well as the changing themes of the age – the division of the Church, the threat of the Turks, the tensions between the rulers in the peninsula and between ecclesiastical and secular power – in visual form.

Decisive elements in the cultural development of the century were the discovery of perspective in painting, the developing ability to think spatially in three dimensions, also in a geographical context, and the invention of printing – all aspects which address the sense of sight.

Perspective made it possible to depict spaces, objects and figures in three dimensions and to produce an apparently perfect match of our real experiences of vision. This was an artistic revolution which was to retain its validity for the next five centuries. Piero della Francesca was the Italian artist who made comprehensive use of the initial experiences made by his predecessors in this field and consistently applied his own theoretical knowledge, which he had presumably acquired through hard work, to the medium of painting. His exceptional artistic intuition always, however, kept him from the danger of making the perspectival composition of the picture and volumetric depiction of figures the most important factor in his paintings. Piero saw this process as a means of presenting his specific message in a topical – and that meant a classic and truthful – manner. This modern concept of art and its deep spiritual and symbolical content, the connection between avant garde dynamics and archaic statics – statuesqueness; between complex picture structures and clear readability, are responsible for the fact that, even today, Piero has lost none of his currency.

Piero's capacity for synthesis was probably developed to a not inconsiderable degree by the social circumstances of his age. The exchange of ideas on a regional and national scale increased enormously during the second half of the century. Borders and territories were constantly changing and therefore lost what in the Middle Ages had been their inescapable significance. This was noticeable even in so small a town as Sansepolcro, which changed its political affiliation on three occasions during Piero's life. In addition, artists from all over Europe were keen to come to Italy, where they were given lucrative and prestigious commissions by the powerful religious rulers in Rome in particular.

Piero understood, in a way that was unique at the time, how to let these non-Italian artistic tendencies have a stimulating effect on his art without in the process destroying its own monumental power and typical coloring.

Let us conclude by turning, once again, to one of Piero's most impressive works, the *Pala Montefeltro* (ill. 75).

The problem with which Piero was here getting to grips was how to translate the perspectival projection to the curved space: the semicircle of saints repeats, on a larger scale, the curve of the apse. By connecting the saints with the architecture which opens out at the sides, the entire pictorial space seems to open out for the observer. This is also where the light is falling onto the scene, focused on the central figure of the Madonna and her child, and breaking off at the circular apse in the background. Nowhere else but here does it become more clear how, in Piero's works, the theoretical knowledge of the precise perspectival spatial conception has to be subordinated to the concrete pictorial idea, the experience of nature, history and sacredness. His artistic and spiritual intuition cannot be curbed by geometric rules. One need only look at the ostrich egg floating from the tip of the shell vault above the oval, egg-shaped head of Mary. Despite apparently correct perspectival foreshortening, the oval is hanging, like an optical illusion, over the ovals of the heads and refers to the universality of this form, its significance and the religious event.

Even though the picture appears to open up to the observer and to be fixed against a realistic architectural backdrop, the composition is characterized by an unapproachable quality, a celestial and mysterious distance. This unapproachable quality is created by the features of the faces, which seem to have been turned to stone like those in a snapshot. In addition, the parallel and symmetrical arrangement seals the figures into an impermeable unity. However, the real main role in the painting is played by the light. The virtuoso direction of the light is how Piero convinces us of the "reality" of his invented picture, both clarifying and defamiliarizing his spatial conception at the same time.

The line of shadow on the rear wall of the apse proves that this must lie far further back than we realize. The bright areas of light on the egg, on the faces of figures and, in particular, on the armor of the duke of Urbino kneeling in the foreground, once again draw the composition together and create the impression that the figures are standing directly in front of the apse, even though the architectural motifs are telling us something different. The appearance that a single strong source of light from the left transept of the church is causing the fields of light, shade and highlights, is contradicted by the window which is clearly reflected in the duke's armor. Light – the bright, blazing light of central Italy – bewitches the composition, qualifies the references and keeps the composition and the observer's gaze in an indissoluble tense relationship that filled Piero's contemporaries with enthusiasm and is still capable of fascinating us today.

Piero's scientific and artistic legacy had a lasting influence on the development of art during the late 15th and early 16th century. With regard to theory, he had a decisive effect on scientists such as the mathematician Luca Pacioli and artists such as Leonardo and Dürer, who recognized the value to art of the mathematical and geometric laws that Piero had written about, and based their own work on them.

As the artistic trends of his age, both traditional and modernizing, were united as an ideal type in Piero's artistic work, it became a milestone in the development of art and an essential benchmark for his successors. The monumental quality of his figures, the perspectival construction of the pictorial space and the spiritual calm of his compositions led, throughout Italy, to the final surmounting of the Gothic style and prepared the way for the soaring artistic achievements in Italy at the beginning of the 16th century.

CHRONOLOGY

1413 Benedetto di Piero Benedetto Franceschi is married for a second time, to Romana di Renzo di Carlo Monterchi.

ca. 1416/17 Piero is born in Borgo San Sepolcro. He is followed by four younger brothers, two of whom die at an early age, and a sister.

1436 On 18 October Piero's name appears in official documents as witness to the drawing up of a will.

1437/38 Works with Domenico Veneziano in Perugia.

1439 A written document exists showing that Piero is working as an assistant to Domenico Veneziano on the production of the choir frescoes in the church of Sant' Egidio in Florence.

1442 Piero is one of the *Consiglieri popolari* in the People's Council in Sansepolcro. In order to take up this position one had to be at least 20 years old.

1445 Piero signs the contract for the polyptych for the Compagnia della Misericordia in Sansepolcro.

1446/47 It is probably at about this time that Piero creates a fresco that no longer exists, in the Este palace in Ferrara.

1450 Piero completes the *St. Jerome* in Venice.

1451 Fresco in the Tempio Malatestiano in Rimini.

1452 The start of work on the frescoes on the *Legend of the True Cross* in San Francesco in Arezzo.

1454 The Compagnia della Misericordia in Sansepolcro sends a reminder about the completion of its polyptych. On 4 October the contract for a polyptych for the church of Sant'Agostino in Sansepolcro is signed.

1458/59 Piero is in Rome and presumably works on frescoes for the papal chambers in the Vatican, which are later overpainted by Raphael.

1459 Piero's mother dies on 6 November.

1460 Signing of the frescoes of *St. Louis of Toulouse* in Sansepolcro.

1462 Receipt of payment for the *Misericordia* altar.

1464 Piero's father dies on 20 February.

1466 The Annunziata confraternity in Arezzo commissions Piero to produce a processional flag.

1467 Piero works on a processional flag in Sansepolcro and holds official positions there.

1468 Piero completes a banner in Bastia, as he had to leave Borgo San Sepolcro because of the Plague.

1469 Piero enters into negotiations with the Corpus Domini brotherhood in Urbino about the completion of an altar painting started by Uccello. He receives part payment for the Sant'Agostino polyptych.

1471 Piero pays his taxes in Borgo San Sepolcro on 23 February.

1473 Final payment for an undetermined work, possibly the polyptych for the monastery of Sant'Agostino.

1474 Final payment for a lost painting for the Lady Chapel in the Badia in Sansepolcro.

1477 From 1 July and with occasional breaks, Piero stays in Sansepolcro until 1480, and is a regular member of the council there.

1478 Completion of another fresco that no longer exists in the chapel of the Compagnia della Misericordia.

1480–1482 Piero is the head of the Brotherhood of St. Bartholomew in Sansepolcro.

1482 Piero rents an apartment in Rimini on 22 April.

1485 Piero dedicates his treatise "Libellus de Quinque Corporibus Regularibus" to Guidobaldo Montefeltro, the son of Federico da Montefeltro.

1487 Piero draws up his will on 5 July.

1492 Piero dies on 11 October and is buried on 12 October in the Badia in Sansepolcro.

GLOSSARY

altarpiece, a picture or sculpture that stands on or behind set up behind an altar. Many altarpieces were very simple (a single panel painting), though some were huge and complex works, a few combining both painting and sculpture within a carved framework. From the 14th to 16th century, the altarpiece was one of the most important commissions in European art; it was through the altarpiece that some of the most decisive developments in painting and sculpture came about.

apse (Lat. *absis*, "arch, vault"), a semicircular projection, roofed with a half-dome, at the east end of a church behind the altar. Smaller subsidiary apses may be found around the choir or transepts. The adjective is **apsidal**.

architrave (It. "chief beam"), in classical architecture, the main beam resting on the capitals of the columns (ie the lowest part of the entablature); the molding around a window or door.

attribute (Lat. *attributum*, "added"), a symbolic object which is conventionally used to identify a particular person, usually a saint. In the case of martyrs, it is usually the nature of their martyrdom.

Augustinians, in the Roman Catholic Church, a mendicant order founded in 1256 under the rule of St. Augustine (AD 354–430). The order became widespread in the 14th and 15th centuries, renowned for its scholarship and teaching. Under the influence of humanism during the Renaissance, Augustinians played a leading role in seeking Church reform.

Bacchus, in Greek and Roman mythology, the god of wine and fertility.

balustrade a rail supported by a row of small posts or open-work panels.

banderole, (It. *banderuola*, "small flag"), a long flag or scroll (usually forked at the end) bearing an inscription. In Renaissance art they are usually held by angels.

Book of Hours, a book of the prayers to be said at specific hours of the day. Books of Hours were usually for a lay person's private devotions, and many of them were richly illuminated. Among the finest were those created by the Limbourg brothers in the early 15th century.

Camaldolense, in the Roman Catholic Church, relating to the religious order of the Camaldolenesi, founded in the early 11th century by St. Romuald at Camaldoli, near Arezzo in Italy.

cartoon (It. *cartone*, "pasteboard"), a full-scale preparatory drawing for a painting, tapestry, or fresco. In fresco painting, the design was transferred to the wall by making small holes along the contour lines and then powdering them with charcoal in order to leave an outline on the surface to be painted.

chasuble (Lat. *casula*, "cloak, little house"), a long vestment worn by a Roman Catholic priest during Mass.

chiaroscuro (It. "light dark"), in painting, the modelling of form (the creation of a sense of three-dimensionality in objects) through the use of light and shade. The introduction of oil paints in the 15th century, replacing tempera, encouraged the development of chiaroscuro, for oil paint allowed a far greater range and control of tone. The term chiaroscuro is used in particular for the dramatic contrasts of light and dark introduced by Caravaggio. When the contrast of light and dark is strong, chiaroscuro becomes an important element of composition.

choir (Gk. *khoros,* "area for dancing; chorus"), in a Christian church, the areas set aside for singers and the clergy, generally the area between the crossing and the high altar.

Cinquecento (It. "five hundred"), the 16th century in Italian art. The Cinquecento began with the High Renaissance (with works by Michelangelo, Leonardo da Vinci and Raphael), and saw both the development of Mannerism and the beginnings of Baroque. It was preceded by the **Quattrocento**.

coffering, a ornamental system of deep panels recessed into a vault, arch or ceiling. Coffered ceilings, occasionally made of wood, were frequently used in Renaissance palaces.

crosier, a staff with a crook or cross at the end carried by a bishop or archbishop as a symbol of office.

diptych (Gk. *diptukhos*, "folded twice"), a painting consisting of two panels hinged together. Usually an altarpiece, the diptych was common in the Middle Ages. They were often portable, the hinges allowing the two panels to be folded together.

fascia, in classical architecture, the three horizontal bands — lying on top of one another, and projecting slightly from bottom to top — in an architrave.

festaiuolo (It.), in Renaissance painting, a figure (often an angel) who by gazing directly out of a picture (and sometimes pointing at the central characters of the events depicted) acts as a link between the viewer and the scene.

fluted, of a column or pillar, carved with closely spaced parallel grooves running vertically.

Franciscans, a Roman Catholic order of mendicant friars founded in 1209 by St. Francis of Assisi (given papal approval in 1223). Committed to charitable and missionary work, they stressed the veneration of the Holy Virgin, a fact that was highly significant in the development of images of the Madonna in Italian art. In time the absolute poverty of the early Franciscans gave way to a far more relaxed view of property and wealth, and the Franciscans became some of the most important patrons of art in the early Renaissance.

fresco (It. "fresh"), wall painting technique in which pigments are applied to wet (fresh) plaster (*intonaco*). Painting in this way is known as painting *al fresco*. The pigments bind with the drying plaster to form a very durable image. Only a small area can be painted in a day, and these areas, drying to a slightly different tint, can in time be seen. Small amounts of retouching and detail work could be carried out on the dry plaster, a technique known as *a secco* fresco.

frieze (Lat. *frisium,* "fringe, embroidered cloth"), in classical architecture, the horizontal band of the entablature between the cornice and the architrave, often decorated with relief sculptures; a decorated band running along the upper part of an internal wall.

Gothic (Ital. gotico, "barbaric, not classical"), the style of European art and architecture during the Middle Ages, following Romanesque and preceding the Renaissance. Originating in northern France about 1150, the Gothic style gradually spread to England, Spain, Germany and Italy. In Italy Gothic art came to an end as early as 1400, whilst elsewhere it continued until the 16th century. The cathedral is the crowning achievement of Gothic architecture, its hallmarks being the pointed arch (as opposed to the Romanesque round arch), the ribbed vault, large windows, and exterior flying buttresses. The development of Gothic sculpture was made possible by Gothic architecture, most sculptures being an integral part of church architecture. Its slender, stylized figures express a deeply spiritual approach to the world, though its details are often closely observed features of this world. Gothic painting included illuminated manuscripts, panel pictures, and stained glass windows.

Heilsgeschichte (Ger. "holy history"), the Passion of Christ; the Christian doctrine of salvation through the suffering and death of Christ.

intarsia (It. *intarsiare,* "to inlay"), a form of furniture decoration in which images are created using thin veneers of differently colored woods, and sometimes also ivory and mother of pearl. It was usually used on wall panelling, cabinet doors, and the like. Intarsia work was developed in particular by Sienese craftsmen during the 14th and 15th centuries and outstanding examples, noted for their illusory realism, were created for the ducal palace in Urbino in the 15th century.

Legenda Aurea (Lat. "golden legend"), a collection of saints' legends, published in Latin in the 13th century by the Dominican Jacobus da Voragine, Archbishop of Genoa. These were particularly important as a source for Christian art from the Middle Ages onwards.

loggia (It.), a gallery or room open on one or more sides, its roof supported by columns. Loggias in Italian Renaissance buildings were generally on the upper levels. Renaissance loggias were also separate structure, often standing in markets and town squares, that could be used for public ceremonies.

lunette (Fr. "little moon"), in architecture, a semicircular space, such as that over a door or window or in a vaulted roof, that may contain a window, painting or sculptural decoration.

miter (Lat. *mitra,* "hat"), a tall, conical hat worn by bishops.

monochrome (Gk. *monokhromatos,* "one color"), painted in a single color; a painting executed in a single color.

narthex (Gk. *narthex,* "box"), in architecture, a portico or lobby at the front door of an early Christian church or basilica.

Order of the Garter, the highest order of knighthood in Britain, established by Edward III in 1348.

palette (Lat. *pala,* "spade"), the board on which an artist mixes colors; the range of colors an artist uses.

pediment, in classical architecture, the triangular end of a low-pitched roof, sometimes filled with relief sculptures; especially in Renaissance and Baroque architecture, a decorative architectural element over a door or window, usually triangular (broad and low), but sometimes segmental.

perspective (Lat. *perspicere,* "to see through, see clearly"), the method of representing three-dimensional objects on a flat surface. Perspective gives a picture a sense of depth. The most important form of perspective in the Renaissance was **linear perspective** (first formulated by the architect Brunelleschi in the early 15th century), in which the real or suggested lines of objects converge on a vanishing point on the horizon, often in the middle of the composition (**centralized perspective**). The first artist to make a systematic use of linear perspective was Masaccio, and its principles were set out by the architect Alberti in a book published in 1436. The use of linear perspective had a profound effect on the development of Western art and remained unchallenged until the 20th century.

piazza, (It.) a public square in an Italian city or town.

pilaster (Lat. *pilastrum*, "pillar"), a rectangular column set into a wall, usually as a decorative feature.

pluviua, an ecclesiastical vestment, often richly decorated, a cope.

polyptych (Gk. *poluptukhos*, "folded many times"), a painting (usually an altarpiece) made up of a number of panels fastened together. Some polyptychs were very elaborate, the panels being housed in richly carved and decorated wooden frameworks. Duccio's *Maestà* (1308–1311) is a well-known example.

predella (It. "altar step"), a painting or carving placed beneath the main scenes or panels of an altarpiece, forming a kind of plinth. Long and narrow, painted predellas usually depicted several scenes from a narrative.

Quattrocento (It. "four hundred"), the 15th century in Italian art. The term is often used of the new style of art that was characteristic of the Early Renaissance, in particular works by Masaccio, Brunelleschi, Donatello, Botticelli, Fra Angelico and others. It was preceded by the **Trecento** and followed by the **Cinquecento.**

relief (Lat. *relevare*, "to raise"), a sculptural work in which all or part projects from the flat surface. **Bas relief** (*basso rilievo*) is a low relief, the figures projecting less than half their depth from the background.

rosette, a small architectural ornament consisting of a disc on which there is a carved or molded a circular, stylized design representing an open rose.

Sacra Conversazione (It. "holy conversation"), a representation of the Virgin and Child attended by saints. There is seldom a literal conversation depicted, though as the theme developed the interaction between the participants – expressed through gesture, glance and movement – greatly increased. The saints depicted are usually the saint the church or altar is dedicated to, local saints, or those chosen by the patron who commissioned the work.

sarcophagus, pl. **sarcophagi** (Gk. "flesh eating"), a coffin or tomb, made of stone, wood or terracotta, and sometimes (especially among the Greeks and Romans) carved with inscriptions and reliefs.

seraph, pl. **seraphim** (Hebrew "angel"), an angel. In the Medieval hierarchy of celestial beings, they are the first in importance. They are usually depicted with three pairs of wings.

sfumato (It. "misty, softened"), in painting, a very gradual transition from light to dark, a subtle modelling of forms that eliminates sharp contours.

Made possible by the introduction of oil paints, *sfumato* was largely developed by Leonardo da Vinci.

Sibyl of Cumae, in the ancient Roman world, a priestess of Apollo who could predict the future. Jewish and Christian additions were later made to the many books of Sibylline prophecies, and the Sibyl of Cumae was widely seen as having foretold the coming of Christ. She is depicted, for example, on Michelangelo's Sistine Ceiling.

stigmata, sing. **stigma** (Gk. "mark, brand, tattoo"), the five Crucifixion wounds of Christ (pierced feet, hands and side) which appear miraculously on the body of a saint. One of the most familiar examples in Renaissance art is the **stigmatization** of St Francis of Assisi.

studiolo, pl. *studioli* (It.), a room in a Renaissance palace in which the rich or powerful could study their rare books and contemplate their works of art. The *studiolo* became a symbol of a person's humanist learning and artistic refinement. Among the best known are those of Duke Federico da Montefeltro in Urbino, and Isabella D'Este in Mantua.

tempera (Lat. *temperare*, "to mix in due proportion"), a method of painting in which the pigments are mixed with an emulsion of water and egg yolks or whole eggs (sometimes glue or milk). Tempera was widely used in Italian art in the 14th and 15th centuries, both for panel painting and fresco, then being replaced by oil paint. Tempera colors are bright and translucent, though because the paint dried very quickly there is little time to blend them, graduated tones being created by adding lighter or darker dots or lines of color to an area of dried paint.

tectonic (Gk. *tekton*, "carpenter, builder"), relating to structure or design.

tondo, pl. **tondi** (It "round"), a circular painting or relief sculpture. The tondo derives from classical medallions and was used in the Renaissance as a compositional device for creating an ideal visual harmony. It was particularly popular in Florence and was often used for depictions of the Madonna and Child.

topos, pl. **topoi** (Gk. "a commonplace"), in literature, figure of speech; in art, a widely used form, model, theme or motif.

Trecento (It. "three hundred"), the 14th century in Italian art. This period is often considered the "proto-Renaissance", when writers and artists laid the foundation for the development of the early Renaissance in the next century (the **Quattrocento**). Outstanding figures of the Trecento include Giotto, Duccio, Simone Martini, the Lorenzetti brothers, and the Pisano family of sculptors.

triumphal arch, in the architecture of ancient Rome, a large and usually free-standing ceremonial archway built to celebrate a military victory. Often decorated with architectural features and relief sculptures, they usually consisted of a large archway flanked by two smaller ones. The triumphal archway was revived during the Renaissance, though usually as a feature of a building rather than as an independent structure. In Renaissance painting they appear as allusion to classical antiquity.

trompe-l'œil (Fr. "deceives the eye"), a painting which, through various naturalistic devices, creates the illusion that the objects depicted are actually there in front of us. Dating from classical times, trompe-l'œil was revived in the 15th century and became a distinctive feature of 17th-century Dutch painting.

tympanum (Lat. "drum"), in classical architecture, the triangular area enclosed by a pediment, often decorated with sculptures. In medieval architecture, the semi-circular area over a a door's lintel, enclosed by an arch, often decorated with sculptures or mosaics.

typology, a system of classification. In Christian thought, the drawing of parallels between the Old Testament and the New. **Typological** studies were based on the assumption that Old Testament figures and events prefigured those in the New, e. g. the story of Jonah and the whale prefigured Christ's death and resurrection. Such typological links were frequently used in both medieval and Renaissance art.

vault, a roof or ceiling whose structure is based on the arch. There are a wide range of forms, including: the **barrel** (or **tunnel**) vault, formed by a continuous semi-circular arch; the **groin** vault, formed when two barrel vaults intersect; and the **rib** vault, consisting of a framework of diagonal ribs supporting interlocking arches.

SELECTED BIBLIOGRAPHY

Aronberg-Lavin, Marylin: Piero della Francesca, San Francesco, Arezzo, George Braziller, Inc., New York 1993

Aronberg-Lavin, Marylin: Piero della Francesca and His Legacy, Washington 1995

Battisti, Eugenio: Piero della Francesca, Instituto editoriale italiano, Milan 1971; Piero della Francesca, Electa, Milan 1992

Baxandall, Michael: Painting and Experience in Fifteenth Century Italy, A Primer in the Social History of Pictorial Style, Oxford University Press, Oxford 1977

Berenson, Bernard: Piero della Francesca o dell'arte non eloquente, Florence 1950; Piero della Francesca or the Ineloquent in Art, London 1950

Bertelli, Carlo: Piero della Francesca, Silvana editoriale, Milan 1991; Piero della Francesca, Leben und Werk des Meisters der Frührenaissance, Cologne 1992

Burke, Peter: Culture and Society in Renaissance Italy, B. T. Batsford Ltd., London 1972

Clark, Kenneth: Piero della Francesca, Phaidon Press, London 1951, new edition 1969

Gilbert, Creighton: Change in Piero della Francesca, Locust Valley, New York 1968

Ginzberg, Carlo: Indagini su Piero, Giulio Einaudi editore s. p. a., Turin 1981; Erkundungen über Piero, Piero della Francesca, ein Maler der frühen Renaissance, Francfort 1981, 1984

Jahnsen, Angeli: Perspektivregeln und Bildgestaltung bei Piero della Francesca, Munich 1990

Lightbown, Ronald: Piero della Francesca, Abbeville Press Publishers, New York, London, Paris 1992

Longhi, Roberto: Piero della Francesca, Sansoni, Rome 1927, Florence 1963